D1686355

FRAMING FILM

FRAMING FILM is a book series dedicated to theoretical and analytical studies in restoration, collection, archival, and exhibition practices, in line with the existing archive of EYE Film Institute. With this series, Amsterdam University Press and EYE aim to support the academic research community, as well as practitioners in archive and restoration. Please see www.aup.nl for more information.

PATRICIA PISTERS
FILMING FOR THE FUTURE

The Work of Louis van Gasteren

AMSTERDAM UNIVERSITY PRESS

dvd © Spectrum Film, Amsterdam, 2016
with financial support of the Netherlands Film Fund.

eye film institute netherlands

Cover illustration: SUNNY IMPLO (1970), installation by Louis van Gasteren in collaboration with Fred Wessels.

Cover design and lay-out: Magenta Ontwerpers, Bussum

Amsterdam University Press English-language titles are distributed in the US and Canada by the University of Chicago Press.

ISBN	978 94 6298 238 3 (paperback)
ISBN	978 94 6298 031 0 (hardback)
e-ISBN	978 90 4852 957 5
DOI	10.5117/9789462980310
NUR	670

© P. Pisters / Amsterdam University Press B.V., Amsterdam 2016

All rights reserved. Without limiting the rights under copyright reserved above, no part of this book may be reproduced, stored in or introduced into a retrieval system, or transmitted, in any form or by any means (electronic, mechanical, photocopying, recording or otherwise) without the written permission of both the copyright owner and the author of the book.

TABLE OF CONTENTS

Acknowledgements 7

INTRODUCTION: ENCOUNTERING A PRESCIENT FILMMAKER 9
Louis van Gasteren 'An Ebullient Director Bursting with Ideas' 10
Selecting from a Vast Non-Linear Spectrum 14
THE OPERATION – BROWN GOLD – ACROSS THE SAHARA

1 **LAND, HOUSE AND CITY** 21
Housing and Architecture: Constructing and Rebuilding a Post-War Country 22
ALL BIRDS HAVE NESTS – A NEW VILLAGE ON NEW LAND – BACK TO NAGELE
The House: History, Memory and Meaning 30
THE HOUSE
Dwelling in the City Roots and Resistance 37
ROOTS OF THE CITY (public art work)

2 **WATER, TRANSPORT AND TECHNOLOGY** 43
Water is Our Element: The Sea as Friend and Enemy 45
THE STRANDING – MAYDAY
Dry Feet below Sea Level: An Integral View on Water 49
AOD (public monument) – A MATTER OF LEVEL - NEELTJE JANS (land art project)
Technologies of Transportation: Roads, Phones and Globe-Conscious 55
RAILPLAN 68 – GLOBE-CONSCIOUS MATERIAL PAINTINGS (art) – WARFFUM – THERE IS A PHONE CALL FOR YOU

| 5

3 WAR AND TRAUMAS OF THE PAST 65
MONTE KLAMOTT (art project)
Mediated Memories of the Second World War 67
Return of the Repressed: From KZ-Syndrome to PTSD 69
NOW DO YOU GET IT, WHY I AM CRYING
The Haunting Shadows of Ducker and Dorbeck 74
A CHAINSAW FOR THE PAST – THE CLOUDY EXISTENCE OF LVG – HAMARTÍA
Sorrows of a Past Never Lived 81
ROERMOND'S SORROW – THE PRICE OF SURVIVAL

4 YOUNG REBELS AND DOORS OF PERCEPTION 85
Generations, Existential Roles and Circles of Life before Death 88
HANS LIFE BEFORE DEATH
Stirring Things Up and Psychedelic Escapes 95
ALL REBELS
Electronic Brains and Audio-Visual Investigation of Perception 101
BECAUSE MY BIKE STOOD THERE – DO YOU GET IT 3, 4 – OUT OF MY SKULL – SUNNY IMPLO (art)

5 EUROPE, POLITICS AND MULTINATIONALS 107
Sardinia, Evolution of One of the Oldest 'Homes' of Humanity 109
CORDEBBU, SALUDE E LIBERTADE, THE SARDONIC SMILE
Sicco Mansholt and the Emergence and Evolution of the European Union 113
CHANGING TACK
Global Capital and Neo-Colonial Wars 121
REPORT FROM BIAFRA – REPORT FROM KARTHOUM – MULTINATIONALS

CODA: FEEDBACK LOOPS IN TIME WITHOUT FINAL CUT 131
Joie de Vivre and Disillusions of Life 133
NEMA AVIONA ZA ZAGREB
Cutting and Re-Ordering, Temporal Looping and 'Nema' 136

Notes 145
Filmography of Louis van Gasteren 165
Art Works of Louis van Gasteren 175
Illustrations 177
Bibliography 179
Index 186

ACKNOWLEDGEMENTS

I spent many hours in the office and archive of Spectrum Film researching this book, watching films, reading newspaper articles and other documentation, and meeting with Louis van Gasteren and his wife Joke Meerman. This book would not have been possible without their generous hospitality and their assistance in finding material and information. I also want to thank Elisabeth Verheus for her support in the archive and Flora Lysen for her archival curiosity. I would like to express my gratitude to colleagues who have read and commented upon (parts) of the manuscript: Frans-Willem Korsten, Christoph Lindner, Rob van der Laarse and James Kennedy, as well as Michael Martin and Hans Beerekamp. I am much obliged to Laura Grimaldi and Blandine Joret for their editorial aid. This book is part of the Framing Film series, a series on Dutch cinema in English, by Amsterdam University Press and EYE Film Institute Netherlands. I would like to thank Jeroen Sondervan and Chantal Nicolaes from AUP, and Giovanna Fossati, Leo van Hee, Rommy Albers, Simona Monizza and Anna Abrahams from EYE. As always, friends and family are important for inspiration, support, understanding, and sharing thoughts and experiences of life.

A note about the translations of films and book titles: In the text, film titles are indicated by their English translation; the first time a title is mentioned, the original Dutch title is also written in brackets. Sometimes, the original title is English (or German or French or Croatian). In the filmography, all films are listed by their original title first, followed by the English translation.

Several references are to books or articles written in Dutch. In the case of untranslated works, I have kept the original Dutch title; in cases of existing official translations I have also indicated the translated version in the text and the bibliography.

INTRODUCTION

Encountering a Prescient Filmmaker

In order to prevent one of his friends in the counter-culture scene in Amsterdam from performing a controversial act of 'mind expansion', in June 1964, filmmaker Louis van Gasteren confiscated the tools that the friend wanted to use to drill a hole in his own skull. Nevertheless, in January 1965 Bart Huges performed the operation to create a 'Third Eye' without any assistance. When Van Gasteren found out the next day, he immediately grabbed his camera and went to see Huges in his small apartment where Van Gasteren filmed him, sitting in bed with a bandaged head, explaining in an astonishingly clinical way (Huges was a student of medicine) how and why he had pursued trepanation. The film that Van Gasteren released years later (in 1979) under the title THE OPERATION (DE INGREEP) also contained black-and-white photographs of Cor Jaring. Watching THE OPERATION almost fifty years after the event, the film remains remarkable; not only because it presents a unique document of the spirit of that period in time, but also because one can feel the urgency of a filmmaker who saw the cultural and political importance of events in the present as a means of understanding the past and the future. A filmmaker engaged as a visionary participant observer in his surroundings, camera and microphone always on stand-by in an era long before we all carried mobile recording devices in our pockets.

After I saw THE OPERATION, I sought out other films by one of the most prolific and longest actively working Dutch filmmakers. I continue to be amazed by the films of Louis van Gasteren, with their unusual audacity, passionate rigour and idiosyncratic combination of the serious and traumatic with the playful and surreal aspects of life. Given that, despite their wide scope and depth, Van Gasteren's films are perhaps less well known than the works of other acclaimed filmmakers of the Dutch documentary tradition, I felt the need to investigate the legacy of these films. During the research and writing

of this book I met regularly with the filmmaker and his wife and long-time collaborator, Joke Meerman. This book owes a great deal to their inspiring hospitality and their generosity in sharing films, documents, background information and priceless stories. This book, however, is not a biography of Van Gasteren's life, nor is it an exhaustive historical overview of all of his work. Rather, I propose to explore and unfold some of the important aspects and recurrent themes in his extensive oeuvre, which spans more than sixty years. In doing so, I hope to uncover how the work of a single filmmaker/artist in a tiny country below sea level connects to global phenomena that concern us all (still and again) today.

LOUIS VAN GASTEREN 'AN EBULLIENT DIRECTOR BURSTING WITH IDEAS'

Louis Alphonse van Gasteren was born in 1922 in Amsterdam, the son of the well-known theatre actor Louis Augustaaf van Gasteren (1887-1962) and the singer Elise Menagé Challa (1888-1962). He had a sister, Joséphine (1917-1989), who was an actress. Van Gasteren grew up with theatre, opera, and communism (at one point, his mother left the concert hall to take on a project noting down the songs of rural Spanish farm workers) and he had a technical education. After the Second World War he became a journalist and film critic and soon started to work as a sound designer at the Polygon Journal, a newsreel company in Haarlem. Van Gasteren is an autodidact filmmaker, due, in part, to having been told that he was just one year too old for a scholarship at the film school Cinecittá in Rome; there was no film education in the Netherlands at that time.[1] In 1951, he started his own production company, Spectrum Film, and has always produced his own films; since 1972, this has been in collaboration with Joke Meerman. In 1964, he was artist-in-residence at the Carpenter Centre of Harvard University, where he made an experimental film with Robert Gardner, OUT OF MY SKULL (1964). In 1969, he founded the company Euro Television Productions to make films about European politics. As a visual artist, Van Gasteren created numerous paintings and installations, such as a series of Marshall McLuhan-inspired GLOBE CONSCIOUS MATERIAL PAINTINGS (BOLBEWUSTE SCHILDERIJEN) and the semi-spherical 'electronic brain' SUNNY IMPLO in the 1960s, a public artwork in a metro station ROOTS OF THE CITY (WORTELS VAN DE STAD) and the AMSTERDAM ORDNANCE DATUM-monument at Amsterdam City Hall in the 1980s. In the 1970s and 1980s he chaired Artec, a foundation that aimed to bring together art, technology and science. Now a nonagenarian (at the time of writing), Van Gasteren is still working. Best known for the more than eighty documentary films he has made, his work has been awarded a number of important national film prizes.[2] The many terrains

that he has covered make Van Gasteren a *homo universalis* and a centipede whose work is not easily classified.

The Netherlands has a strong documentary tradition, and it was mostly within this tradition that Van Gasteren experimented with new forms. Film historian Bert Hogenkamp has offered some reasons why the non-fiction genre has been a preferred and flourishing mode of filmmaking in the Low Countries.[3] First, there are pragmatic/economic reasons: as the Netherlands is a small country, filmmakers cannot necessarily count on huge film budgets. The documentary form requires less investment than feature films with extensive sets, highly paid actors and costly production design. As a result, it attracted many young talents who produced artistic quality that was well received by Dutch audiences and critics alike. This may be partly due to the fact that the realism of the documentary form was more acceptable than fiction films to the different (religious) groups in a population which, until the mid-1960s, was extremely 'pillarized' according to denomination. Additionally, many film productions were commissioned by companies interested in realistic portrayals of their factories, educational programmes or news. Moreover, as Peter Cowie has remarked, the flat landscapes, the water reflecting big skies and special light inspired not only painters but also filmmakers, who are preoccupied with the 'exigencies of geography' and with 'life as it is, rather than life as it might be.'[4] Add to this the Netherlands' Calvinist sobriety, better suited to realist discourse than the fantastic and the spectacular, and we have some of the main ingredients of a national character that allowed, and still allows, the documentary genre to blossom in the Netherlands. The films of Joris Ivens are the most famous example of this documentary legacy.[5] In the 1950s, Herman van der Horst and Bert Haanstra received international acclaim when their work won recognition at the Cannes Film Festival as well as many other international festivals. While the filmmakers of this generation were very different (Ivens was a communist, Haanstra a humanist and Van der Horst an aesthete), their work had some thematic and stylistic correspondences. As Hans Keller, in FOOTNOTES TO AN OEUVRE (VOETNOTEN BIJ EEN OEUVRE, 1994), his documentary on Herman van der Horst, summarizes: 'Water, still to be reclaimed land underneath, the sky mirroring in the water frequently, surrounded by the horizon.' These are the ingredients of the so-called Dutch Documentary School (named after Dutch seventeenth-century painting traditions). The films in this school are made with artisanal precision. Often composed according to the 'rhyme' of images and sounds, people, objects and landscapes had metaphorical or allegorical significance. We do not see a particular labourer or an individual fisherman but 'the labourer' and 'the fisherman'.[6]

Van Gasteren belongs to the post-war generation of filmmakers who expanded this classic way of filmmaking. In the late 1950s and early 1960s,

filmmakers all over the world began to rebel against the successful but also confined and beaten formulas of the 'cinéma de papa', as François Truffaut, one of the most famous representatives of these 'new waves' in France, called it.[7] Aided by new, lightweight equipment and excited by the anti-establishment revolts of the time, the call for more spontaneous and unconventional ways of filming resonated with filmmakers in the Netherlands. This spirit found footing in fiction films, such as the work of Adriaan Ditvoorst, whose first film, THAT WAY TO MADRA (IK KOM WAT LATER NAAR MADRA, 1965), is one of the most remarkable examples.[8] Unsurprisingly, however, the 'new wave' translated most prominently in the documentary genre. Hogenkamp recalls that in 1966 a photo exhibition about the harsh police tactics used during demonstrations against the marriage of Crown Princess Beatrix to Claus von Amsberg was organized at Van Gennep, a publishing house in central Amsterdam.[9] The artist-writer Jan Wolkers performed the opening and people queued outside, along with the police. Van Gasteren heard about the opening at the last minute and immediately grabbed his camera, joined by his cameraman Theo Hogers. Though they arrived too late for the opening, they did record four policemen assaulting a student who was simply crossing the street. The unedited footage was shown that same evening on television. In our contemporary digital media age this may seem unremarkable, but, at the time, both the spontaneous style of filming and the immediate distribution on national television caused some controversy, leading to apologetic words from the mayor of Amsterdam that same evening on another television programme.[10] Van Gasteren re-used the footage in a short eleven-minute film, re-staging the opening speech of Jan Wolkers and including an interview with the student who was attacked, Bob Bermond, recorded a week later in Van Gasteren's studio. He also slowed down and repeated the footage and gave the film the title BECAUSE MY BIKE STOOD THERE (OMDAT MIJN FIETS DAAR STOND, 1966). (When Bermond was attacked he was on his way to find his bike). Though the footage had already been broadcast on television, the film was censored for release in film theatres. The censors said that Van Gasteren's editing and manipulation of the images in this way would not convey reality. While today the film remains a unique and historical document, it is also an analysis of the power of images themselves (a theme that Van Gasteren would return to in other films). It is also a strong example of the ways in which the classic documentary tradition had changed.[11]

Van Gasteren did not renew the documentary genre with just this one particular 'direct cinema' method. In fact, he renewed the genre with each successive film. In *Docupedia.nl*, film and television critic Hans Beerekamp provides an overview of the most current documentary genres in the Netherlands. Loosely referring to the work of documentary theorists Bill Nichols

and Michael Renov, Beerekamp proposes ten basic documentary forms in the Dutch documentary landscape: the Voice of God; abstract expression; observational style; portraits and biographies; talking heads; compilations and found footage; ego documents; rhetorical documentary; fake documentary; and visual essay.[12] In his conclusion, Beerekamp notes that Louis Van Gasteren is mentioned most often and actually in almost every category: 'If Bert Haanstra was until now the most successful documentary maker, Joris Ivens the most internationally well-known, and Johan van der Keuken the most original, Van Gasteren is by far the most multifaceted.'[13] On the occasion of the première of Van Gasteren's autobiographical film NEMA AVIONA ZA ZAGREB (2012), Beerekamp gave a speech for the filmmaker in which he explained further:

> You started in 1954 with RAIL PLAN 68, a hymn to the labour of the construction of tram tracks on the Leidseplein, influenced by the classic Soviet cinema but also a form of abstract expression. Your indictment against policing in Amsterdam, BECAUSE MY BIKE STOOD THERE, was a form of observational cinema, but was also highly effective rhetorically. Already in 1989, you changed the Voice of God into a dialogue with a computer in A MATTER OF LEVEL. When this film was recently shown to students of the Film Academy, this was the only classic documentary which interested them. You connected talking heads and biography in the politically relevant portrait of your friend Sicco Mansholt in CHANGING TACK. Your series of short films of the 1970s, DO YOU GET IT? examined in visual mini-essays the significance of image and sound. You even practiced the fake documentary in FLYING SAUCERS HAVE LANDED, a coffee advertisement from 1955. And it is hard to find a more sophisticated ego-document and use of found footage than HANS LIFE BEFORE DEATH (1983) and the series ALL REBELS, composed of the residual materials of HANS. And this did not even contain that fantastic excerpt of [legendary singer] Ramses Shaffy who is getting his first Dutch passport that you willingly ceded to Pieter Fleury [for his film on Shaffy in 2002]. It is the most used quote from RAMSES and television never explains that it was shot by Louis.[14]

In a nutshell, Beerekamp summarizes the scope, extent, and multidimensionality of Van Gasteren's work. Paradoxically, this high productivity and diversity of topic and style might actually be one of the reasons why his work is less known to the wider popular and international audience than the filmmakers of the classic Dutch documentary school. Although, as I hope to illustrate in the following chapters, certain preoccupations are characteristic and recurrent in Van Gasteren's work, and certain themes (such as water management)

are classically Dutch, there is not *one* salient stylistic feature (such as image rhyme in the traditional Dutch documentary school), or *one* main topic (such as the division between the rich and the poor, as in the work of Johan van der Keuken), which would make his work easy to categorize or identify.

In 1979, Peter Cowie described Van Gasteren as 'the most flamboyant and volatile of independent Dutch filmmakers. [...] He uses naught but his own equipment and is an ardent admirer of the American experimental filmmakers, as well as of Antonioni and Resnais. [...]'[15] Cowie goes on to evaluate Van Gasteren's experiments in fiction films, THE HOUSE (HET HUIS, 1961) and THE STRANDING (STRANDING, 1960), as well as his influential documentary, NOW DO YOU GET IT, WHY I AM CRYING? (BEGRIJPT U NU WAAROM IK HUIL?, 1969) that he describes as 'a chilling documentary about a former inmate of Belsen, who is liberated of his subconscious burden of terror by undergoing doses of LSD, and "confessing" to a professor of psychiatry at Leiden University.'[16] Cowie emphasizes the vast scope of Van Gasteren's work by calling him an 'ebullient director bursting with ideas, covering every subject from germ warfare to higher mathematics.'[17]

In NEMA AVIONA ZA ZAGREB, Van Gasteren himself describes this vital desire to film everything. Van Gasteren released NEMA AVIONA ZA ZAGREB in 2012, at the age of 90, and the film is told from the perspective of Van Gasteren at this old age. However, the film consists primarily of material shot between 1964 and 1969, when Van Gasteren intended to actually complete the film but, due to circumstances (explained in the final film), never did. In one scene from the 1960s we see him at home with his wife at that time, Jacqueline, philosophizing about the omnipresence and power of film. He explains: 'I would like to show everything [...] every step I make [...] also towards the inside [...] everything that I am connected to. [...] Take this stool, this patina. How can I make somebody experience how comfortably one sits on a thing like this [...]' This, then, is the ultimate aim of the entire oeuvre: to capture on film every perception, from inside out and from outside in.

SELECTING FROM A VAST NON-LINEAR SPECTRUM

A journey through the work of Van Gasteren cannot be made in a linear fashion. Talking to Louis van Gasteren in person, one notices that distances in time do not seem to exist for him. In a single conversation he recalls events from his youth as vividly as very recent occurrences, jumping lucidly between layers of time in an associative way. In the 1960s, Van Gasteren spent some time with Fellini in Rome, and Fellini's conception of co-existing temporal dimensions is perhaps relevant to recall here. As Fellini expressed in his films

and declared in interviews: 'We are constructed in memory; we are simultaneously childhood, adolescence, old age and maturity.'[18] Van Gasteren might almost be seen as a character in a Fellini film for whom time is a never-ending process of going back and forth between layers of past and present without clear transitions or distinctions. As philosopher Gilles Deleuze argued, in Fellini's fiction films, such as 8 ½ (1963) or AMARCORD (1973), time is like a growing crystal of actual and virtual events that keep exchanging places and keep influencing one another.[19]

Similarly, Van Gasteren's work is a process of layering and looping back and forth in time. In this respect, Peter Cowie states something interesting about Van Gasteren's early fiction film THE HOUSE: 'His ambitious, half-hour work, THE HOUSE is an attempt to split up a fragment of thought in time. Thus it flashes back and forth throughout the history of an old house that is in the process of being demolished. Memories of love, of birth, and of death in the war, are revived.' He continues, quoting Van Gasteren: 'As the house is pulled down, so the lives of its occupants are constructed, not out of need to put everything in chronological order, but from the knowledge of the inevitable end.'[20] It is interesting to note a difference between Fellini's non-chronological layering of time and Van Gasteren's. While Fellini always returned to the virtual layers of the past and always departed from the (nostalgic, mythical, fabulated) past, Van Gasteren indicates here that the construction of the past is necessary not simply out of nostalgia for the past itself, but because of the knowledge of the inevitable end; or, put differently, because of knowledge of the future.

The non-linear treatment of constructed time that is the main topic of THE HOUSE is perhaps more difficult to reach within non-fiction films but is very much a part of Van Gasteren's work, even more so when considered in its totality. This is demonstrated by the fact that many of his film projects exist in several versions: the same material can lead to different constructions, different films showing different aspects of the past, considering 'the end' (meaning both contextual aim and temporal distance). Indeed, the very first film that Van Gasteren produced with his company Spectrum Film, BROWN GOLD (BRUIN GOUD, 1952), commissioned by the chocolate factory Van Houten, has additional versions. The documentary (directed by Theo van Haren Noman) is filmed on location in Ghana and the Netherlands and follows the entire process of chocolate production, from the planting, harvesting and selling of the cacao beans in Accra, to their transportation in little boats to the big transport vessels at sea and all of the steps of their production into chocolate in Dutch factories. Van Gasteren and Van Haren Noman made two other films from the material shot for this film: CROSSING THE SAHARA (DWARS DOOR DE SAHARA, 1953) depicts the film crew's adventurous journey by truck from Amsterdam to Paris, Marseille and Algiers, across 3000 kilometres of desert sand with

only a few oases and settlements, all the way to the Gold Coast. In the short film ACCRA, PORT WITHOUT CRANES (ACCRA, HAVEN ZONDER KRANEN, 1953) we recognize images from BROWN GOLD, though they are composed differently, with more focus on the physical labour of the cacao farmers and especially the strenuous physical work of the rowers who take the heavy bags of beans to the large ships in the water.

From the beginning of his career, Van Gasteren never actually made just one film, but rather clusters of films that function as feedback loops: picking up new elements, presenting scenes in different ways. In the case of BROWN GOLD, Van Gasteren did this immediately after shooting all of the material. More often, however, films, places or people are revisited because time (the future) has changed the perspective on the past. HANS LIFE BEFORE DEATH (HANS LEVEN VOOR DE DOOD) and ALL REBELS (ALLEMAAL REBELLEN) are both films that were completed in the 1980s. Archive material used in each film was shot in the 1960s, but Van Gasteren very prominently features the 1980s perspective of the protagonists of the 1960s counter-culture movement. Van Gasteren also returns to previous films, as he did in THE PRICE OF SURVIVAL (DE PRIJS VAN OVERLEVEN, 2003) where he returns to the widow and children of the camp survivor in NOW DO YOU GET IT, WHY I AM CRYING? And in BACK TO NAGELE (TERUG NAAR NAGELE, 2007), he returns to the village of Nagele, which he filmed in the late 1950s during its construction from reclaimed land in A NEW VILLAGE ON NEW LAND (EEN NIEUW DORP OP NIEUW LAND, 1960). All these films will be discussed extensively in the chapters that follow, but for now it suffices to point out how Van Gasteren's work is actually an open system where time is malleable and foldable, time and again allowing material to be reconstructed from another perspective, from another moment in time, from the future.

Given this fluid and complex system of interconnected films, combined with the wide range of formal styles and topics, I find myself confronted by the challenging task of making choices about which aspects and which works to discuss in order to do justice to the richness of the source materials. Undoubtedly I have missed important elements, which I hope will be picked up by others. I have based my selection on observations in the films themselves, many of which are truly amazing in terms of their historical value and surprising visionary insights when watched from a twenty-first century perspective. Each chapter centres on a few films that guide the main thoughts around a particular recurrent theme in Van Gasteren's work. These films are related to other works in Van Gasteren's oeuvre and to their cinematographic, historical, political, cultural or philosophical contexts. Each chapter is also informed by newspaper articles, interviews and correspondence from the meticulous archive of Spectrum Film and by personal recollections and information from Louis van Gasteren and Joke Meerman in our numerous meetings.

The first chapter, 'Land, House and City,' departs, quite literally, from home. Van Gasteren's house in Amsterdam is also his studio and the office of Spectrum Film and provides a literal starting point for our journey. In the first part of this chapter I will focus on the post-war reconstruction of the Netherlands, as depicted in ALL BIRDS HAVE NESTS (ALLE VOGELS HEBBEN NESTEN, 1961), and the construction of the village of Nagele on the reclaimed land of the Noord-Oost Polder. This village was designed by a team of architects, among whom Gerrit Rietveld and Aldo van Eyck, and captured by Van Gasteren in A NEW VILLAGE ON NEW LAND (1960). Van Gasteren's fiction film THE HOUSE, significant for certain other themes in Van Gasteren's work, unravels the more philosophical dimensions of the house, its history and its meaning for its inhabitants. Finally, I move to the artwork THE ROOTS OF THE CITY (1980), made to commemorate the history and battles over housing in Van Gasteren's own neighbourhood in Amsterdam, the Nieuwmarkt.

In Chapter 2, 'Water, Transport and Technology,' Van Gasteren's fascination for water management, for hydraulic engineering and for technology forms the central focus. The chapter begins with a mapping of the significance of water for the Netherlands and for Dutch cinema. Van Gasteren has made several films and art projects related to water management, but the chapter will focus on A MATTER OF LEVEL (EEN ZAAK VAN NIVEAU), a film in which Van Gasteren uses the youngest media technology in the 1980s, the personal computer, to tell the story of controlling the sea level. In this chapter, I will demonstrate the ways in which Van Gasteren's approach to this typically Dutch topic differs from his predecessors. The final part of this chapter moves to another technology, discussing, among other works, THERE IS A PHONE CALL FOR YOU (D'R IS TELEFOON VOOR U, 1964), a wonderful media-archaeological investigation into the history of telephony, and a very telling example of Van Gasteren's fascination with technology, transport and communication.

In Chapter 3, 'War and Traumas of the Past,' we encounter the traumatic effects of the Second World War. NOW DO YOU GET IT, WHY I AM CRYING? and ROERMOND'S SORROW (HET VERDRIET VAN ROERMOND, 2005) are the works that will inform this chapter. Both films have been shown on television and have found resonance in society. NOW DO YOU GET IT, WHY I AM CRYING? played a political role in the 1972 debates in the Netherlands about releasing prisoners of war. Van Gasteren depicts the long-lasting effects of war with great compassion, not least because the war was and still continues to be a traumatic event in his own life. This painful and haunting story will be discussed in this chapter by reviewing several documentaries made on Van Gasteren in which he discusses the war and its aftermath. The Second World War is a topic that frequently returns in Dutch feature films. This chapter will look at the different roles that fiction and non-fiction can play in working through memories

that burn within the skull, memories that colour all other perceptions, life and the world, as becomes painfully apparent in THE PRICE OF SURVIVAL, the last important film that will 'close' this chapter.

Chapter 4, 'Young Rebels and Doors of Perception', brings us to the postwar youth rebellion and counter-culture of Amsterdam in the 1960s. HANS LIFE BEFORE DEATH presents a penetrating portrait of the young composer Hans van Sweeden and his suicide, as seen through the eyes of his friends some twenty years later. ALL REBELS and several other films from this period provide invaluable documentation of the spirit of the time, and of a generation who refused to be traumatized, looking for ways out of the fixed norms of society and patterns of perception. As previously indicated in my description of THE OPERATION and BECAUSE MY BIKE STOOD THERE, Van Gasteren seemed to be present everywhere and filmed unique events that are both culturally and politically important. Van Gasteren was also very active as an artist in this period and some of this artistic work, such as the experimental film OUT OF MY SKULL (1965), will be part of the discussions in this chapter. SUNNY IMPLO (1970) is simultaneously an imaginative solution to extended consciousness and a reaction to the effects of overcrowded city life. SUNNY IMPLO is a fascinating artwork consisting of a huge sphere that provided visitors a 'non-chemically induced trip' (provoked by an 'electronic brain'). Standing under and inside the orange globe, the sounds and light effects have a calming effect on the isolated individual.[21] The art work itself no longer exists, but as an image it aptly represents the most productive period of Van Gasteren's career and I have therefore chosen it for the cover of this book.

In the final chapter, 'Europe, Politics and Multinationals,' we see Van Gasteren as a relentless reporter, travelling the world to investigate the socio-economic and political circumstances of farmers and ordinary people in Europe, interviewing experts on the growing influence of multinational corporations and setting off to Africa to investigate the war in Biafra and a court case in Sudan. The chapter starts with Van Gasteren's series of film portraits of the island of Sardinia, an island that he has visited, researched and documented for over forty years. This resulted in three films for Dutch television and four films for German television (WDR) about the fascinating atavism and archaeological and anthropological value of this Mediterranean island, increasingly threatened by tourism and multinational corporations. In this period, Van Gasteren often followed his friend Sicco Mansholt, former Dutch Minister of Agriculture and Euro-Commissioner for Agriculture, who was highly influential in the reformation of agriculture in the European Union. Van Gasteren interviewed him on many occasions that come together in a moving portrait of Mansholt, CHANGING TACK (OVERSTAG, 2009). This film will be the central focus of a chapter that relates to the topical issues of multinationals, global capitalism and ecological debates.

I conclude with a Coda, 'Feedback Loops in Time without Final Cut'. Here, I return to the particular ways in which time, especially the future, is a determining element in Van Gasteren's oeuvre. NEMA AVIONA ZA ZAGREB captures many of these ideas, and so with this film I synthesize and conclude by reflecting on the power of constructing images and reconstructing time. Van Gasteren's personal archive in his house, annex office and studio is full of historical material that demonstrates how conscious this filmmaker has always been of the potential future significance of documentation in any form. This book only uncovers a sliver of all that remains to be rediscovered in the richness of (film) history.

CHAPTER 1

Land, House and City

A canal house near the Nieuwmarkt in Amsterdam. Louis van Gasteren has lived and worked in the same house in the centre of his hometown for more than 60 years. He moved into the house after the Second World War, initially as a guest of the writers Marga Minco and Bert Voeten, and sharing it with Gerrit Kouwenaar and Tientje Louw; Remco Campert and Lucebert also frequently stayed in the house.[1] In the 1950s, Van Gasteren was able to obtain a loan from the chocolate company Van Houten and buy the entire premises, which has since then also served as his studio and office for Spectrum Film, Euro Television Productions, Artec, and other organizations that he has run. Over the years, many filmmakers have learned their editing skills at Van Gasteren's Intercine editing table and today his equipment is still regularly used by filmmaker colleagues.[2] Still operational today, from the 1950s until the 2010s Spectrum Film was a small enterprise employing six to eight people. As Peter Cowie has remarked, 'the fact that Van Gasteren owns a *house-cum-studio* in central Amsterdam is typical of the almost pugnacious desire for self-sufficiency inherent in the Dutch. Instead of agents, one discovers, many directors have their own offices and secretaries.'[3] Bert Haanstra lived in a villa in the village of Laren, where he had a studio and small projection room. John Fernhout used to run his affairs from a windmill used by the Dutch resistance during the war. And Johan van der Keuken called himself a 'small independent' (*'kleine zelfstandige'*) mostly working with a small crew that included his wife, who was the sound operator for his films.[4] In between his journeys over the world, Van der Keuken regularly filmed the people in his home city, most notably in AMSTERDAM GLOBAL VILLAGE (1996).[5]

For Van Gasteren, too, the city and people of Amsterdam occupy an important place in his work. It is from his house and hometown that Van Gasteren has always departed on his journeys, near and far. When, in the early 1950s,

Van Gasteren left Amsterdam for an adventurous film expedition to the African Gold Coast to film cacao production and transport in Accra (for the chocolate company Van Houten), the film crew was waved off by a crowd on Dam Square in the city centre. The voice-over in CROSSING THE SAHARA (1953) comments: 'Like the Montgolfier brothers, the first balloonists before they chose the airspace for the first time, Messrs Van Haren Noman and Van Gasteren say goodbye to a deeply moved crowd while they run their first lap around the cobbled heart of their hometown, jubilantly departing for faraway places.'[6] And ever since, Van Gasteren has continued making journeys to many different places, nearby and faraway, sometimes directing his camera towards the city itself, especially in its turbulent eras such as the 1960s and the 1980s when rebellion and resistance determined much of the city's fate; sometimes moving towards other parts of the Netherlands, for instance to investigate the post-war housing situation, and the country's ideas of architecture and modern living on reclaimed land; and sometimes moving towards Europe and the rest of the world or towards deep inner spaces and neurological and philosophical questions of perception and memory. In this chapter, we stay close to Van Gasteren's home and investigate the house, the city and the low lands as a departure point for the rest of his work, grounding the filmmaker in his local heritage and roots.

HOUSING AND ARCHITECTURE: CONSTRUCTING AND REBUILDING A POST-WAR COUNTRY

In the post-war Netherlands the housing shortage was considered the most important 'enemy of the state'. The greater part of the city of Rotterdam was bombed at the beginning of the Second World War. Moreover, the Germans needed human and material resources for their military actions, which led to a general building freeze. In the second half of the 1940s the construction of houses started again, but prices for building materials were high and the Dutch government was short of money. Between 1947 and 1949 the government spent a good portion of its budget on the so called *'politionele acties'* ('police actions'), a large-scale military operation in Indonesia, where, after the surrender of its Japanese occupiers in 1945, a fight for independence had begun.[7] As Floris Paalman indicates in his book, *Cinematic Rotterdam: The Times and Tides of a Modern City,* several films made during that period, such as A HOUSE (EEN HUIS, Henry James and Rob Out, 1948) or Max de Haas' HOUSING SHORTAGE (WONINGNOOD, 1950), address the issue of the housing shortage in the Netherlands.[8] In his film FOUR WALLS (VIER MUREN, 1965), Johan van der Keuken shows the dilapidated urban landscape and the cramped living spaces

of 1960s Amsterdam, where renovations started much later than in Rotterdam, which had to be rebuilt from the ground.[9]

As Paalman demonstrates throughout his book, in post-war Netherlands there was a close collaboration between government city planners, architects, and filmmakers (who acted as mediators) working to rebuild communities and a modern welfare state. The US-funded European Recovery Program (the Marshall Plan) gave a crucial boost to these building programmes. Modern urban theories, such as the ideas of American philosopher of technology and urban development Lewis Mumford, found their way into post-war city planning and rebuilding.[10] In 1939, Mumford collaborated on an educational film, THE CITY, which explains that each year 'our cities grow more complex' and that in order to sustain this growth, life has to be modernized: 'The age of rebuilding is here,' the opening titles of the film postulate. New technologies, new knowledge about the soil and a new social order would help build a new and better society. In an article in *The New Yorker*, Mumford writes about Rotterdam and its completely new city centre and its modern ideas about urbanization and housing, which were resonating widely in post-war Europe.[11] Jan Schaper's OLD TOWN GROWING YOUNGER (VLAARDINGEN KOERST OP MORGEN, 1955/1958) is influenced by Mumford's ideas about the modern city, presenting a 'close-up' of the renovation of one of Rotterdam's neighbouring towns.[12]

Van Gasteren also mentions Mumford as an important influence on his ideas on housing and urban planning.[13] Van Gasteren, however, views the problem of housing from a global perspective, a perspective that will return regularly in his later work, as in his Globe Conscious Material Paintings discussed in the next chapter and in his interest in multinationals, global capitalism, and other political issues that I will turn to in the last chapter. The film ALL BIRDS HAVE NESTS (1961) opens with a turning globe, followed by a voice-over indicating that three billion people now inhabit our planet, and every two seconds three babies are born: 'Every day 130,000 new human beings arrive. They will become adults. They will live, will work, but will also want to have a house.' The images and voice-over are accompanied by a striking musical composition by Hans van Sweeden, a highly talented composer and friend of Van Gasteren who would commit suicide at a young age, and whose story Van Gasteren would pick up much later in his acclaimed film HANS LIFE BEFORE DEATH (discussed in Chapter 4). The factual information and images about population growth are followed by images of birds and animals, cut to the rhythm of music and the cadence of a female and male voice singing a ballad (written by another documentary filmmaker, Jan Vrijman):

> All birds have nests / Proud aviators high above cliffs and rocks included /
> Or the restless nomads / Only looking for protection in passing / And the

winged churls / Who live among humans [...] But man is not an animal / He asks for more than a nest / He asks for houses for dwelling / A house for the child that is born / A house for its first cry / A house for playing and living/ A house where the child can grow into an adult [...] And then society at large awaits him / *Modern* society [...][14]

The ballad in ALL BIRDS HAVE NESTS continues, explaining that industrial production of houses is necessary to keep up with the demands of modern society. The film was commissioned by the Dura factory in Rotterdam, a manufacturer of prefabricated homes, in collaboration with the architect Ernest Groosman, a designer of prefab houses. In the second part of the film, many scenes are shot inside the factory, showing the machines and the workers that handle them, in a style reminiscent of classic Soviet cinema.[15] Van Gasteren recalls that it was quite hard to present the film in an interesting way (it was much too dark and too dull inside the factory) and that many of the factory images became 'matter-of-fact reporting.'[16] The ballad-form, however, makes the film more than just a commissioned promotional film. The film closes with scenes of a family living in its new house.

The energy and optimism about rebuilding the country of ALL BIRDS HAVE NESTS is similar to that of another film from the same period, A NEW VILLAGE ON NEW LAND (1960). In this film, Van Gasteren follows the process of the construction of a new village, Nagele, on the reclaimed land of the Noordoostpolder. The Noordoostpolder is part of the Zuiderzee Works, conceived by Cornelis Lely (1854-1929), a civil engineer and statesman. After many years of technical research and political lobbying, and after several severe floodings along the shore of the Zuiderzee in 1916, Lely's plan to turn the sea into a lake was finally authorized. The Zuiderzee Works started in 1920.[17] In 1932, the sea was shut out by the Afsluitdijk, a dike 35 kilometres long and 96 meters wide: the Zuiderzee became a lake, the IJsselmeer. The construction of the Afsluitdijk, an impressive process achieved through the enormous physical labour of thousands of men and machines, was filmed by Joris Ivens in NEW EARTH (NIEUWE GRONDEN, 1933). Shot with one camera on land and one camera at sea, NEW EARTH depicts this huge project as a battle between land and sea. At the end of the film, however, Ivens questions the usefulness of this process, and the need for the construction of new agricultural land (the Wieringermeer Polder was regained from the open sea in 1930). Ivens addresses global famine and the massive unemployment in the United States and other parts of the world, juxtaposing it with images of overproduction in the Netherlands: 'We are drowning in grain,' the voice-over commentary in the film angrily emphasizes over and again.

Once the sea had been closed off, the reclamation of land in the IJsselmeer

started. During the war the draining of the Noordoostpolder continued. The Germans were interested in the reclaimed land, perhaps because it matched their *Blut und Boden* theory; more pragmatically, it was because the new soil would offer important food supplies. In contrast to the situation in the 1930s, the war had brought famine and food shortages to Europe. The Noordoostpolder (NOP) was also called *Nederlands Onderduikers Paradijs* (Dutch Hiding Paradise). Many men escaped transportation to the camps by labouring in the polder. Herman van der Horst meticulously documented the embankment of the Noordoostpolder, the dredging and draining of the water, and the development of the land in WRESTED FROM THE SEA (DER ZEE ONTRUKT, 1955). Van der Horst's film is instructive about the technical procedures to win 48,000 acres from the sea: the bailing of water, the digging of 1900 km of ditches, and the placement of 120 million drainage tubes to keep the land dry. Next came the testing and processing of the soil to determine the types of crops and vegetation to be planted. Van der Horst also shows the construction of the first farms on the Noordoostpolder, built according to prefabricated assembly principles that, as mentioned above, had been introduced more widely at the time. However, neither the war, nor other social issues implicated in the massive operation of populating the new land of the Noordoostpolder is addressed in Van der Horst's film.

Van Gasteren, along with Ivens and Van der Horst (and other Dutch filmmakers such as Bert Haanstra), shares a fascination with the Netherlands' fight against the water, water management and the reclamation of land. In the next chapter I will turn to the particular ways in which Van Gasteren has approached this and other aspects of Dutch culture in a documentary called A MATTER OF LEVEL. Here I would like to focus on a film in which Van Gasteren followed the construction of a brand new village in the Noordoostpolder, Nagele. Nagele is a unique village, not only because it was the last of the ten villages, centred around the town of Emmeloord, that were constructed on the newly created land of the Noordoostpolder, but also because it was completely constructed and planned from the drawing board by renowned architects including Mart Stam, Aldo van Eyck, Gerrit Rietveld and garden architect Mien Ruys.[18] These architects belonged to a group of modern functionalist architects, De 8 and Opbouw, who formed the Dutch branch of the Congrès Internationaux d'Architecture Moderne (CIAM) that between 1928-1959 formed an international meeting place of the International Style.[19] During the seventh CIAM conference in 1949 the Dutch architects collectively presented their plans for Nagele. Van Gasteren knew Mart Stam and became fascinated by the project when he saw a drawing of the village featuring a cemetery with plots measured to the exact sizes of its future population. 'To consider Nagele's death before even the first inhabitant had arrived, is remarkable,' Van Gas-

teren points out.[20] The idea of following the process of Nagele's construction was born. When Van Gasteren embarked on this project in the mid-1950s some of the important decisions about the village had already been taken. For this reason, Van Gasteren restaged some of the meetings and discussions between the architects and also developed larger scale models to explain the plans. A NEW VILLAGE ON NEW LAND was completed in 1960 at the moment when, after ten years of planning and building, Nagele received its first inhabitants and community life started to develop. The film offers an important historical document on modern architecture and community planning. NEW VILLAGE ON NEW LAND opens with the typing of a 'shopping list' for Nagele:

 2500 inhabitants
 210 houses
 30 shops with houses
 30 businesses with houses
 3 churches
 1 municipal office
 3 schools
 1 bar-hotel
 1 cemetery
 1 fire department
 1 post office

At the beginning of the film, Aldo van Eyck explains that although Nagele is constructed from scratch, a village is more than the sum of its 'shopping list.' Sketching on a piece of paper, the architect demonstrates how villages and cities normally emerge at a strategic location along a water- or land route, and how they develop and grow from the centre out to peripheral areas. He continues by showing how differently Nagele was conceived. Firstly, Nagele was constructed in a completely new and entirely flat landscape. Once water (Nagele is about 4 metres below sea level), nothing meets the eye until the sky and the earth meet at the horizon. Many people who moved to the polders in those early days fell into depression because of the vast and endless landscape; car accidents happened more frequently than elsewhere because of 'polder blindness': the straight and endless roads in the polder made people less attentive, and an unexpected obstruction could have fatal consequences for a day-dreaming driver.[21] Therefore, the first thing all architects of Nagele agreed upon was to create hedgerows of trees and bushes to give the village the feeling of protection.

 The village itself had to be a model for modern architecture that was spacious, and full of light and breathing space. Van Gasteren shows several plans

and models of the village and the architects at work at their drawing tables. The final plan agreed upon by all of the architects comprises a large green central square, designed by the garden architect Mien Ruys, seven neighbourhoods, each designed by different architects, including Jan and Gerrit Rietveld, Mart Stam, Lotte Stam-Beese and Ernest Groosman. Nagele differs in architectural style from all the other villages in the Noordoostpolder, which were built according to the more traditional Delft style. Most of the buildings on the architectural shopping list presented at the beginning of the film were realized. The municipal building and post office remained in the central town Emmeloord, but Nagele did get a cemetery and three schools (all designed by Aldo van Eyck) as well as four churches. It might seem strange and exaggerated to have three schools and four churches in a small village, but this was a very conscious strategy by the Dutch government at that time. The Noordoostpolder had to be representative of all denominations in the Netherlands, and so there had to be a protestant, a catholic and a public school, as well as several churches. A balanced and representative population was also taken into consideration during the selection of farmers and other inhabitants for the Noordoostpolder.[22]

Van Gasteren shows how, based on the architectural plans, the entire village is built, how the green zones are designed and planted, and how a family arrives, happily inspecting their light and modern house with a flat roof. The smile of a housewife when she turns the tap and there is running water is a telling indication of the improvement in her housing situation. Van Gasteren continues: a bike repair shop opens; a hairdresser fixes curlers; the butcher's sells its first sausages; the postman arrives from Emmeloord and gets on the bike that he transported on his car. The first babies are born, children go to school, the men work the land surrounding the village and mothers take care of the household. A NEW VILLAGE ON NEW LAND ends with children releasing balloons in the air with a greeting card from their new village. Life has been rebuilt; everything seems to be organized meticulously. The film reflects the more general optimism about new beginnings and a new future for the postwar Netherlands. Of course, it was not all as happy as it was portrayed. Another Dutch filmmaker, Alex van Warmerdam, comments in his own way on the general atmosphere of optimism in the late 1950s and early 1960s. In his black comedy THE NORTHERNERS (DE NOORDERLINGEN, 1992) he paints an absurdist picture of the inhabitants of a fictional nameless village that bears a striking resemblance to Nagele in its modern architecture, its endless horizons and a planted forest on its edges. At the beginning of the film, a model family is being photographed: 'Look more hopeful, to the future,' the photographer instructs them. The characters are akin to the ones we encounter in Nagele: a postman, a butcher, housewives and children. But the postman secretly reads

all the inhabitants' letters and thus knows all their intimate secrets; the butcher is sexually frustrated as his wife becomes increasingly religiously devout; and the butcher's son tries to escape by fantasizing he is Patrice Lumumba, the first prime minister of liberated Belgian-Congo whose murder was world news in the early 1960s. Radio messages about the liberation of Belgian-Congo and the death of Lumumba are the only connections to the world outside of this isolated 'village under construction'. Van Warmerdam's absurdist fiction film reveals in a brilliantly witty fashion the hidden darkness beneath the shiny surfaces of the reconstructed Netherlands. In his later work about the rebels of the 1960s, Van Gasteren would explore the darker aspects of Dutch post-war culture in a different way.

As for Nagele, Van Gasteren was certainly interested in the people that he filmed. Even though A NEW VILLAGE ON NEW LAND does not offer the inner perspective of its new inhabitants, 50 years after completing the film, the director was still interested in Nagele and wondered what happened to those men and women that arrived in the polder and their expectations. According to Van Gasteren, the strict government selectors did not always take into account how difficult it would be to start a new life, relatively far from family and friends.[23] And so, in 2011, Van Gasteren returned to Nagele to see what had happened to the village and its inhabitants. In BACK TO NAGELE Van Gasteren shows Nagele as it is now, interviewing many old and new inhabitants, architects involved in the current remodeling of Nagele, housing corporations and two consecutive mayors of the Noordoostpolder. At the beginning of the film the director, by this time almost 90 years old, arrives in a helicopter to get a bird's eye view of Nagele's straight lines, between its green edges and the surrounding agricultural fields. Still curious about the cemetery, he finds out that Nagele's first grave was for a small girl, Jaquelientje, killed tragically by a tractor. Van Gasteren's return is during a period when the community is making an effort to deal with the changes of the last five decades. In its conception Nagele was a paradise with respect to housing and facilities. Slowly but surely many things changed. Agricultural machines took over much of the work of farmers; improved connections to other parts of the country made it easier to commute and work in surrounding cities; many shops and facilities disappeared because they were no longer profitable (only the hairdresser survived); houses no longer met the new standards for things such as size or use of sustainable energy and many pragmatic renovations destroyed the original design. Several scenes from the first Nagele film are spliced with those of the village 50 years later, when much of the village looks neglected and dilapidated.

But Van Gasteren returns to the village many times and registers the initiatives of the current inhabitants, together with a new group of architects and the council of the Noordoostpolder, to develop plans for Nagele's renewal.

Decisions are now made in a much less authoritarian way; many parties are involved in the remodeling plans which, while not always easy, mark a significant cultural change towards the emancipation of citizens. The former catholic church is now a small museum that displays the documentation of the original and unique architectural values of the village, a new community centre with a meeting room and sports facilities is built to give the villagers a new meeting place, and Mien Ruys' original green plan for Nagele's cemetery is finally realized: a pergola, a metal arch construction that will be overgrown by hornbeams, now forms a green entrance. After a shortage of labour caused by the ageing of the population, farmworkers have returned, but this time from other parts of the European Union, mainly from Poland. Like new pioneers, they find jobs in a Noordoostpolder that is now more multicultural. In an interview about BACK TO NAGELE, Van Gasteren mentions that it is still hard to get a cup of coffee in Nagele and argues that more should be done to preserve the village's unique character, which would make it more internationally attractive. Van Gasteren proposes a Mien Ruys Gardening and Horticulture training centre.[24] One of the architects of the new Nagele, Bas Horsting, proposes establishing an educational centre for the preservation of small villages that could also play an international role, since the problem of disappearing small communities and villages is a transnational phenomenon. At the end of the film we return to an aerial view and we see Nagele, green and lush in a straight landscape. From above it still looks the same, but we know that Nagele has developed, in some respects differently than the original architects predicted. In two films, spanning a distance of 50 years, Van Gasteren documented some important changes. In the 1950s, when the village was built, Nagele was a model village. On the one hand, it was typically Dutch in that it was built on the former Zuiderzee and represented all denominations of the then dominant social structures in the Netherlands. But it also resonated with the more international spirit of optimism, growth, modernism and collective effort in architecture. In Nagele this was not simply an idea on a drawing board, it was actually built. In the twenty-first century Nagele has suffered from the departure of inhabitants and loss of facilities, and this resonates with other larger international developments. Global urbanization puts pressure on many small communities and villages that are disappearing all over the world. And yet its slow recovery and the efforts of different parties in Nagele to restore a sense of community life also show that new circumstances demand new solutions to adapt to continuously changing circumstances.[25]

THE HOUSE: HISTORY, MEMORIES AND MEANING

The urgent need to solve the housing shortage and a desire to rebuild the country after the Second World War are central concerns of ALL BIRDS HAVE NESTS and NEW VILLAGE ON NEW LAND. In these films Van Gasteren expresses the collective optimism of the time and the impulse to move into the future, using the latest industrial building technologies and modern architecture. During the same period, however, he also investigates the meaning of the house on a more abstract and conceptual level. In the short film THE HOUSE (1961), Van Gasteren considers the concept of 'the house' on a deeper level with respect to human relations, to history and to memory. THE HOUSE (based on a scenario by Jan Vrijman), on the one hand, is an exercise in the formal elements of fiction film. On the other hand, it is an exploration of new ways to express philosophical thoughts. In 1971, Van Gasteren would make four film portraits of philosophers for Dutch public television (NOS). He filmed Arne Naess, Henri Lefebvre, Sir Alfred Ayer and Leszek Kolakowski in their homes. '[Philosophy] is a way of showing that what seems obvious, is not obvious at all and that maybe what seems to us natural and evident, is very doubtful,' Kolakowski states at the beginning of his portrait. Alfred Ayer proposes something similar when he states that philosophy is a fairly abstract activity without grand answers, which attempts to answer certain perennial questions about (the limits of) human knowledge. Van Gasteren would acknowledge later that these philosopher portraits meant a lot to him because they made him realize, with hindsight, that THE HOUSE had been an attempt to try out a new method of thinking; namely, in images and sounds – although he did not consciously realize this at the time.[26] Let me first describe THE HOUSE, and then contextualize this remarkable short feature film within post-war European cinematic traditions and within a philosophical framework of modern understandings of the dimensions of time.

THE HOUSE tells the story of a house and its inhabitants. It questions the significance of a house, scratching beyond the surface, (literally) taking away its façade. The film does so in an experimental manner.[27] There is almost no dialogue, other than a few utterances. Everything is expressed visually and it is up to the viewer to do much of the construction of the story of 'the house' that is presented in non-chronological fragments, like pieces of debris. When THE HOUSE appeared, Dutch film critic Charles Boost described the film beautifully and very aptly and it is worth quoting at length:

> A house is demolished. A veranda is slowly released from the embrace of the house, an ornamented façade collapses with dignity to its destruction, a bay window hesitates in its fall. A lifetime lies shattered in its

rubble. The film THE HOUSE fits its pieces together. Not in a logical order, but randomly and in the slow connections prescribed by the demolition process. The window once framed an amorous shadow play; the ornamented façade brings to life a conversation between architect and owner; before its construction begins, and when the demolishers penetrate the house, this conversation breaks open into a memory of the birth of a daughter, the infidelity of the woman. The demolition of the house takes place before the placement of its first stones, the happiness of the young couple is preceded by the sorrows that will befall them; before she is introduced to her husband, we see the daughter kneeling over his deceased body. Her dreamy 'Je meurs de soif au bord de la fontaine' sounds through the rooms before she is born. There is no fixed point in time, so there is no looking backwards or forwards. Everything is now. And slowly, out of shreds and fragments grows the mosaic of a human life; the history of a house and its inhabitants. In sudden suggestions of images and sounds, violently interrupted by falling walls, crumbling rooms, and showers of debris, half a century is contracted into 30 minutes. Asymmetrically to the demolition of the house, the lives of its inhabitants are built, not out of a desire to chronologically reorder all the pieces, but presenting the events of life informed by the knowledge of its inevitable outcome.[28]

Boost clearly describes the film's non-chronological narrative. In line with Van Gasteren's fascination with the cemetery in Nagele that was planned before any actual inhabitants were in sight, THE HOUSE begins with an ending. Van Gasteren's interest in time returns in many different ways throughout his work, a point I will return to in respect of THE HOUSE momentarily.

THE HOUSE presents several interesting recurring thematic concerns within Van Gasteren's oeuvre. First, we see Van Gasteren's fascination with architecture and houses as technical constructions once more. We see the plans of the house (sometimes followed by the demolition of a detail, an ornament or a room before we see how it was built or in actual use) and the architect plays a key role, not only because he designs the house, but also because he falls in love with the wife of the man who commissioned the house. Secondly, Van Gasteren's communist upbringing and appreciation of manual labour is clear in the scenes where, brick by brick, the house is constructed. Thirdly, the universal aspects of life, love, disillusion, birth and death are also compressed and contained in the house. Van Gasteren also addresses these existential questions in his films about Amsterdam's generation of rebels in the 1960s and in his autobiographical film, NEMA AVIONA ZA ZAGREB, which I will discuss later on in this book. In THE HOUSE we see disillusionment not only

in the adulterous love affair between the wife and the architect (who, through the layers of time will often look longingly from a distance at the house), but the owner, too, deceives his wife with one of the maids. The only honest love affair, between the daughter and her husband, comes to a violent end. And yet children are born, parents pass away and life goes on, inclusive of disillusionment, sorrow and deception. Until it all falls apart. Despite its tragic dimensions, Van Gasteren addresses these universal questions of life in a light and playful way. There is a sort of happy despair and an occasionally surreal touch in THE HOUSE. Light music sets a cheerful tone and the coquettish use of French words that are sometimes laid over images of the ruined bourgeois house imbues the images with a touch of self-mockery that lightens them. This is typical of Van Gasteren; he regularly juxtaposes his sense of humour with his sense of disillusionment and deception.

His preoccupation with (subtle changes in) perception is presented very concisely in THE HOUSE and is yet another, fourth element that Van Gasteren will return to in later works, such as in his DO YOU GET IT? series that I will discuss in Chapter 4. THE HOUSE makes multiple references to the act of perceiving, such as when we observe the architect viewing the house from a distance through binoculars. During the opening title sequence of the film, the camera shows us the house at night, from the outside and from a distance. Inside, there is a party going on and we see the shadowy profiles of a man and a woman kissing. The camera zooms in, framing the man and the woman in a way that recalls the shadow play, perhaps even the shadows in Plato's cave; a reference to early conceptions of cinema. The framed window dissolves into the window of the house being demolished. The final title sequence returns to this party scene. We hear the same party music as at the beginning of the film. We see the owner of the house staggering in the garden, a glass of wine in his hands. He sits down on a garden chair, clearly under the influence. Glancing at his house, his drifting eye is suddenly caught by two shadowy figures at the window [...]. The camera-eye from the beginning of the film now appears to be a subjective point of view. This change of perspective places all of the preceding events in a slightly different perspective (perhaps the owner of the house has known all along that his daughter may not be his biological daughter). A fifth theme that is strikingly present in THE HOUSE is the war. One of the events in 'the life' of the house is its occupation by a Nazi army division. A German officer (played by Van Gasteren himself) enters the living room. The daughter's husband asks in German what he wants: '*Das Haus*,' is the brief answer, and one of the few (non-French) words that are actually spoken in the film. By the time the Germans enter the house we have already seen images of the daughter's husband shot dead. And we understand that the arrival of these occupiers means the traumatic end of the house and its inhabitants. I will dis-

cuss the traumas of the Second World War and its destructive after-effects in some of Van Gasteren's other films in Chapter 3.

Here, I would like to focus on the particular features THE HOUSE shares with European post-war cinema more generally. Van Gasteren grew up with European pre-war cinema. As a child, his father took him to film shows and on one occasion he even met one of the Lumière brothers, the famous film pioneers. Marcel Carné's HOTEL DU NORD (1938) is among his favourite film references, as is David Lean's BRIEF ENCOUNTER (1945).[29] THE HOUSE shares characteristics with post-war European cinema, which was strongly marked by the Second World War. In his autobiography, *Fun in a Chinese Laundry*, Joseph von Sternberg mentions THE HOUSE together with Alain Resnais' LAST YEAR IN MARIENBAD as examples of original ways in which cinema can achieve motion: 'Motion can also be achieved by altering the position of the camera and by technical manipulation in the laboratory (LAST YEAR IN MARIENBAD), [or] by jumping backward and forward in time (THE HOUSE) [...].'[30] Von Sternberg appreciated the experimental style and wit of Van Gasteren's film and calls it a superlative experiment. Although less well-known than Resnais' films, stylistically THE HOUSE is akin to other French and European films of the same period.

Philosopher Gilles Deleuze, who wrote two important books on cinema, has argued that the Second World War marks a watershed in the way that cinema expresses thoughts, or expresses its 'soul'.[31] In *Cinema 1: The Movement-Image*, Deleuze describes pre-war cinema, which largely corresponds with classical cinema, as a sensory-motor mode of cinematography that follows characters in their (seemingly) continuous actions. Time in the movement-image is chronologically ordered (even flashbacks are motivated and recognizable as flashbacks). Characters know where they are (in space and in time) and even if they have obstacles to overcome, they know how to act in goal-oriented ways. The Second World War marks a break, not only in the world order, but also in cinema. This break should not be thought of as a singular causal event. Rather, the war marks a shift. At least two elements can be connected to the emergence of the new type of cinema that Deleuze conceptualizes in *Cinema 2: The Time-Image*. Intrinsically, the methods of classical cinema, or the movement-image, were hollowed out by the German propaganda-machine: 'Hitler as filmmaker,' as Deleuze calls it.[32] Extrinsically, the war had such a traumatic effect on society as a whole that it simply had to penetrate into the soul of cinema's particular form as well. According to Deleuze, cinema is not a representation of the world (as a second order, or illusionary reality). Cinema has its own audio-visual power that operates (has effects) in the world. Of course, cinema also relates to elements from the world, often in profound and complex ways. And so, literally out of the ruins of a war-devastated Rome,

cinema was reinvented in Italian neo-realism. Roberto Rossellini's films such as ROME, OPEN CITY (1945) and GERMANY, YEAR ZERO (1948) present characters that are no longer able to act in goal-oriented ways; they wander and wonder over the debris of the war, captured by the intolerable, the incommensurable and the impossibility of what had happened. In this mode of cinematographic thinking and expressing, time is no longer indirectly ordered in a chronological way, but 'time is out of joint'. The past pops up unexpectedly from beneath the rubble of the present; it no longer fits in a logical order. The temporal order is mixed up and all layers of the past start to speak for themselves, irrationally breaking open the membrane of the present, forming 'crystals' of time where the virtual of the past slides into the actual of the present; characters seem lost, alienated from a modern world that seems cold and clinical.

There was no formal or stylistic recipe for this new mode of cinematography. Each director found his (sometimes her) own expressive form in the films of the new waves that happened in the many cinemas of Europe and other parts of the world in the late 1950s and 1960s. Perhaps most famous is the *nouvelle vague* in France, of which Jean-Luc Godard and François Truffaut are the most well-known exponents.[33] In Italy, Federico Fellini, Michelangelo Antonioni and Vittorio De Sica are examples of time-image cinema that Deleuze conceptualizes. In the Netherlands, the new wave is usually associated with the films of Adriaan Ditvoorst (such as THAT WAY TO MADRA, 1965 and PARANOIA, 1967); the early films of Frans Weisz (THE GANGSTER GIRL, 1966), Nicolai van der Heyde (A MORNING OF SIX WEEKS, 1966), and the wild and low budget experiments of Wim Verstappen and Pim de la Parra (JOZEF KATUS' NOT SO HAPPY RETURN TO REMBRANDT'S COUNTRY, 1966). Van Gasteren was actually in between the older generation of the Dutch documentary school filmmakers like Van der Horst and Haanstra and this new wave generation, which was the first generation of feature filmmakers of the Dutch Film Academy (Frans Weisz went to Rome). In-between generations and in-between fiction and non-fiction filmmakers, Van Gasteren is not always recognized as part of this new wave, with the exception of his short film BECAUSE MY BIKE STOOD THERE, discussed in the introduction. That film, which certainly reflects the spirit of a rebellious post-war generation of youngsters attempting to cope with the traumatic legacy of the previous generation, will be elaborated on in Chapter 4. THE HOUSE, however, as an experiment in new temporal understandings and post-war sensibilities, fully resonates with the new waves of modern post-war filmmaking.

The temporal structure of THE HOUSE is akin to Alain Resnais' HIROSHIMA MON AMOUR (1959). Resnais, whose NIGHT AND FOG (1955) was one of the first documentaries that included devastating images of the Nazi concentration camps, was actually asked to make a documentary about the ravages of the nuclear attacks on Hiroshima and Nagasaki. Struck by the impossibility

of showing this event in documentary images fifteen years after the events, he asked writer Marguerite Duras to write a scenario for a fiction film dealing with the impossibility of properly remembering and acknowledging the atrocities of the past. The objects and images in the museum of Hiroshima (that did end up in the film) do not suffice: 'You have seen nothing in Hiroshima,' a voice-over claims on several occasions. The documentary became a fictional love story between a Japanese man and a French woman. She is in Hiroshima for the shooting of a film about peace. They meet on the last day before she returns to France. But the love affair provokes an eruption of memories. Collective memories of the disaster become mixed up with the woman's memories of her love affair with a German soldier who was shot during the war; an affair which caused her to be scorned and isolated after the war. Time and place become confused; she becomes the French city of Nevers in the past during the war, and he becomes Hiroshima in 1945. At least this is what is suggested by the way the different individual and collective memories are mixed up in the woman's story and in the editing that jumps non-chronologically between all of these different moments of the past and present. And there is a fear of forgetting, a fear that the past will always cyclically return, that new wars and new love affairs will occur, even if this is unimaginable considering the intensity of the love and the pain in the present of the film.[34]

As Charles Boost indicated about THE HOUSE, HIROSHIMA MON AMOUR contains no fixed point in time, everything seems to be part of a present that is adrift. This present has to be specified however, because it is a different conceptualization of the present than in classical cinema. In his cinema books, Deleuze is highly influenced by the philosopher Henri Bergson, who was a sort of academic pop star around the turn of the century (who apocryphally caused the first traffic jam in New York City when he was lecturing at Columbia University). Bergson's theories about perception and memory, most famously presented in *Matter and Memory,* were no longer in vogue when Deleuze picked them up again to conceptualize the movement-image and the time-image in cinema. Deleuze spends several chapters explaining the influence of Bergson's work on Deleuze's cinema concepts, so there is much more to this than I can do justice to here;[35] but, in short, it is possible to see that in classical sensory-motor cinema (the movement-image mode) the present is a stretch of what Bergson calls 'duration'; that is, a stretch of the living present in which we have no trouble moving and recognizing the world in a habitual, sensory-motor way. However, in the cinema of the time-image, we experience a more unfamiliar form of time that opens up when habitual perception is suspended. Bergson uses the example of a man falling ill, who unable to move automatically, starts to live more in his memories (or imagination). According to Bergson, the past consists of layers that are all preserved and that co-

exist. Just as space does not cease to exist outside our perceptual scope, the past does not disappear, even if we no longer see it with our eyes in the here and now. Cinema can visualize temporal relations beyond its habitual perception. According to Deleuze, the time-image is profoundly Bergsonian in its treatment of time: 'These are the paradoxical characteristics of a non-chronological time: the pre-existence of a past in general; the coexistence of all the sheets of the past; and the existence of a most contracted degree.'[36] This 'most contracted degree' is the present of the non-chronological time-image. This present is not simply a stretch of time in our sensory-motor here and now, but it is the culmination point of all the layers of the past: 'I have seen everything in Hiroshima,' the woman's voice says repeatedly in Resnais' film. The 'now' that Boost refers to in the quote above as the present of THE HOUSE, has to be seen as Bergsonian time where co-existing layers of time appear directly in the present of the image. Deleuze demonstrates furthermore that throughout Resnais' work we 'plunge into a memory which overflows the conditions of psychology, memory for two, memory for several, memory-world, memory-ages of the world.'[37] We can understand how HIROSHIMA MON AMOUR connects a 'memory for two' to a collective memory-world and world-memory. In its own specific way, THE HOUSE compresses personal and collective memories in its aesthetic form. I will return to the particular role of the future in Van Gasteren's work (THE HOUSE included), but for now I would like to suggest that THE HOUSE, with its non-chronological layers of time, belongs to the modern post-war time-image that had wider resonances.

In sum, I think Van Gasteren's intuitions were correct when he argued that with THE HOUSE he was looking for another form to express philosophical ideas. With this film he has explored and expressed a new conceptualization of time that he shares with post-war filmmakers of the time-image. He has taken on the role of philosopher, as Arne Naess in the television portrait that Van Gasteren made of him in 1971 argues, 'to widen the perspective [...] in the sense of taking the broadest framework in time [...].' In a similarly philosophical way, Van Gasteren has shown with THE HOUSE that 'a house is more than four walls and a roof, more than doors, windows, corridors, more than rooms and an attic. A house is a life. Birth, love and death. Echoes of hesitating footsteps of a child and the faint sounds of a piano, noises of people, intimate whispering, a grievous lamentation.'[38] A house has memories, it has profound meaning for its inhabitants; it is related to individual and collective history. THE HOUSE brings all these philosophical dimensions of architecture and housing to the fore.

DWELLING IN THE CITY: ROOTS AND RESISTANCE

A house is, of course, situated in spatial surroundings that are as determinative an influence on our life as the house itself. Van Gasteren is also a chronicler of his home city, Amsterdam. For his first independent film, RAILPLAN 68 (1954), he took his camera to the Leidseplein to film the replacement of the tramways, completed in a single night. I will discuss this film further in the next chapter because it is also an early expression of Van Gasteren's fascination with (communication) technology. Another aspect of Van Gasteren's Amsterdam that I will elaborate on in a later chapter is the artistic rebellious counter-culture of the 1960s. Van Gasteren produced important film portraits of this generation and of the city in works like JAZZ AND POETRY (1964), HANS LIFE BEFORE DEATH (1983), and ALL REBELS (1983), which poignantly capture the spirit of the 1960s in the Netherlands. In this chapter, however, I want to remain close to the theme of housing, as this was a problem in Amsterdam and other Dutch cities in the Netherlands that persisted throughout the 1960s until the late 1980s. In 1980, Van Gasteren made a monumental artwork in the Amsterdam metro, ROOTS OF THE CITY, which reflects the struggles over housing in his own neighbourhood, the Nieuwmarkt. The Nieuwmarkt is a very old neighbourhood in the centre of Amsterdam. In 1975, the construction of a new metro station led to protests, resistance and ultimately violent riots. These riots must be viewed in the larger context of the squatters' movement in Amsterdam in the 1970s and 1980s. Before moving to the Nieuwmarkt and Van Gasteren's artwork, let me briefly sketch Amsterdam's housing situation during this period.[39]

As mentioned previously, filmmaker Johan van der Keuken also directed his camera at Amsterdam at regular intervals. His work shows that while the people in FOUR WALLS (1965) suffered their lack of living space mostly in silence (families of eight or more people in cramped tiny one-room apartments), the generation of city dwellers portrayed in THE WAY SOUTH (1980) no longer accepted the housing situation, angered by the fact that many large, expensive buildings stand empty while numerous people go without a decent place to live; this led to the squatters' movement that has become an integral part of Dutch cultural memory of the 1970s and early 1980s. It also led to the violent riots that marked the coronation of Queen Beatrix in Amsterdam on 30 April 1980, in which the housing shortage figured as an issue: 'No House, No Crown' ('*Geen woning, Geen kroning*') was the much-heard slogan. In THE WAY SOUTH, Van der Keuken filmed the squatters from the day of the coronation onwards, regularly returning to them in subsequent months. In June 1980, he interviewed a new member of the squatter community he had been following, a recently divorced elderly lady who was welcomed by the collective. She expresses her admiration for the fact that the new generation is no longer

willing to endure the city's dismal housing policies; admitting how easily her own generation was pushed into a rut, she is in awe of the squatters and feels inspired by them to do and speak as she wishes. The spirit of the times that Van der Keuken captures, then, is one to which revolution, resistance and protest have become meaningful concepts. What stands out from a present-day perspective is how idealistic the squatters' motives are, how well they manage to operate collectively, bound together by solidarity, and how they get support from others such as lawyers who offer *pro bono* help to deal with legal issues.[40]

As another Dutch documentary maker, Joost Seelen, demonstrated in his film THE CITY WAS OURS (DE STAD WAS VAN ONS, 1996), this collective idealism would not last, and the squatters' movement would collapse in the late 1980s under the weight of bitter internal conflicts.[41] In his film, Seelen interviews ex-squatters in the setting of their own contemporary homes, recalling the turn of events in the 1980s. The collective spirit of the 1970s was first characterized by the non-violent occupation of empty houses in all parts of the city, which was met with violence from the police when evacuating the squatted premises. In 1978, police violence towards the squatters provoked an emotional response in the wider population, many of whom were reminded of the German occupation. Moreover, as the elderly lady in Van der Keuken's THE WAY SOUTH also expressed, the housing problem was widely felt and the spirit of freedom and the resistance against authorities was initially admired. The squatters could count on popular support. But the squatters' actions and reactions became increasingly violent and the group became generationally and ideologically divided on issues concerning internal power, negotiations with politicians and the use of violence. This led to an internal war and the end of the squatters' movement in 1988. Their efforts, however, were not in vain. Many of the buildings that were squatted have been bought from or by the city council and turned into houses; other historic buildings in the city, especially along the IJ, have been preserved and have since been creatively renovated, first by the squatters themselves and later by architects.[42] According to Joost Seelen, the squatters' movement also marked an important historical shift, because as a movement they embodied both a Marxist inspired political collectiveness as well as a fight for maximal individual freedom, which in a sense announced contemporary hyper-individualism.[43]

Returning to the 1970s and 1980s however, we are back in the time of social protests concerning housing. In 1975, the city council ruthlessly decided to evacuate a substantial number of reasonably well-maintained houses in the popular Nieuwmarkt neighbourhood in order to make room for the construction of the east side of the metro line. The inhabitants of these houses were not squatters; indeed, they had been living there legally for many years, often for their entire lives. They had been protesting since 1969 and suggesting

alternative routes to the city council that would follow the same trajectory but would spare most houses. A major concern of the local inhabitants was that after the demolition there would no longer be any affordable housing because the city planners wanted a highway, hotels, offices and expensive mansions to be built in the area. The slogans 'Dwelling is not a favour but a right' (*'Wonen is geen gunst maar een recht'*) and 'No tubes but houses' (*'Geen buizen maar huizen'*) summarize the local sentiments of the period. The inhabitants were not heard. In March and April of 1975 a large police force entered the Nieuwmarkt quarter, occupants were violently removed from their apartments, furniture was thrown out, cars were pushed into the canals and, by the end of the day, the houses were hit by the heavy blows of sledgehammers and the wrecking ball.

The metro station was built. During its construction, the council passed a proposal to invite some artists to produce some work for this station. Initially, the former inhabitants, many pushed into different neighbourhoods, did not want to collaborate on embellishing something that they had fought against. After some time however, and considering the fact that the metro was now a fact, they nominated a few artists from the area to produce work that would honour the history of the neighbourhood and the protests that were part of this station. Louis van Gasteren, whose house is a stone's throw from the Nieuwmarkt, was one of those artists. Van Gasteren, together with Jan Sierhuis, Bert Griepink and Roel van den Ende made a large social-realistic photograph for the metro wall, entitled GREETINGS FROM THE NIEUWMARKT (GROETEN UIT DE NIEUWMARKT, 1980), which included historic photos of the former houses and buildings as well as images of the protests. The title is derived from a satirical postcard that was created during the 1975 riots in which this 'holiday greeting' is written underneath an image of an armed police force in front of De Waag (a fifteenth-century building at the Nieuwmarkt that used to serve as a gate to the city).

The artists also placed individual works underground at the Nieuwmarkt. Bert Griepink and Roel van den Ende, who both lost their houses in the demolition process, produced works recalling those events, using mirrors and protest posters in holes in the wall. Jan Sierhuis placed an actual wrecking ball against the tube wall, commemorating the houses that were demolished and as a more subversive symbol of hitting back. In the documentary GREETINGS FROM THE NIEUWMARKT (Guus van Waveren, 1980), Van Gasteren recalls how during a presentation of the artists' plans to the neighbourhood's old inhabitants, one of them started to tremble, caught by the traumatic recollection of the merciless destruction of their former homes. In his Nieuwmarkt artwork, ROOTS OF THE CITY, Van Gasteren pays an underground tribute to the lives and the houses that had disappeared above the ground. His work made the actual

building process of the tubes visible. In order to dig the tubes, the centuries-old piles upon which the houses of Amsterdam were built had to be cut. These piles are 'the roots of the city'. Van Gasteren placed girders underneath cut-through piles, symbolically supporting the houses and the life above ground. Obviously these girders were not placed in reality, and ROOTS OF THE CITY is a reminder of the lack of respect shown towards the inhabitants, the history, the houses and the technologies of the construction of the city. Van Gasteren expresses it as follows:

> Amsterdam, that beautiful city / is built on piles / anyone can build a metro: A matter of money, technique and power / what weighs heavier: building costs / or Human misery?
>
> You would search for roads / Not to have to demolish homes / Not to pull piles out of the ground / Not to damage this neighbourhood / Not to dislodge people / You would do everything to keep the homes / On their piles: the roots of the city
>
> Perhaps you would saw them up / And 'catch' them with a construction / To not move them aside, let them stand / To show that above the ground people live / Like an underground proof of existence / Of those people / Of those houses / That are no more!
>
> This is what this project wants to make you aware of.[44]

Besides the artworks, some of the slogans, such as 'Dwelling is not a favour but a right,' were placed on tiles in the ground. In the documentary GREETINGS FROM THE NIEUWMARKT, Tine Hofman, one of the former inhabitants who coined the slogan, dryly remarks that it is actually symbolically quite apt that the rights of ordinary people were trampled underfoot. And yet, the protests were not completely in vain. The metro did come, but instead of a highway and hotels, the Nieuwmarkt retained its residential function. The artists have rather mixed feelings about the effects of their artworks and their position as artists. Guus van Waveren followed the artists during the construction of their works in the carcass of the underground. Towards the end of the works, Van Gasteren remarks that he feels their relationship to the work is changing: 'When we were working on the scaffolding it felt as if we were making something revolutionary, creating an artistic protest. But now, everything becomes slick and clean, the work almost institutionalized. Soon at the official opening neat ladies and gentlemen will look at it and say: "Yes, interesting, neat [...] that is how it was, neat [...]".' The other artists recognize his point, adding

that it feels like the artworks can also be claimed to demonstrate democratic tolerance of dissent. 'Blood has been shed but it is so beautiful.' Jan Sierhuis reflects on the tragedy of the artist who is on the side of resistance: 'whenever you do something responsibly, sensitive to its contents, you will also become an accomplice to the powers that be [...]. You want to make an artwork that resists, but if you do it in a good way, there is always something that escapes, an aesthetic dimension beyond the problem you express that is compromising.' And yet, he adds, this bittersweet aspect of being in the middle (between resistance and power), is perhaps also the place that art needs to occupy. In any case, art is primarily a resistance to time, to forgetting.

Today, not only the memories that the artworks preserve but the artworks themselves need to be protected. During recent renovations to the Eastline of the Metro several of the artworks that were placed there in the 1970s (and at other stations) were damaged and even removed. Now, some citizens in the Nieuwmarkt have started another initiative 'Save the Metro Art' ('*Red de Metrokunst*').[45] And now inhabitants and the city council are cooperating to save or restore the 1980 artworks. ROOTS OF THE CITY shows Van Gasteren's commitment to the city and the people that live there. Van Gasteren's interest in architecture and the building process, as well as the meaning and memories of actual dwelling and living, come together in this city monument. Its story is closely related to the particular housing problems of Amsterdam and the Netherlands in the 1970s and 1980s.

Between 1980 and 1988, Van Gasteren worked on another public monument, the Amsterdam Ordnance Datum (AOD) or *Normaal Amsterdams Peil* (NAP). In the middle of Dam Square, below the cobbled surface, the standard measure point for water levels and heights is hidden under the ground. When a new city hall was built in Amsterdam Louis van Gasteren and designer Kees van der Veer developed a plan to make this international point of reference visible in a monument, a project that I will elaborate upon in the next chapter. Having discussed the significance of the land, the city and the house as the foundations of life, the next step is to look at technology, water management and transportation, all specific areas of human progress that Van Gasteren has researched and filmed with passionate curiosity and a sense of wonder.

CHAPTER 2

Water, Transport and Technology

'The Dutch know about water. It comes and goes. It has a will of its own. It challenges. And the Dutch answer.' These are the opening words of THE NETHERLANDS MADE IN HOLLAND (1995), a short English language film about the Dutch waterworks. Unprotected, two-thirds of the Netherlands would be covered in water. Schiphol Airport, for instance, is about 10 feet (3.3 metres) below sea level. In THE NETHERLANDS MADE IN HOLLAND Van Gasteren invites us to listen to the sounds of water: the sound of a spade driven into the peat, formed thousands of years ago from sphagnum moss and other microfauna that grew in the watery soil of the low lands; the sound of the digging of ditches to drain the water; the sound of the turbines of the watermills, pumping machines, and sluices; the sound of the building of dikes and dams, the drilling, dredging and guiding of the water; the sound of the waterland itself: the sea, the rivers and canals, the splashing of the water against the dikes; the sound of the seasons, wind, rain and ice; and the sound of the ramming of piles into the soft ground to give the houses and buildings a stable foundation. The last sounds of the film are actually the most important ones: the simple sound of footsteps on pavement. 'All my life I have had dry feet thanks to the Dutch water management,' Van Gasteren has acknowledged on many occasions.[1] As an artist and investigator, he questions the things we consider normal and common, such as simply having dry feet. In a country largely situated below sea level this is actually not so simple at all. The significance of water and water management, but also more generally the importance of modern technology and technological innovations that ensure human survival and progress, which Louis van Gasteren has investigated with wonder and interest on many occasions, are the central concerns of this chapter.

Obviously Van Gasteren is not the first or only Dutch artist to have directed his attention to the special relationship between water and the Low Lands.

Poets, painters and filmmakers have been fascinated with this topic for centuries, and Van Gasteren's work belongs to the aquatic traditions embedded in the Dutch soul, born of centuries of struggle with the elements. Van Gasteren's fascination with the ocean and sea vessels is evident from his early films such as THE STRANDING (1956) and MAYDAY (1963). More particularly, however, Van Gasteren is interested in the technologies and organization integral to water management that is largely hidden from ordinary view. The Amsterdam Ordnance Datum (AOD) or *Normaal Amsterdams Peil* (*NAP*) is one of the invisible markers of water management that Van Gasteren has made visible with a water monument for the city. The AOD is the reference for surface elevations that was first established between 1683 and 1684 by the City Water Authority of Amsterdam. During the course of one year the water level of the IJ (the body of water on which Amsterdam is located) was measured during low and high tides, and its mean level, the Amsterdam Ordnance, was established and fixed by means of marker stones in the dikes and sluices of the city (one of these stones is still visible in the Eenhoornsluis). In the nineteenth century, this reference was rolled out to the rest of the Netherlands as the standard reference for measuring heights, and since 1955 it has been the standard measure for heights in Europe.[2] As such, the AOD is comparable to other international references such as Greenwich Mean Time and the metre in Sèvres, France.

In 1953, after many additional precision measurements the central AOD benchmark bolt was placed on a pillar deep in the ground under Amsterdam's Dam Square, sunk into a more stable layer of ground to ensure its stability. When a new city hall was built in the 1980s, Van Gasteren and graphic designer Kees van der Veer proposed a monument to make this unique and remarkable AOD reference, which lay hidden beneath the cobblestones of Dam Square, more prominent and visible. In collaboration with the architects of the new city hall, Wilhelm Holzbauer and Cees Dam, they created the monument. It was opened to the public in 1988 at the entrance of the new building ('the Stopera'). The monument consists of various elements. In the basement there is a visitor room with a pile topped by a bronze button indicating the zero level of the official AOD, exactly measured from the benchmark under Dam Square. Visitors can descend to the basement and put their hand on the button at the zero AOD level and imagine all the water that would be over their heads if there were no water management system. Another element is a 30-metre long relief mural that shows a cross-section of the Netherlands, indicating its levels and heights and the different layers of soil. In a film that Van Gasteren made for German television (WDR), HEIGHT OVER ZERO (HÖHE ÜBER NULL, 1982), we see Van Gasteren (with Klaas Metz and Kees Romeyn) at work in the Zuiderkerk, building an exact 1:1 scale model of this part of the monument. The third element of the AOD monument in the City Hall consists of three great transpar-

ent water columns. Two of the columns show the constantly changing water levels of the North Sea at IJmuiden and Vlissingen. The third column shows the water level at the time of the horrific flooding of 1953, when large parts of the southwest of the Netherlands were wiped away by the sea. Its height, + 4.53 m. AOD, is a frightening reminder of the powers of the sea.

WATER IS OUR ELEMENT: THE SEA AS FRIEND AND ENEMY

In a documentary by colleague filmmaker Bert Haanstra, THE VOICE OF WATER (DE STEM VAN HET WATER, 1966), a voice-over at the beginning of the film utters the complaint that another film about water is perhaps a little redundant. 'It has all been shown so many times already,' Haanstra's voice postulates: 'the picturesque villages at the Zuiderzee, the reflections of the houses in the water, the canals in the Venice of the North. It has all become a cliché, why make yet another film on this liquid element?' With self-conscious irony, Haanstra refers to the films of the Dutch documentary school, including his own water films such as MIRROR OF HOLLAND (SPIEGEL VAN HOLLAND, 1950) and AND THE SEA WAS NO LONGER (EN DE ZEE WAS NIET MEER, 1955). And yet, THE VOICE OF WATER once again presents images of the 'water soul' of the Dutch, some of which have become iconic: swimming lessons of little children who need to overcome their fears, a little boy who does not dare to put his head under water; an eel fisher on his little boat on a foggy night, recreational use of the water in summer on little boats and at the beach, in winter on the ice; children speaking to their fathers at sea via radio. After showing the Dutch in all their myriad relations to water, Haanstra ends his film by quoting the words of the poet Hendrik Marsman: 'and in all regions / the voice of water / with its eternal disasters / is feared and heard'.[3] The images under these words show us the terrible flooding disaster of 1953 when over 1800 people were swallowed up by the North Sea and over 100,000 people lost their houses, cattle and land. Haanstra recalls the story of one woman who lost her husband and all her children except one son who, by coincidence, was safe in a hospital. After reaching safety, she wrote a letter to her son telling him about the disaster. We hear her reading the letter again, more than ten years later. And then we see mother and son, silently standing on the beach, the waves of the sea behind them. The knowledge of what those waves took from them devastatingly resonant in their silent postures. Haanstra concludes that yes indeed, 'we need to listen to the voice of water again and again, we cannot escape from the water, we are surrounded by it.' And so we had better learn to deal with it. In the final images of the film we again see the little boy from the beginning of the film who was afraid of the pool water. One year later he has overcome his fears, jumps in the

water and swims. The 'brave little Dutch boy that has put up a fight and keeps his head above the water' that Haanstra ends his film with, is clearly meant to be viewed allegorically, to say something about the Dutch and their fight against the elements in general.

Van Gasteren filmed the sea and its destructive forces in his own particular way in two films early in his career, the fiction film THE STRANDING (1956 /1960), and the documentary MAYDAY (1963). THE STRANDING was the first fiction film in the Netherlands shot outside the studio using existing locations and settings: the harbours and streets of Rotterdam, the island Terschelling and, most spectacularly, a wrecked ship in the North Sea, the Swedish ship the Ecuador that was stranded off the coast of Terschelling in 1956. Van Gasteren actually wanted to make a documentary film about a shipwreck, and in particular about the activities that spontaneously emerge around a wreck. Whenever there is a ship stranded on the coast, people come to visit, a fish-and-chips trailer appears, parking spots are created and whole families come to look at the ship and touch its wrecked metal. Van Gasteren had a subscription to Radio Scheveningen, the service that coordinates the coast watch, so that he would be notified as soon as there was a ship in distress. When Van Gasteren received news of the Ecuador's stranding, he immediately took off in a helicopter and recorded the ship struggling in the ferocious sea. The images were shown on Dutch and Swedish television news reports on the event that same evening. But the Ecuador was too far from the coast for any of the expected activity to happen on the shore. And so Van Gasteren immediately thought of a plan to use the wreck as a natural setting for a fiction film. Because the waves were bashing the ship with brutal force, it would only be a matter of time before it would break in two and become unusable as a setting. In haste Van Gasteren wrote a script about a criminal deal involving two identical suitcases (containing fake diamonds and fake money). He collected all his family, friends and collaborators and checked into a hotel on the island of Terschelling. A salvage ship took the crew to the Ecuador: 'We behaved like irresponsible shore side people, incredible! We slept in a cabin, knowing that the next night it would be smashed by the water. We played with our lives. I stood there holding lamps, powered by a DC generator, sparking, boiling the water! We just didn't think of the risks at all. But everybody was totally engaged. Everything was possible.'[4]

Because of the rush involved in writing the script and because, at that time, Van Gasteren was not yet experienced as a script writer and director, the film's story is rather chaotic. Even the revised 1960 version (which was 'fixed up' Hollywood film noir-style by the American script doctors Herrick and Harper) was not received very well by the larger public at the time. Critics, however, valued the powerful images of the sea and the remarkably striking scenes on the ship.[5] Even today, images of people trying to escape from an

actual sinking ship (or entering it again to fight over the suitcases left behind) and being smashed by the wild sea, with the knowledge that the images were created without any digital effects, are rather overwhelming. Aesthetically, these images make us spectators, like the visitors on the shore that have come to see the ship, to 'touch' its metal and to feel the force of the elements. But it was not an easy task to achieve the effect of the experience of water with purely audio-visual means: 'Filming running, wild water is difficult,' Van Gasteren explains. 'We experimented with filming streaming water, and found out that shooting it with 36 frames per second (and projecting it 24 fps) gave the best effect.'[6] The breakup of the ship itself was filmed in Van Gasteren's own studio, in the basement of his house. His collaborators Kees Romeyn and Jan van Vuure built a set using tubes painted like cracking iron and water tanks. As the iron pipes cracked, water flooded into the studio, into the street, and into the canal in front of the house. These staged images of the breakup of the ship are seamlessly edited with the footage of the actual ship, with an overwhelming effect. The fictional story line is less convincing, although the narrative mise-en-scene of STRANDING seems to anticipate other film noir / detective films that were made in the Netherlands in the 1960s, such as RIFIFI IN AMSTERDAM (John Korporaal, 1962) and 10.32 MURDER IN AMSTERDAM (10.32 MOORD IN AMSTERDAM, Arthur Dreifuss, 1966). These films were skewered by critics at the time for the clumsiness of their scripts.[7] With the passage of time, however, they have become more interesting as historical documents that preserve the flavour of the time in terms of the location shooting and in the gestures and language of the characters in the awkwardly presented fictional stories. But they miss the impetuous power of the sea scenes of STRANDING.

The short documentary film made for television, MAYDAY (1963), is another film in which Van Gasteren directs his camera at the sea. Dutch fishermen have regularly been captured on film, most famously by Herman van der Horst in SHOOT THE NETS (HET SCHOT IS TE BOORD, 1951), which was made in the context of the Marshall Plan and which won the Grand Prix at the 1952 Cannes Film Festival. Van Gasteren's film, however, follows the coast guards of Radio Scheveningen and the rescue brigades that respond to the emergency signals of ships at sea. Official nautical rescue teams were set up for the first time in the Netherlands in 1824 when on just one day, 14 October 1824, seventeen ships wrecked along the Dutch coast.[8] Since then, rescue workers still work largely on a voluntary basis, but they are supported by good equipment and some professional sailors. In MAYDAY, Van Gasteren combines different formal elements that infuse the mostly non-fiction images with poetic reflections. For MAYDAY he collaborated with the writer Simon Vinkenoog, whose words we hear at the beginning of the film: 'Wind-force nine, ten, eleven. The cry of a human being in distress. A vessel in peril. What is a dead sailor? [...] The howl-

ing of the sea.' The film shows us footage of the rescue boat Brandaris saving all 41 souls from a distressed ship who were drowning in the gigantic waves of the North Sea. We also see scenes of passengers inside a ship, desperately trying to leave the sinking vessel. These are actually the semi-fictional scenes filmed inside the Ecuador that Van Gasteren staged for STRANDING and now re-used in MAYDAY. We see a Scheveningen Radio telephone operator making connections between people at sea and rescue workers on the coast: 'A doctor is on his way!' And we see 'a doctor' jumping out of a helicopter at sea (performed by Van Gasteren himself).

Then the camera follows the Prins Hendrik rescue boat on its way to the Nautilus, another ship that perished on the coast of the island of Texel. Here things go terribly wrong. Twenty-three of the twenty-four sailors aboard the Nautilus found their deaths in the cold waters of the North Sea. Van Gasteren films how they are taken ashore from the Prins Hendrik. A police officer tried to prevent Van Gasteren from filming the bodies but a rear admiral intervened and gave his permission to continue filming. 'This rear admiral understood what I was doing,' Van Gasteren recounted later:

> If I want to convey what a shipping disaster means, I have to film the deceased bodies of the seamen arriving in Den Helder. [...] This is terrible to do, it hurts your stomach; I have sleepless nights over it. I have the images recorded in film containers, but I do not sleep. However, if you want to get something across, you sometimes need to transcend your own habitual conditioning, your own value system: you need to shoot it because you need it [to convey this experience of the sea].[9]

MAYDAY also contains an interview with the only survivor of the Nautilus, Lienhard Frey, recorded at his home in Germany where he recalls the terrible event. The ex-sailor Frey talks about the five long hours that he was drifting in the dark icy waters and how he was miraculously rescued. Bringing together all these different formal cinematographic elements (documentary footage, staged scenes, interviews) in an organic composition, MAYDAY provides us with an experience of the ferocious power of the sea and of the unyielding desire to rescue those who are threatened with being swallowed by it, even if the effort is sometimes in vain.

Many ships have wrecked before the Dutch coast, countless sailors have found a watery grave, and even more people have lost their homes and lives in relentless flooding disasters. However, each disaster has led to new projects to protect the land and keep the salty water out. Cornelis Lely's plans for the Zuiderzee Works, discussed in the previous chapter, were only executed after the flooding of 1916. The national flood disaster of 1953 initiated another

huge water management project, the Delta Works. The Delta Works is a series of construction projects to protect the islands of Zeeland and South Holland from the sea. The works consist of dams, sluices, locks, dikes, levees and storm surge barriers with moveable flood gates that are only closed in cases of heavy storms and flooding danger. These movable barriers are the result of many years of negotiation between the government and civilian groups interested in protecting the local eco-systems and fishery. The Delta Works were completed in various stages and only completely finished in 2010. To facilitate the construction of one of the dams, the Oosterschelde Dam, an artificial work island, named Neeltje Jans, was created. When the dam was completed in 1986, the island remained fallow. Van Gasteren was asked by the province of Zeeland to design a new plan for Neeltje Jans. He invited the architects Wilhelm Holzbauer and Frei Otto and the builders Martin Manning of Ove Arup & Partners to collaborate. Together they developed a multilayered land art project on the island that would express the gargantuan scale of the Delta Works and its multiple relationships to technology, water management, ecosystems, energy, fishery and nature. To emphasize the fact that the former work island was created artificially, Van Gasteren wanted to symbolically pin down the island with giant screw nuts along its borders. The multifaceted plan was accepted and the budget (of about 60 million Euros) was approved, but financing appeared difficult. The project was never realized. What remains of Van Gasteren's Neeltje Jans project are its drawings and plans.[10] Neeltje Jans has become a family attraction park. The American Society of Civil Engineers has declared the Delta Works (with the Zuiderzee Works) one of the Seven Wonders of the Modern World.

DRY FEET BELOW SEA LEVEL: AN INTEGRAL VIEW ON WATER

Van Gasteren trained as an electrical engineer and has always been deeply interested in technology. As a filmmaker he started as a sound technician and he has always stayed in close touch with all the technical procedures of the filmmaking process. His fascination with Dutch water management is primarily technological, an admiration for building and creating the conditions to dwell.[11] Technology, however, is never a solely functional instrument. Rather, it is co-constitutive of a whole way of being that is reflected on many different levels. In this sense, A MATTER OF LEVEL (1990) presents just such an integral view of life and technology in relation to water. Of course, the title refers in the first instance to the AOD, the water level, and all the technological and scientific inventions and measures that Dutch water management applies. However, the film presents this concept of water management on many different

levels, ranging from the purely technological aspects of reclaiming the land, to building bridges, the (pre)democratic self-governmental organization of water management, ecological concerns and art. A MATTER OF LEVEL (co-directed with Raymond le Gué) was produced in the late 1980s and is one of the first films (in the Netherlands) that used computer technology. Animator Gijs Bannenberg created a number of scenes for the film and more than 50 DEC unix desktops and 10 SGI units together with video recording equipment were used in making the film.[12] The computer itself, as an apparatus with its own logic and new way of communicating, serves as a framing device for accessing the levels of a thousand years of water management. At the beginning of A MATTER OF LEVEL a Tulip lap-top computer appears, opens and is switched on. While the image zooms in on the computer screen, which displays a seagull in flight, the following words appear:

> Spate
> Protection
> And
> Decision
> Engineering

SPADE appears to be a vocal mode computer program (performed by Henny Spijker), a sort of Siri *avant la lettre*, communicating with the user of the computer (performed by the voice of Van Gasteren himself). 'Hello Louis, what can I do for you?' Spade asks. 'Give me the Amsterdam Ordnance Datum,' Van Gasteren's voice commands. The computer searches and, like a Google Map, zooms in from a cosmic perspective to the planet Earth and to Europe and the Netherlands. Via an interactive dialogue between computer and user, we are given access to various aspects related to water management, presented in short films, interviews, images, statistics and digitally animated maps and drawings. As a Japanese tour guide explains the significance of the AOD monument, the computer user asks why this measuring agreement was made in the Netherlands, and Spade explains that this was a necessity because water is everywhere in the Netherlands, even in the language. Another file then opens and examples of Dutch water idioms are provided: Whoever does not want 'to dike' will have to move (*Wie niet wil dijken moet wijken*); You either pump or drown *('t Is pompen of verzuipen*); Who cares for water, wards off water (*Wie water deert, die water weert*); Whoever wants to turn water into land, has a gold purse in his hand (*Die water wil maken tot land, staat met zijn goudbeurs in de hand*). The latter expression obviously relates to the enormous costs of the water works and the readiness of the otherwise rather sober (Calvinist) Dutch to spend huge sums of money to pay for dry land; it may also refer to the fact

that dry land can also be profitable and is a good investment. Every time Spade tells or shows something that the computer user wants to know more about we hear Van Gasteren's voice commanding 'Stop!' followed by a new question or remark. As a sort of hypertext,[13] each interaction with the computer leads to a new level of investigation, ranging from the spades in the water-absorbing sphagnum to the builders of dams and bridges; and from the water managers to artificial landscapes that look like Mondriaan paintings: the beauty of colourful tulip fields in straight lines, flat meadows, reflecting skies and endless horizons. 'But what is the drawback of all that kind of created beauty?' the computer user asks. 'One has to pump for eternity,' Spade answers while a computer animation demonstrates how this drainage system works, how mills pump up the water. 'It's a matter of level': groundwater, rainwater, river water, sea water; it all has to be pumped and transported continuously.

In another passage, the president of a water board, a so-called '*dijkgraaf*', explains how the water management is organized in decentralized water boards ('*waterschappen*') whose responsibility it is to regulate, control and maintain all the water management in a certain region. The water board has several tasks: to protect the land with sea- or river weirs; to manage the water level in lakes, ponds, canals, ditches and gulleys; to ensure the quality of surface and drinking water; to maintain routes and roads. The '*dijkgraaf*' explains that the water boards, which were formed in the Middle Ages, when population growth demanded better organization of land and water, were the first democratic organizational forms. The reclaiming of the land and protection from the water was primarily initiated by civilians ('*burgers*').[14] And collaboration on such an essential and common goal needed to be done between equal and free partners. Hence the sense of equality and freedom that has always been ingrained in the national character. It has also always been done on a small and local scale, characteristic of the Dutch way of thinking. The preference for negotiation and compromise, rather than fighting and overruling, is another characteristic that finds its roots in the organization of water management.[15] This is what the Dutch call the 'polder model'. It is a model of negotiation that often leads to endless procedures and long meetings before a compromise is reached and a decision can be taken. However, it is a model that allows democratic participation and sometimes leads to creative, though often costly, solutions (the storm surge barriers in the Oosterschelde Dam being a good example). To open here a 'hyperlink' to a more recent and slightly absurdist version of the polder model, it is interesting to mention the excellent television series, DUTCH HOPE (HOLLANDS HOOP, Dana Nechustan, 2014). When Fokke (Marcel Hensema), a burnt-out forensic psychiatrist inherits the farm of his estranged father, he moves with his wife and children to the flat green countryside. Instead of corn and potatoes, he finds fields of weeds and a

network of dark criminal activities. After a variety of hilarious misunderstandings, mishaps, murder and mayhem he earns the respect of Sasha, the leader of an eastern European criminal network. When Sasha asks how it feels to be the boss, Fokke answers: 'Well, if you don't mind, I'd like us to be equal partners. This is what we call "polder model." And you'll be surprised to see how it involves strikingly little murder.' It is a tongue-and-cheek reference to the Dutch preference for flat organization on all levels.

The formal structure of A MATTER OF LEVEL, of navigating an online archive and opening multiple screens, accessing ever more information, anticipates in a very playful way our own contemporary computer use and rapid access to information on the internet. Van Gasteren and the production team did a lot of research concerning all water matters, much of which could not be included in the film. Therefore, A MATTER OF LEVEL is accompanied by a publication that presents more background information on each level that is addressed in the film.[16] In the book *Een Zaak van Niveau* we find: old Roman texts about the Netherlands; archaeological and geological information about the peat soils; a plethora of water idioms; an historical overview of the water as enemy, listing the most notable flooding disasters; examples of the ways in which the water has been used as a friend (such as the cutting of dikes to relieve the city of Leiden from its Spanish rulers in 1574, led by William of Orange from a distance, and other historic moments when the water actively served as an ally to defend the country); the history, tasks, finances and organization of the water boards; all technological aspects related to water management; and ecological concerns related to the global rise of the sea level. In a text wittily named 'How are we doing, doctor?' Van Gasteren comments on the file 'Geo-Psychiatry' that is presented in the film: 'Is this meant ironically? Is the filmmaker venturing into medical territory? Is it really true that fifteen million people suffer from the Amsterdam Ordnance Datum-syndrome?'[17] In this text Van Gasteren elaborates on the psychic make-up of the Dutch that is so strongly related to the physiological conditions of the land. A list of the 54 political parties that participated in the elections of 1933 exemplifies the stubborn desire for self-regulation; other symptoms of the Dutch geo-mentality are expressed in the determined conquering of the seas and a general aversion for anything excessive or, as the saying goes, 'anything that exceeds grass level'. But all this allotment and protection behind the dikes also implies mental and emotional allotment and diking, which is a negative characteristic of the 'AOD-syndrome', Van Gasteren argues.[18]

Another file (or level) in the film that is elaborated upon in the book is dedicated to the arts.[19] An early representation of a water landscape is an anonymous painting of the St. Elisabeth flood of 1421, which inundated large parts of the land, swallowed up tens of villages, and created the aquatic forests of

the Biesbosch. In the seventeenth century, Dutch landscape paintings became famous for their characteristic cloudy skies, typical light reflections and meadows. Jacob van Ruisdael, Albert Cuyp, Paulus Potter and Meindert Hobbema are famous painters in this tradition. In the nineteenth century there was a second wave of famous landscape paintings, known as The Hague School (Haagse School, 1870-1900). Jan Hendrik Weissenbruch, Jacob Maris, Josef Israel and Anton Mauve are famous for their use of grey light, which reflects the interplay between the damp land and atmosphere. The Hague School's emphasis on overwhelming landscapes also influenced Vincent van Gogh, and later Piet Mondriaan, who started to transform the physical and psychic landscapes in even greater abstraction. Jan Dibbets is a contemporary photographer who continues to work in the tradition of Dutch landscape paintings and artistic translation of endless horizons and dispersed and filtered light. Dibbets provides us with another more contemporary 'hyperlink', because he also figures in DUTCH LIGHT (HOLLANDS LICHT, 2003) a documentary by Peter-Rim de Kroon, Maarten de Kroon and Gerrit Willems on the myths and (scientific) realities of this typical light reflected in so many artworks of the Low Lands. The starting point for the makers of DUTCH LIGHT is a remark by Joseph Beuys, who argued that the light in Holland lost its unique brightness as a result of land reclamation in the Zuider Zee in the 1950s. The makers of DUTCH LIGHT established a baseline on the dike linking the villages of Marken and Monnickendam, from which they observed the light at different times of the day and in different seasons. For a year they kept returning to the same spot on what is now a lake, the IJsselmeer, to record the landscape in different types of light.[20] For the duration of the film we see the same piece of landscape changing under different seasons, under different circumstances of light. And in between these returning points art historians, scientists, climatologists and artists discuss the power of light and technologies for observing and capturing the qualities of the elements in art, including their own camera lenses, 35 mm film and 4K digital restoration.

One other aspect about the water management in A MATTER OF LEVEL that I want to mention is the export of technological know-how. In the film we see the Dutch building manager of a project in the Norwegian Ekofisk oil fields explaining the gigantic scale of the concrete rings that were sunk into the sea to protect the oil tanks from the crushing ice. The voice mode Spade presents other related files: the building of a bridge in Bahrain and the dredging of sand in Nigeria by Ballast Nedam and Boskalis Dredging. The book documents other examples, such as the reclaiming of the biggest lake of Japan, Hachiro-gata near Akita, preparing it for agriculture.[21] In a more recent film, Van Gasteren went with a crew and some actors to Japan to investigate the legacies of Dutch water engineers who, in the nineteenth century, introduced

the Tokyo Ordnance Datum (*Tokyo Peil*), an analogue to the AOD. IN JAPANESE RAPIDS (IN EEN JAPANSE STROOMVERSNELLING, 2002) mixes the formal elements of fiction and non-fiction in different ways from the hypertextual organization of the elements in A MATTER OF LEVEL. Here, archival photos, maps, letters and other documents are combined with interviews, a performance of Schubert's 'Fischerweise' ('Fishermen song') by Japanese musicians, and the (rehearsals of) dramatized scenes that evoke the past. In Japan, Van Gasteren and his crew follow the traces of hydraulic engineers such as Cornelis Van Doorn, Johannis de Rijke, Antoine Rouwenhorst Mulder and George Arnold Escher (father of the artist/graphic designer Maurits Cornelis Escher). Between 1872 and 1903 these 'watermen' were invited by the Japanese Meiji government for their knowledge of water management and their advice on reclaiming land, developing ports and improving rivers throughout the island. In the first sequences of the film we see an old man, helped by an assistant, putting water from a lake into a bottle and leaving in a car. Later on, in IN JAPANESE RAPIDS it will become clear that this man is Ushie Hashimoto, the president of the Asaka waterworks, which today provide drinking water for 320,000 people and 10,000 hectares of fertile ground for rice planting, based on the plans and advice of Van Doorn. Cornelis van Doorn was the first engineer who arrived in Japan in 1873.

A moment later we see the actors Ramón Gieling and Wilbert Gieske travelling by train in Japan, visiting locations that still bear the marks and legacies of these men. They arrive at the Kitakami Canal museum, and encounter the name of Van Doorn as the engineer who made the canal and its sluice. At first, Gieling and Gieske seem to perform the roles of investigators in a documentary, but slowly we find out that they are preparing for a role in a fiction film about Escher and De Rijke. Wilbert Gieske plays the role of George Arnold Escher, who was in Japan between 1873 and 1878. Ramón Gieling impersonates Johannis de Rijke, who stayed for 30 years in Japan, between 1873 and 1903. During the course of the film, while they discover more about the past of their historic characters, we see the actors prepare for their roles, reading the script and putting on their make-up and costumes. It is only at the end that we see some scenes of the film-in-the-film, entitled 'Far Away' ('*Ver Weg*') in which we see Escher and De Rijke in Japan, toasting their friendship with sake, and then again many years later when they meet again back in the Netherlands. In these final scenes of the film-in-the-film, it appears that after 30 years, De Rijke was rather disappointed and no longer felt appreciated in Japan. In IN JAPANESE RAPIDS, the theme of (the impossibility of) grasping the distance of geographical, cultural and historical distance is captured in the self-reflexive formal presentation of the fictional parts that are mixed with all the non-fiction elements. At the end of the film, a Japanese delegation is in Amsterdam in 1992 to visit the grave of De Rijke, paying tribute to his legacy, a recognition

he did not feel during his lifetime. In 1999, another delegation visits the grave of Van Doorn. It is raining cats and dogs when Hashimoto, who we saw at the beginning of the film, takes the bottle with water from the Inawashiro Lake and pours it over the gravestone.

The pouring of water over a gravestone is not only a symbolic gesture to honour the waterworks themselves but also brings in a final aspect about water that repeats in Van Gasteren's works and that is our more metaphysical relationship to this liquid element. According to Van Gasteren:

> We start life in amniotic fluids, we exit the "mother ship" and it pours with rain, the wind whistles; we learn to swim; we are continuously preoccupied changing the water flows and keeping it out of the land, concretely or as merchants [and tax payers] to provide money to make this happen; we are surrounded by water on a daily basis, visibly, all our life. Autumn comes, leaves fall in the canals. We die and our coffin ends up in the ground water. End of cycle.[22]

Colleague filmmaker Hans Keller proposed 'the cloudy existence of Louis van Gasteren' as the title for the documentary portrait that he made on the occasion of Van Gasteren's 85th birthday. Whereas the title certainly contains a symbolic connotation (related to issues developed in the following chapters), clouds contain humidity from the earth that rises to the sky and descends again as rain; clouds come in many shapes and variations; they can be hit by lightning; H2O is an essential element from birth to grave.[23] The work of Louis van Gasteren is permeated with the power of water, its life force and dangers, its management, and its multiple significations in connection with the Dutch soil and soul.[24]

TECHNOLOGIES OF TRANSPORTATION: ROADS, PHONES AND GLOBE-CONSCIOUS

One day in 2014, while driving with the filmmaker and his wife through Amsterdam, we were detoured because of works on the tram rails in the city centre. The works had been going on for months and still did not look finished. 'Sixty years ago this work was done in one night,' Van Gasteren pointed out, 'I filmed it,' referring to his film RAILPLAN 68 (1954). Van Gasteren knew about the replacement of the tram rails at the Leidseplein and went to the Ministry of Culture and the Amsterdam City Council to request financing for a short documentary. He received 15,000 guilders (about 7,500 euros), put in about 5,000 euros from his own pocket, and made the film as the first independent production of his company, Spectrum Film. The result is a powerful

short documentary, almost completely without dialogue, in which the images speak for themselves in a Soviet-revolution style of montage. The beginning of the film presents us with an overall impression of the Amsterdam city traffic, of pedestrians, bikes, cars and trams crisscrossing the streets in a way that is still very much the same today.[25] Then, a few men arrive and in full traffic they roll out a map and start measuring the railways using a rod, a string, nails and chalk. From their measurements in the street we move to the drawing plans of the city councillors; and from the cost estimate by the German Georgmarienhütte steel factory the images dissolve to the actual factory in Osnabruck. Red-hot steel is bent and moulded into slender rails; factory workers operate the machines, sometimes jumping over the scorching steel pipes. The material is loaded onto a train and a graphic match between the wheels of a train and the wheel of an organ brings us back to Amsterdam where the material arrives on a boat via the canals. The road is prepared for the replacement of its rails, again in full traffic. And then it is night. For seven hours there are few cars and no trams. The workers toil all night, as the clock shows us regularly that time is ticking away. The rails are put into place by the collective physical force of the labourers, while the foreman sings in regular repetitive screams 'Hey, all together!' ('*Hé, gelijk dan!*'). At the other end of the city the first tram starts to run, seemingly unknowing of the work going on at the Leidseplein. Suspense until the last moment: will the work will be done in time?

RAILPLAN 68 pays tribute to the technical skills and physical labour of the worker in an Eisensteinian montage style that emphasizes the workers in connection with the machines. In addition to his Russian colleague filmmakers, Van Gasteren was also inspired by his communist mother, who collected work songs in the Spanish countryside, then performed and preserved them.[26] Van Gasteren indicated that he considered it important not to depict the labour as too mechanical; he wanted to introduce a human touch:

> There are small details in the film, such as this man who is rolling a cigarette and puts his box of tobacco on a vibrating compressor-tank. While he is sealing his cigarette, the box rolls off the tank and drops down.
> I think that is a very human gesture in the midst of the violence of the Atlas compressors. I restaged that event, after I saw it happen. Just like the worker jumping over a red-hot pipe of steel. You see it once, and then you think: I should make this happen again tomorrow [...]. Actually, this is forbidden, but you want to have the image to convey the actual danger that is implied in these jobs. It's quite something, those burning patches of steel![27]

The (re)staging of certain scenes in order to express something of the actual experience that is being filmed is a technique that Van Gasteren employs with all sorts of variations throughout his oeuvre. The human touch is another important and recurring element. Despite his fascination for technology and technological skills, ultimately there is always an interest for Van Gasteren in what this means for a human being. As an artist and filmmaker he tries to gain an understanding of human existence: 'a place, a human being occupying it, his actions, and the consequences for himself and his environment.'[28] What happened to the person that has built this house and lived there, to the person that operated this machine, worked all day and night to get this tram driving over the rails in time? It is a commitment that stretches way beyond the production process of a film. So, when one of the workers passes away months after the film was finished, Van Gasteren went to the funeral. And, to his dismay, he discovered that the widows of workers remain penniless. Film is never independent of the small gestures of humanity, nor disconnected from the larger questions of social and political order. RAILPLAN 68 was also the first film Van Gasteren edited himself.[29] In the Netherlands the film was barely noticed, overshadowed by the successes of the classical Dutch documentary school films of Van der Horst and Haanstra. In the Soviet Union, a thousand copies of RAILPLAN 68 were distributed.

Van Gasteren developed a series of projects related to modern means of transportation that have influenced the twentieth century and that have an enduring effect in the twenty-first century. While RAILPLAN 68 was an ode to the factory workers and street labourers, in the 1960s he worked on a series of sculptures and paintings that he labelled 'Bolbewust,' which literally means 'Globe-Conscious.' Clearly, this idea resonates with the concept of 'Global Consciousness' that Marshall McLuhan developed in the same period. Van Gasteren and McLuhan met in 1965 when Van Gasteren spent six months as a guest professor at the Carpenter Center of Harvard University, and during the 1967 Universal Exposition in Montreal they spent four days together experimenting with the notion of progress. In *Understanding Media* McLuhan proposed his ideas on modern technology, which he interchangeably called media, as the 'extension of man.'[30] He coins the phrase 'the medium is the message' meaning that a medium affects society not through content but through the characteristics of the medium itself. Modern media technologies will transform the whole earth into a 'global village,' McLuhan argued in the 1960s, long before the introduction of the personal computer and the explosive growth of media technologies thereafter. McLuhan's idea of a 'global consciousness' was also inspired by space travel, and the first pictures of the earth seen from space, looking like a 'blue marble.'[31] This image, which pointed at the fragility of our planet, inspired the counter-culture magazine *Whole*

Earth Catalogue (WEC) that between 1968 and 1972 presented a global culture as though it were a 'Google in paperback form.'[32] So in the 1960s and 1970s global consciousness was 'in the air' and would be connected to many other counter-cultural expressions that I will elaborate on further in Chapter 4.

But there are always visionary thinkers and creators who see the dawn a few hours before everybody else. McLuhan certainly was one of those visionary thinkers who developed his ideas earlier and more prophetically than anyone before. And so was Van Gasteren who, in the early 1960s, on the other side of the globe, developed projects and ideas resonating with McLuhan's global consciousness. The art projects AUTOSCULPTURE IN TELECREATION (AUTOSCULPTUUR IN TELECREATIE, 1964) and the series, GLOBE CONSCIOUS MATERIAL PAINTINGS (BOLBEWUSTE MATERIESCHILDERIJEN, 1965-1968), must be mentioned in tandem with McLuhan's ideas. On 27 November 1964, Louis van Gasteren launched his plan for AUTOSCULPTURE IN TELECREATION at the Stedelijk Museum in Amsterdam. The idea was to create a monument to the modern age by artistically re-using wrecked cars. He envisioned mounting the wrecks like gigantic sculptures in city squares in such a way that they would match the scale of the surrounding buildings. At night the gigantic sculptures would generate light from the cars' original lighting: headlights, tail lights, indicators, brake lights and interior lights could be switched on and off from different places on earth. He imagined connecting the electrical power of the lighting points to a telephone connection within the sculpture, with every lighting point matched with a different extension on the telephone line. With one phone call any individual lighting point could be activated. From Chicago an individual could turn on the headlights of a crushed fire truck on the 14th floor of a building in Osaka.[33] The plan was also displayed at Amsterdam's Museum Fodor in 1968, and in 1970 Van Gasteren developed it into a prototype for display in the Dutch pavilion of the World Exhibition in Osaka (Japan). The building, consisting of 40 metres of wrecked cars, covering interior public spaces (cinemas, sport facilities, restaurants, and a theatre), was never built.[34] While AUTOSCULPTURE IN TELECREATION remained a maquette and drawings, its main idea, that 'because of the unlimited possibilities of contemporary telecommunication, thirteen million Dutch and three billion world citizens can telecreate' was quite visionary.[35]

Between 1965 and 1968 Van Gasteren transformed his Globe-Conscious concept into a series of paintings that derive from the idea that 'whenever I am driving a car I'm extremely aware that the road stretches along the globe like a ribbon; I just feel that with my four wheels under me I'm essentially rolling along a geoid.'[36] Van Gasteren considered the entire globe as art and started to make paintings from materials and objects from roads and streets 'upon which we, as contributors to modern traffic, scurry along, and whose beauty

often escapes us.'[37] Street bricks, manhole covers, asphalt thumbtacks, tram railways, objects sunken in tar are all lifted from their functional context and become aesthetic objects in a series of twenty-four paintings. The paintings were originally exhibited in the Stedelijk Museum in 1966 during a group exhibition of League New Images (Liga Nieuwe Beelden) and a year later in the Van Abbe Museum in Eindhoven. In 1968 they were part of a solo exhibition in Museum Fodor.[38] At the opening of this solo exhibition, footage of which is included in Van Gasteren's autobiographic film NEMA AVIONA ZA ZAGREB (2012), Van Gasteren was interviewed for the newspaper *De Volkskrant* where he explained his idea of globe-conscious art:

> Defining art has always been a shady business to me. I've always wanted to escape those definitions and formulations. Formulas and categories cannot hold because new media constantly emerge, and they constantly change the inter-relations between things and people. [...] we passed our youth without any television; we had a radio with coils. Today youngsters are going through a gigantic electronic development: that total participation! Experiencing the news has become a direct and immediate affair. We contain the globe in our pocket [...] McLuhan does nothing more but point out that since man flies in a DC-8 around the world, the relationship to his little field has changed.[39]

Besides emphasizing the connection between Van Gasteren and McLuhan, the reference to his intellectual soulmate also relates to the fact that McLuhan opened the exhibition in Fodor via an Early Bird satellite connection from Toronto. As can be seen in NEMA AVIONA ZA ZAGREB, visitors to the exhibition's opening were waiting in front of a television screen indicating 'We are waiting for image-connection with Canada.' And then McLuhan appears in an elevator on the TV screen, announcing:

> Painting now moves from representation to a direct encounter with the environment. This involves a certain amount of violence and the artist thereby helps us to new discoveries of identity. When this new electronic environment goes around the old mechanical one, the old mechanical environment, the roads, the car, the auto, these forms become art forms. Just as when satellites go around the planet, the planet itself becomes an art form; in fact, [it] ceases to be nature in the old sense at all. This kind of revolution is reflected now in painting, too. The direct encounter with the environment as art form is a formal violence that helps us to discover a sense of identity, which we would otherwise not have a chance of doing. I now declare this exhibition open and I move on to another level.[40]

With these words McLuhan disappears from the screen and the opening party in Amsterdam gets underway. McLuhan spoke from a previously recorded film (shot in an elevator in Montreal during the 1967 World Expo when Van Gasteren spent some time with McLuhan), but the suggestion of a live recording via satellite connection (reinforced by a non-functioning transponder just outside the museum) was 'early bird' indeed.[41]

The affinity between McLuhan and Van Gasteren is also implicitly present in the two films that Van Gasteren made about the introduction of the telephone in the Netherlands, WARFFUM 22 05 62 (1962) and THERE IS A PHONE CALL FOR YOU! (1964). These films were commissioned by the national Dutch Postal Services, Telegraphy and Telephony Company (PTT) on the occasion of the completion of the fully automated telephone network in the Netherlands. Even though these films were commissioned, WARFFUM and THERE IS A PHONE CALL FOR YOU! are more than promotional films. They match the wider 'McLuhanesque' globe-conscious techno-philosophy that Van Gasteren embraced in the early 1960s. So when McLuhan transformed his idea of 'the medium is the message' playfully into 'the medium is the massage,' those ideas were already resonating underneath Van Gasteren's telephone films. McLuhan argues:

> All media work us over completely. They are so pervasive in their personal, political, economic, aesthetic, psychological, moral, ethical, and social consequences that they leave no part of us untouched, unaffected, unaltered. The medium is the massage. Any understanding of social and cultural change is impossible without knowledge of the way media work as environments. All media are extensions of some human faculty – psychic or physical.[42]

In his telephone films, Van Gasteren shows us how that particular medium has extended and altered us.

On 22 May 1962, Dutch television broadcast WARFFUM 22 05 62. The occasion for the film was the opening of the last telephone exchange in Warffum, in the north of the Netherlands. The opening, performed by the general director of the PTT, G.H. Bast, would link every national phone connection automatically to any other subscriber in the Netherlands. In addition to this moment of the opening of the Warffum telephone exchange and the festivities around it, the rest of the short film is a series of staged scenes (performed by non-actors) that demonstrate in a mosaic way how the telephone has changed the way we can communicate with one another. The film starts with the remark in voice-over that the telephone has become a medium that has touched every aspect of life and that we have become so accustomed to it that we barely notice it, let alone think about how it works and what it means. Then we see how a

mechanic receives a cup of coffee in the cantine of the telephone exchange in Utrecht, not having anything to do yet. A little later, he is called by the local exchange in Maastricht with a malfunction: 'unilateral speech' between Maastricht, number 13079 and Bilthoven, number 2099. While he is solving the problem, searching in the endless but clearly labelled and numbered rows of automated switchboards, the film opens to multiple parallel places and events in the entire country: in Tiel a baby is born; in Amsterdam a manager leaves his office; in Alkmaar cheese sellers have run out of a particular type of cheese; in Rotterdam a reporter is sent to Warffum; in Harlingen a mother tells the milkman that soon she will be able to speak to her daughter in Eindhoven, and so on. The mechanic finds the problem in B-group, sections 7-12. And we see then how, in the same group, in neighbouring sections, automated connections are made: a man is called at work and flies off to the hospital to find his newly born son, a manager makes a call in a telephone booth in a street in Amsterdam, a farmer receives an order for cheese, the reporter in Warffum makes a phone call to his newspaper, using the new phone that connects him without the interference of an operator. He dictates the text we have heard at the beginning of the film to a colleague in Rotterdam; his words are recorded on an audiocassette. In a concise and rather sketchy way, WARFFUM acknowledges the technology and human operators behind the telephone network, and emphasizes how this has affected the possibilities of communication at distance, in emergencies, for business and for everyday situations. The phone has extended our voice and our ears, but also expanded our senses of distance and proximity. Already in the 1960s we did not consider this particularly unusual but in a very light and succinct way Van Gasteren puts the sense of wonder and of the human touch back into the technology.

THERE IS A PHONE CALL FOR YOU! presents the same topic in a documentary mode. The film is an extremely well researched and well documented media-archaeological study of the technological inventions and developments of the telephone. The film presents the medium of the telephone as an environment but also in a larger technological environment. The general idea of media archaeology is that the past is excavated in order to understand the present and the future. Or, to speak with McLuhan's oft-quoted metaphor: to approach the present through a rearview mirror perspective. McLuhan's emphasis on temporal connections and translations between media (such as the dynamic relations and transformations between orality, the printing revolution and new orality in television in *The Gutenberg Galaxy*) have been influential for developing a media archaeological perspective.[43] What is interesting for our purposes here is that Van Gasteren takes the moment in the present, the completion of the fully automatic phone network in the Netherlands in 1962, as a moment to look into the rearview mirror of that particular medium and also

to look at its possible futures. Media-archaeologists know that 'media cultures are sedimented and layered, a fold of time and materiality where the past might be suddenly discovered anew, and the new technologies grow obsolete increasingly fast.'[44] What is interesting in THERE IS A PHONE CALL FOR YOU! is that Van Gasteren actually puts the history of the telephone into a three-fold and dynamic perspective, or dynamic environments. Firstly, the telephone is presented in connection to many other changing technologies and communication media. Secondly, he explains the technology behind the medium in an extremely well-informed and clear way. And thirdly, he always looks at the human factor, the human element in any invention and use of the telephone. Regarding the first point, THERE IS A PHONE CALL FOR YOU! starts with the images of a train, ships, bikes and other means of transportation before we move to 1876 and Alexander Graham Bell's famous first words transmitted by telephone 'Watson, could you please come here.' At the same time, we also see horses with carriages, a steam ship, and a nineteenth-century train, which represent the technological transportation environment of that period when Bell made his invention to transmit the spoken word. Then we move to Amsterdam in 1881 when 49 telephone sets were centreed around an exchange at Dam Square. At regular intervals throughout the film the changes in technologies of transportation will return and show how the developments of the telephone system are related to the evolution of the car, the plane, the electric train, the motorways and, eventually, also space travel. And so technical developments are never presented in isolation, but always in a dynamic context of the modern technological world and its other means of transportation.

With regard to the second point, the technology itself is not only illustrated with interesting footage from Polygon news archives and beautiful photographs on glass plates from the archive of Jacob Olie at the Amsterdam city archive, but it is also technically explained via clear commentary in a voice-over text read by Wim Povel and illustrated with simple and schematic technical drawings.[45] These drawings reveal the increasing complexity of the technology: we move from telephone sets, each with its own battery and copper wires to transmit the vocal messages high above the ground, and from cranks to hooks to make the connection with the operators in the telephone exchanges. We understand via schematic drawings that transmission above the ground quickly became too complicated and we see in film footage how ditches were dug, this time not to drain water but to hide transmission cables under the ground. The first cable through the North Sea makes connection with England. The central exchange is decentralized in sub-exchanges. New inventions follow one another, always by necessity because an old system could simply no longer fulfil the task or handle the growth. Signal reinforcement is necessary when the cables disappear into the ground, networks become increas-

ingly complex; telephone operators cannot handle all the calls, exchanges are overfull. In 1932, the PTT decided to become the first company in the world to start the transformation of the national networks into automated systems that no longer required an operator. The Second World War and the Water Disaster in the south of the Netherlands in 1953 put the development of automated systems seriously on hold. In news reel footage we see how, after the war, everything was destroyed and had to be rebuilt. In 1953, thousands of phone connections were washed away along with so many other losses. And then we are in Warffum in 1962, the opening of the automated network, when 1.3 million people are subscribed to the national telephone network and can find one another by using phone books that are transcribed by punch printing and photography. There are also glimpses of the future; telecommunication via satellite is already possible, but soon every point on the planet will be connected to every other point and there is a phone in a car. Technology will move on, just like we human beings move on.

Finally, however, THERE IS A PHONE CALL FOR YOU! makes clear that all these inventions and all these technologies do not change for their own internal reasons. There are always people who use them and who are important partners in the step by step evolution of any technology. In a 1964 article called 'The Telephone and the Undertaker', his review of THERE IS A PHONE CALL FOR YOU!, Jan Blokker emphasized this human dimension by highlighting the Strowger switch (the word '*hefdraaikiezer*' in Dutch does not do justice to the name) that in the film is pointed out in voice-over commentary. Almon B. Strowger, an undertaker in Kansas City, missed many clients because the local operator switched his calls to his competitor.[46] Out of anger and frustration he invented the turn switch that still influences how we use our phones today. Sadly, his invention fell into the hands of some clever types and Strowger himself died in poverty. But this human dimension of the medium is what makes this film about the telephone an early example of Van Gasteren's eye for an integral, multilayered perspective on technology and on the world that we also encounter in many other films. Besides the human dimensions, political circumstances are also an influence. The automatization of the telephone was hugely delayed by the Second World War, and the much wider and particularly traumatic implications of the war have had a very prominent place in the life and work of Louis van Gasteren. The complicated knots of war and trauma are what the next chapter will try to disentangle.

CHAPTER 3

War and Traumas of the Past

If, for the Dutch, water is the ever present and relentless force of nature to reckon with, the Second World War and its aftermath is the historical event that continues to reverberate, both in individual psyches as well as in the collective consciousness. Like in other parts of Europe, this episode in world history left an immense scar on the conception of humanity and its relation to the world. As the Dutch poet Lucebert expressed powerfully: 'In these times, what one used to call beauty / beauty has burned its face.'[1] The unimaginable atrocities and cruelties of the Nazi regime entailed a profound break with a fundamental trust in the idea of the progress of modern man. If rational and systematic use of technology and meticulously efficient administration systems could be used to decimate entire population groups, how can there ever be any hope for humankind again? Made twenty years after the end of the war, Jean-Luc Godard's science fiction alias film noir ALPHAVILLE (1965) is perhaps still one of the saddest expressions of this dystopian despair, reflecting the cruelty of modern technology and the extinction of all that is human. The film is set in some distant future, but in fact the whole setting is modern Paris of the 1960s where people are still deeply and traumatically marked by the effects of the Second World War and which has turned into a 'capital of pain.'[2]

There is no beginning and no end in describing the countless and complexly entangled events and effects of this war. Making sense of the rubble and ruins that left large parts of the world shattered and torn 70 years after the fact is even more difficult. Film scholar Thomas Elsaesser and historian Frank van Vree, among others, have shown how history is dynamically related to memory, often mediated by literature, film images and other audio-visual monuments that reflect and co-construct the evolving ways in which we are in touch with the past.[3] Immediately after the war there was a need to clear the debris, to rebuild and move on, leaving the war behind. Based on Harry

Mulisch's novel, the film THE ASSAULT (DE AANSLAG, Fons Rademakers, 1986) reflects the gradual release of memories in the story of a young boy who loses his parents and brother during the war. The fictional story is contextualized by changes in society at large that reflect changes in public recollection of the war. In THE ASSAULT each new decade is introduced with news reels or documentary footage. The 1960s are announced with footage from Van Gasteren's BECAUSE MY BIKE STOOD THERE, a film that translates the rebellious spirit of the post-war generation.[4] THE ASSAULT can be considered as a film that reflects a shift in commemorative practices in the Netherlands, which experienced a turning point in the 1980s, as is evident from the history of the Dutch transit camp Westerbork. From this camp more than 100,000 Jewish citizens were deported to concentration camps in Germany and Poland, mostly the extermination camps Auschwitz-Birkenau and Sobibor (a few transports went to Bergen-Belsen or Theresienstad). After the war it had several other designations before, in the early 1970s, all 120 barracks were destroyed or sold.[5] It was only in 1983 that Westerbork was turned into a memory centre and an important site of remembrance. In the meantime, historical studies, television programmes and films had also done a lot of work in weaving new 'textures of memory.'[6]

In Germany, too, it took some generations before the war was an issue that could be discussed.[7] First the material traces of the war were covered. Mountains of rubble, so-called '*Trümmerbergen*' in Berlin as well as in other German cities, covered up the debris of the destroyed buildings.[8] They have now been turned into parks and public spaces. After the wall fell in 1989, Louis van Gasteren, supported by, among others, the architect Wilhelm Holzbauer, proposed a project in the city of Berlin to memorize the material and immaterial stories hidden beneath those hills. The project, which he had already begun developing in 1980, was named MONTE KLAMOTT (which means 'frazzle mountain'), after the nickname of one of the *Trümmerbergen*.[9] In the MONTE KLAMOTT project Van Gasteren proposed to open a slice of the mountain to show the stories it hides, as well as to pay homage to the so-called *Trümmerfrauen*, the women who after the war separated the reusable materials from useless rubble and rubbish.[10] The project was never realized, but MONTE KLAMOTT can be considered as an allegorical image for an important aspect of Van Gasteren's work and life, in which the acknowledgement of the rubbish and wounds of the war has played an important role.

This chapter deals with the films of Van Gasteren that explicitly relate to the existential traumas of the chaos and unimaginable violence of the experience of war. Born in 1922, Louis van Gasteren was a young man during the Nazi occupation of the Netherlands. Events during that war would mark his life and work. In 1969 he made a documentary film, NOW DO YOU GET IT, WHY

I AM CRYING? (BEGRIJPT U NU WAAROM IK HUIL?), which played an important role in the acknowledgement and treatment of the war traumas of survivors of the concentration camps. The war is also an important issue in three documentary portraits that have been made about Louis van Gasteren. In these documentaries, Van Gasteren talks about his own haunting memories of the war, as will be discussed in the second section of this chapter. Finally, the continuing legacies of the Second World War return in THE PRICE OF SURVIVAL (DE PRIJS VAN OVERLEVEN, 2003) and ROERMOND'S SORROW (HET VERDRIET VAN ROERMOND, 2006).

MEDIATED MEMORIES OF THE SECOND WORLD WAR

During the First World War the Netherlands managed to remain neutral and escape the atrocities that hit so many other countries between 1914 and 1918. While many had hoped that the Netherlands could maintain this neutrality again when Hitler started to invade neighbouring countries in 1939, this idea came to an abrupt end when the Nazis marched into Belgium, Luxembourg and the Netherlands on 10 May 1940. After the aerial bombardment of the historic city centre of Rotterdam four days later and threats of a similar fate for other Dutch cities, the government capitulated and the Netherlands became occupied territory for the next five years, until 5 May 1945 when the country was liberated by American and Canadian Allied forces. Countless historical accounts, books, documentaries and films are still calibrating the historical complexity of this turning point in world history. In his book, *In de Schaduw van Auschwitz,* Frank van Vree discusses how literature, film and monuments are continuously adding new perspectives and layers to the past, making the Second World War a form of 'living history' that is still open ended. In the Netherlands alone there are over two thousand monuments, countless drawings and paintings, dozens of theatre plays and feature films, a thousand documentaries, over 150 children's books, 700 novels and countless poems. Photo archives, history books and articles on this topic make up entire libraries and all this is still growing.[11] To situate Van Gasteren's work in relation to the Second World War, I will first sketch the particular Dutch situation in a few mediated forms of memory, weaving, so to speak, some patches of memory tissue that give an indication of the complicated patterns in the quilt of this period of history.

After the war the spirit for rebuilding the country was strong. As Van Vree has shown, the commemoration of the war consolidated during this first period into a rather unified national discourse of heroes and perpetrators, both exemplified and co-created by the long running television series THE OCCUPA-

TION (DE BEZETTING, 1960-1965).[12] Over the course of 21 episodes, historian Loe de Jong appeared on the (only) national television screen to memorialize the war in the Netherlands. Based on personal recollections, extended historical research and many photos, documents and film footage, the series wove a strong texture of national history. At the beginning of the war, De Jong, who was Jewish, fled to England where Queen Wilhelmina and the Dutch government resided in exile. In England, De Jong became the voice of Radio Orange (*Radio Oranje*), sending messages about the allied forces and other important news about the war to his compatriots on the other side of the North Sea. Needless to say, possessing a radio and listening to Radio Orange was illegal and dangerous. Nonetheless, a very high percentage of the Dutch secretly listened to De Jong's voice as the voice of hope and consolation. The television series and his historical magnum opus, *Het Koninkrijk der Nederlanden in de Tweede Wereldoorlog*, subsequently turned De Jong into an absolute authority on the war.[13] In the first episode of THE OCCUPATION, De Jong concludes that at the same time as the Germans invaded the country, resistance emerged. The moral clarity of the difference between 'good' ('Us' the Dutch, the resistance) versus 'bad' ('Them' the Nazis, the enemy) is quite prominently emphasized throughout the television series. Also, the first serious Dutch feature film about the war, THE SILENT RAID (DE OVERVAL, Paul Rotha, 1962), reflects these specific 'black and white' colourations (between good versus bad) of the fabric of memory. This film recounts a raid on a prison in Leeuwarden by the local resistance, which happened without any bloodshed. The events in the film are based on historical facts researched by Loe de Jong who also wrote the script. Characters are more like symbolic figures representing the resistance versus the Nazis. THE SILENT RAID was a huge popular success, reflecting the national spirit of a unified view of the past of heroes versus perpetrators.[14]

This view, however, had already been undermined in literature that was slowly finding its way into a wider collective consciousness. For instance, in *De tranen der Acacia's* (1949), novelist Willem Frederik Hermans painted a gloomy picture of life in Amsterdam under the occupation. Hermans' war characters are not easily classifiable as good or bad and reality is unfathomable. His book *The Darkroom of Damocles* (*De Donkere Kamer van Damokles*, 1958), is a classic of Dutch literature. It was made into a film with the title THE SPITTING IMAGE (ALS TWEE DRUPPELS WATER, Fons Rademakers, 1963) whose main character is equally ambiguous, moving in a completely chaotic, alienating and Kafkaesque war situation. I will return to this film in the next section because it is a film that is indicative of Van Gasteren's own war experiences. Here I raise AS TWO DROPS OF WATER to point out how a more complex and variegated perspective on the war emerged, though still on a limited scale.[15] Experiences of the war from a Jewish perspective and from the perspective of camp survivors

were addressed in rather limited or abstract ways in Loe de Jong's television series THE OCCUPATION and in public discourse. As Van Vree has observed, only a few minutes are devoted to Westerbork and there is only one camp survivor witness, whose viewpoint is expressed through a poem and a drawing, without a face.[16] This does not mean the Jewish perspective was not known. It was present in writing, and the first publications appeared soon after the war. In the Dutch context, the diary of Anne Frank, written in the secret hiding place of the Frank family during the war was published in 1947 by her father Otto Frank, the sole survivor of the family.[17] Among many other important books, Marga Minco's *Bitter Herbs* (*Het Bittere Kruid*, 1957), recounting the experience of the war through the eyes of a young Jewish girl, became an influential reference.[18] Internationally, the Eichmann tribunal that started in 1961 also turned attention to the deportation of the Jews. And in the Netherlands, an impressive historical research by Jacques Presser, *The Destruction of the Dutch Jews* (*Ondergang*, 1965), presented troubling facts about the deportation of huge numbers of Jews in the Netherlands that undermined the dominant discourse of the collective, unified and righteous resistance of the Dutch.

By the mid-1960s, the experience of the gruesome war years, full of fear, hiding, resistance, collaboration and betrayal, found cultural expression in various novels and historical publications and later in cinematic forms.[19] But the deep and lasting traumatic psychological effects of the war, especially of survivors who returned from the concentration camps, were largely unacknowledged, repressed and locked up in troubling shreds and blotches of memory that were too dark to bring into the light; too unimaginable to share or make comprehensible for anyone who had not been there to experience the degradation of humanity, feeling 'the shame of being human.'[20] At the same time, these traumatic experiences were too radical to stay repressed and locked up forever. For many people, the impact of these repressed experiences coloured all other aspects of life. Van Gasteren's film NOW DO YOU GET IT, WHY I AM CRYING? (1969) played an important role in bringing the consequences of the haunting memories of the war to the attention of both the government and the larger public.

RETURN OF THE REPRESSED: FROM KZ-SYNDROME TO PTSD

The initial idea to address the problem of the deep sorrow related to traumatic war memories came in the context of a film project with the title NEMA AVIONA ZA ZAGREB that Van Gasteren started to work on in the 1960s and which for a long time remained an unrealized project. It was not until 2012, on the occasion of his 90th birthday, that NEMA AVIONA ZA ZAGREB was completed.[21] For

fifty years this autobiographical film project was always in the background of Van Gasteren's work. He developed many ideas and shot numerous scenes, many of which never ended up in the final film. Some were transformed into other films, such as the original recordings for NOW DO YOU GET IT WHY, I AM CRYING? Van Gasteren explains:

> Initially it was my intention to include a few scenes in ZAGREB. This feature film would be composed of sequences dealing with death, life and birth; and enfolded inside that life is hidden a kernel of deep human distress and immense grief caused by traumatic events. I am myself traumatized by that war, and I have to get out of it. Therefore, it was quite logical that I found out about the KZ-syndrome. And so I went to Bastiaans, because he had all the facilities to deal with this problem.[22]

Jan Bastiaans was a professor of psychiatry at the University of Leiden who after the war specialized in the treatment of concentration camp survivors who suffered from the so-called KZ-syndrome (after the German word for concentration camp, 'Konzentrationslager'). In the early 1960s Bastiaans started to experiment with Pentothal and LSD in his therapeutic sessions, which, at the time, was not uncommon in psychiatric clinics.[23] After 1966, when LSD became an illegal substance, Bastiaans retained the right to continue his treatment using Pentothal and LSD to unblock repressed memories. Van Gasteren found Joop Telling, a concentration camp survivor who was prepared to be filmed undergoing LSD treatment by Bastiaans. Van Gasteren filmed the therapeutic LSD-session and immediately realized that he could not just use five minutes for his own film but that this should be a film in its own right. NOW DO YOU GET IT, WHY I AM CRYING? was first shown in purely academic and medical contexts. In 1969 the film premiered as a closed event in a large theatre in The Hague in the presence of Queen Juliana and other government officials. Discussions about the desirability of a public release of the film started to appear in the press. Though early on there was a general fear that the effects of the film would be too devastating for a public presentation, gradually recognition of the lasting effects of the war and the need to gain more attention for victims of the war gained ground in public debates. This recognition and a deeper awareness of the lasting effects of the war that remained undiscussed in the initial post-war decades, was precisely the common goal that Van Gasteren, Bastiaans and Telling shared in the project of this film. They made a second version of the film that was more suitable for a wider audience.[24]

NOW DO YOU GET IT, WHY I AM CRYING? is shot in a sombre way. In the prologue of the film we hear Joop Telling's voice remembering Bergen-Belsen: 'eat or to be eaten, it was the law of the jungle.' Then professor Bastiaans appears

behind his desk, explaining the physical and psychological problems of camp survivors, asking if it could be possible for those who returned from hell to ever forget those experiences. A few gruesome and horrific photographs of the concentration camps underline his words. Then we see and hear Telling's wife recalling the horrific moment when, some time after the war, after four and a half years of separation, she saw her husband again for the first time. She did not recognize him, and 'got sick at the thought of having to sleep with this man.' They had been married for four months when he was arrested on 15 September 1941 for distributing a pamphlet calling for a strike against the terror of the Nazis ('*Staakt tegen de Moffenterreur*') while he was at work at the shipyards in Amsterdam North. Telling recounts that, after imprisonment in Amsterdam and Amersfoort, he was transported to the camps in Büchenwald, Ravensbrück, Sachsenhausen, Bergen-Belsen, Pölitz and Barth. On 30 April 1945 he was liberated by the Russians and in June 1945 he returned home, suffering from tuberculosis, from which he recovered in 1947. Between 1947 and 1967 he worked again at the shipyards until he could no longer sustain any labour and had to stop working all together. Bastiaans explains the symptoms of the KZ-syndrome, words that also appear on screen: 'high form of alertness; over-sensitive perception; emotional lability; anxiety and suspicion; aggressive hyper-activity or depressive apathy; psychosomatic disturbances; early aging; distorted perception of time.' The psychiatrist continues by stating that for those who have experienced the war in all its bestiality the experience of time is different: a second can seem to last an eternity and the doors of perception are always open. The emotions that accompanied their horrific experiences could never be shown or expressed in the camps and long after the war those feelings of unspeakable fear, disgust, and pain remained hidden. Because our imaginations are limited, it can be impossible for many survivors to be fully understood. Then Bastiaans explains the use of LSD-25 for therapeutic purposes and also acknowledges that while the presence of a camera crew might influence the process, this effect would be eliminated in follow-up sessions where there would be no camera.

 The session starts with a dose of 150 micrograms LSD-25 and Bastiaans asks his patient Telling to describe any changes in perception that he notices. They are sitting in a very simply decorated room with a table and two comfortable chairs. Through the windows the cars on a motorway are visible. Bastiaans sometimes asks him to perform some of his memories, for instance, how he had to salute. Telling stands to attention, shouting in German 'Protective custody prisoner 42.392 present' ('*Schutzhäftling 42.392 meldet sich an*'). The camera often focuses on Telling's hands, his face, and his hands in his face and on his bald head and his tears. 'What do you see now?' Bastiaans asks after a second dose of LSD-25. 'Everywhere blood. So much blood. There

was always blood. And bodies. I am worried. You want to understand, but you simply cannot understand,' Telling answers desperately. And he adds: 'I see dragons, the dragon claws of the Nazi-beast. What a childish representation. But we felt them, they never let go.' When Telling wonders what will happen with the film Bastiaans answers: 'We are trying what you are trying, to make people understand what happened. It was not a person but a system. Are you afraid the system will win again?' Telling replies that this is what he sees repeated in the world news every day. The film shows several other exchanges during the five hour session and concludes with Bastiaans explaining again how important these types of confrontation are to gaining self-understanding *and* to assist others in gaining insight into the lasting and traumatic effects of the war. He concludes with the hopeful message that these sessions have a beneficial effect and decrease the severity of the KZ-syndrome. We see Telling once more walking in a garden, apparently confirming Bastiaans' words.[25]

The film played an important role in the Netherlands in garnering attention for the traumatic effects of the war, precisely because of the rather restrained and sober style of the film and the intimacy of the setting and the revelations. After the premiere of the film in 1969 the Queen remarked that she had never seen inside 'the living room' of one of her fellow countrymen.[26] In 1972, NOW DO YOU GET IT, WHY I AM CRYING? became an important element in a tumultuous national discussion that marked a definitive shift in the recognition of the after-effects of the war. At that time, the government, guided by a pressure group for reforming justice, was considering the release of the last three German war criminals, known as the Breda Three.[27] The minister of Justice, Dries van Agt, was in favour of their release, as were several other members of the government. But the Jewish community, members of the former resistance and many other survivors of the war, supported by Bastiaans and several other psychiatrists, protested heavily. On 24 February 1972 NOW DO YOU GET IT, WHY I AM CRYING? was shown for the minister and members of the parliament in the presence of Rabbi Soetendorp and Professor Bastiaans, who introduced and discussed the film.[28] Two days later the film was shown on national television, a move which had provoked much debate. There was a fear that the impact of the film on public screens would be too big, raising too many painful memories. The film was nevertheless broadcast on the current affairs programme BEHIND THE NEWS (ACHTER HET NIEUWS, by broadcaster VARA), with a panel of four psychiatrists, among whom were Bastiaans and Dick van Tol, who had also been present at the recording of Telling's LSD session.[29] Furthermore, several hospitals equipped 'Psychic Emergency Rooms' in anticipation of possible pathological reactions by television viewers, and a team of specially instructed telephone operators was ready to answer the questions of worried or shocked viewers. The ERs did not receive any television-related cases that

night, but there were over 800 calls and several hundred letters.[30] Some people gained the courage to seek help after the broadcast, and more generally an understanding of the traumatic effects of the war became part of the national consciousness.[31] Van Gasteren's film also helped raise funds for a special clinic for post-war syndrome treatment. In 1973, barely a year after the television broadcast, the clinic Centrum 45 was officially opened in Oegstgeest. Today, this Centre remains the only specialized clinic in the Netherlands for treating war-related traumas.[32] The 'Breda Three' were not released.[33]

Van Gasteren was very aware that the issues addressed in NOW DO YOU GET IT, WHY I AM CRYING? had much wider repercussions for many other wars and other parts of the world: 'the same goes for Portuguese soldiers who went to Angola, the people in Northern Ireland and Vietnam veterans.'[34] On 11 February 1973 the film was broadcast in the United States by CBS on the series 60 MINUTES. Here, too, the film raised emotional reactions, mainly because the moment of broadcast coincided with the return of prisoners of war from Vietnam. The timing of the broadcast was questioned by many viewers who thought it was cruel to subject the families of returning POW soldiers to more horror. Others felt the film was helpful in raising awareness of traumatic events that were hard to understand and even harder to discuss.[35] Again, a year later, on 13 December 1974, NOW DO YOU GET IT, WHY I AM CRYING? was shown on German television (WDR). While it was not the first television programme that addressed the war, in Germany memories of the war had also gone largely undiscussed and were perhaps even more deeply repressed.[36] Here, too, the screening of the documentary was framed by a panel of experts and a telephone helpline.[37] However, during the discussion the attention of the film was redirected into abstract elaborations, comparing the violence of fascism to the violence of bolshevism and questions of personal responsibility versus authoritarianism.[38] Very few people called the phone lines. Not only was the panel discussion awkward and unproductive but nobody discussed the issues addressed in the film directly.

Having been the perpetrators, Germany, of course, had an additional traumatic relationship with the war.[39] As Thomas Elsaesser has shown in his book *New German Cinema*, it was only after the shock of the commercial television series HOLOCAUST (NBC, 1978), broadcast in Germany in 1979, that a succession of German filmmakers took on the task of working on their own collective memory. Most famously, filmmaker Edgar Reitz condemned HOLOCAUST, claiming that the Americans 'have taken away our history.' Reitz argued that 'there are thousands of stories among our people that are worth being filmed, that are based on irritatingly detailed experiences which apparently do not contribute to judging or explaining history, but whose sum total would actually fill this gap.'[40] Between 1979 and 1984 Edgar Reitz would make the television

series HEIMAT, Rainer Werner Fassbinder would embark on his BRD trilogy and other films that explicitly address Germany during and after the war.[41] Many other German filmmakers would pick up the task of working through personal and collective memory, offering in this mediated way a means for a society to talk to itself and deal with history. But in the early 1970s this was all still largely unexplored territory and NOW DO YOU GET IT, WHY I AM CRYING? might have been too direct and too painful at that time for a German context. Nevertheless, the film addresses the condition that is now defined as PTSD (Post Traumatic Stress Disorder). In the wake of the Vietnam War, Lebanon, the Iraq wars, and countless other wars, soldiers and refugees are suffering from similar symptoms that continue to need working through in personal therapeutic contexts and in popular and other collective forms.[42]

THE HAUNTING SHADOWS OF DUCKER AND DORBECK

In an interview in 1989 Van Gasteren declared that he would have liked to have filmed Willem Frederik Hermans's *The Dark Room of Damocles* because he recognizes himself in the novel's main characters, Osewoudt and Dorbeck, leaving the exact nature of this recognition undefined.[43] In Hermans' war novel the young man Henri Osewoudt lives with his wife and his insane mother in the annex of a cigar shop in Voorschoten, a small town near The Hague. Osewoudt lives an inconspicuous life but becomes involved in the resistance and receives his assignments from a mysterious man called Dorbeck, who is his spitting image.[44] The only difference between them is the colour of their hair, Osewoudt is blond and Dorbeck's hair is black. The story was filmed with the title AS TWO DROPS OF WATER (1963) by Fons Rademakers. Even though much from the novel had to be cut, the film largely follows the plot of the book.[45] The blond main character is now called Ducker. His black-haired lookalike Dorbeck (both played by Lex Schoorel) in the film literally falls out of the sky, landing with a parachute in Ducker's backyard. The excellent camera work in black-and-white photography (by Raoul Coutard who also shot Godard's ALPHAVILLE) and the sober settings give the film an abstract quality that matches the deeper dimensions in the book, questioning the nature of reality: Is Ducker an inexperienced resistance fighter falling victim to his shadow; or is he to be seen as a traitor who has made up Dorbeck as an imaginary figure? Many events in the story tie an inextricable knot around those questions. Even the last scene of the film, in which we see Dorbeck after the war with Ducker's former girlfriend Marianne, is open to interpretation: are these images confirming the reality of the existence of Dorbeck, who survived the war; or are these the last images in the mind of a dying Ducker? The state of reality in this

final sequence remains uncertain even though there are many details in both the novel and the film that prove the reality of Dorbeck's existence. Hermans' impenetrable conception of reality is emphasized by his own postscript to the novel, added in 1971, where he quotes Wittgenstein: 'I can look for him even if he is not there, but I cannot hang him when he is not there. One should be able to say: "in that case he should also be there when I look for him." In which case he should also be there when I do not find him, and also when he does not even exist.'[46]

The novel *The Dark Room of Damocles* and the film AS TWO DROPS OF WATER are pure fiction and so there is no one-to-one transposition possible. Yet there are several elements in Hermans' story that resonate with Louis van Gasteren's experiences of the war (which is possible because Hermans knew the Van Gasteren family). On a more general level, there is the matter of the ungraspable, slippery and complex nature of reality in general, and of the messy reality during war time in particular. Moreover, the ambiguous or double nature of resistance and its Janus face of ethical dilemmas of violence that transcend any threshold of behaviour under normal circumstances are noticeably close to the story of the novel/film. More specifically, there are some scenes in the film that do seem to resonate in salient ways with Van Gasteren's war experiences. Towards the end of the film at the end of the war, Ducker, throughout the film we have seen performing all kinds of illegal acts for the resistance on the orders of Dorbeck, is taken for a traitor and thrown in prison. He witnesses the liberation from behind iron bars, listening to the sounds of the national anthem in the streets, unable to participate in the celebrations. Van Gasteren, too, was in prison during the liberation of the Netherlands. As Hans Beerekamp describes in a 1989 interview that dealt with memories of liberation day on 5 May 1945: 'Louis van Gasteren, twenty-two years old, saw the liberation of Amsterdam through a bullet hole in a window of the prison at the Amstelveenseweg. He contracted an eye infection.'[47] Having dealt with the war in his films, as described earlier, this interview was the first occasion when Van Gasteren mentioned publicly in a national newspaper his detention during the war and the reasons for his imprisonment. It would have enormous consequences.

During the war, Van Gasteren was working with the resistance making, among other things, false identity documents for Jews who had to go into hiding. Between 19 and 24 May 1943 he took a Jewish man named Walter Oettinger into hiding in his own one-room apartment. Oettinger, however, behaved with perilous recklessness by leaving the room and going to the hairdresser. Van Gasteren's neighbour had a relationship with a pro-Nazi henchman (a so-called NSBer). In May 1943 the Nazi regime was at the height of its cruelty and any act of resistance or assistance to Jews ('*Jüdenhilfe*') was inexorably pun-

ished with razzias or other severe forms of reprisal. One could never be sure who was watching from behind the curtains or who could be trusted. It was imperative for Oettinger to move to another hiding place but his next refuge was unexpectedly cancelled and Van Gasteren did not know how to keep him in safety. After looking in vain for other hiding places and consultations with other members of the resistance, Van Gasteren was advised to liquidate his fugitive.[48] Finding no way to rescue the man, this is what he finally did. He received assistance to hide the body and take it in a box to a canal. The body was found in the canal, the evidence trail led to Van Gasteren's address and he was arrested. He was taken into custody by the Dutch police and was not handed over to the Germans, which would have meant certain deportation. He was put on trial for homicide, but the words 'resistance', 'hiding' and 'Jew' were never mentioned as this would have had led to severe consequences both for Van Gasteren and for other members of the resistance. He was condemned to four years imprisonment. After the liberation, however, he could not be released with others whose cases were pending. All non-convicted resistance fighters and other prisoners of war were free to walk out, but there was no article in the law for Van Gasteren's exceptional and complex case. Because he had been legally convicted, he had to wait for an order from a higher court, but since the High Court was abolished in 1944 and required some time to be reinstalled after the war, a review of his conviction was not immediately possible. Meanwhile, the Amstelveenseweg prison was filled with Nazis and high officials of the SD and SS. Instead of dancing in the streets with Dutch flags Van Gasteren was surrounded by the enemy; being fluent in German (as well as in English and French) he found himself translating hearings in prison, a schizophrenic situation that he recalled fifty years later, sitting on a mountain in Sardinia, in the documentary A CHAINSAW FOR THE PAST (EEN KETTINGZAAG VOOR HET VERLEDEN, Ad 's-Gravesande, 1997). Eight months after the war Van Gasteren was reprieved, released from prison and rehabilitated as a member of the resistance.

After his rehabilitation, Van Gasteren tried to leave the war behind and to pick up his life, in line with the spirit of the immediate post-war period, when countries had to be rebuilt and the wounds of the war were too fresh and painful to examine. Having developed an interest in photography and cinematography at an early age,[49] Van Gasteren began writing about film and organizing special screenings for the Amsterdam Film Liga. He subsequently worked as a sound designer at the Polygon Journal and then started to make films himself, such as BROWN GOLD, RAILPLAN 68 and THE STRANDING, to name a few early films that I have discussed previously. Nevertheless, the ghosts of Ducker/Dorbeck and the schizophrenia of the war returned in several guises. First, with these haunting presences in his psyche, Van Gasteren tried to understand what

happened during the war by transforming the war events into scenes that he intended to include in his autobiographical film, NEMA AVIONA ZA ZAGREB. As discussed in the previous section, some scenes were transformed into the film NOW DO YOU GET IT, WHY I AM CRYING? Other scenes about his war experiences were actually shot but never ended up in the ZAGREB film, which came out in 2012. Nevertheless, the anxiety of the war period expressed in these scenes, which remained on the shelf, was always in the background. In Hans Keller's documentary portrait, THE CLOUDED EXISTENCE OF LOUIS VAN GASTEREN (2007), Van Gasteren recounts that during his arrest in 1943 he was terribly afraid that he would fall into German hands and would be interrogated by the SD ('*Sicherheitsdienst*') and disappear forever in '*Nacht und Nebel*'. The scene kept on returning in his nightmares. He also filmed it but the footage remained unused in his archive. In HAMARTÍA (2014), the most recent documentary on Van Gasteren, director Rudolf van den Berg includes the scene that translates this anxiety dream: We see how an invisible Van Gasteren is interrogated in German and then taken away. In a long corridor we only hear footsteps, and then a sign on a door saying: Careful – Waxed Floor ('*Vorsicht – Frisch Gebohnert*'). 'That was a sign in the SD office. It was my biggest fear that this sign would be the very last thing I would see,' Van Gasteren explains. When asked by Van den Berg why this scene about the war never ended up in the final ZAGREB film, he answers that the war remained too complex an issue to include in a film that also addressed so many other autobiographical elements. All the decisions made on a micro-level, everything that can go wrong on this human scale, which have macro-political and uncontrollable consequences, are too complexly entangled to express in a few scenes.

A second level on which Van Gasteren tried to address and understand the war was on a meta-reflective or philosophical level. This is a level, however, where the medium of film perhaps failed him. In all three documentary portraits of Van Gasteren that have been made, a particular scene from his early film, THE HOUSE (1961), is quoted; namely, the scene where Van Gasteren himself is dressed in the Nazi uniform of the Wehrmacht officer who gives the order for a summary execution. Ad 's-Gravesande shows the excerpt at the beginning of A CHAINSAW FOR THE PAST, introducing Van Gasteren who talks about the war events and its aftermath, which he discusses extensively much later in the documentary. More directly, Hans Keller asks ten years later in THE CLOUDED EXISTENCE OF LOUIS VAN GASTEREN: 'Did you never think when you decided to perform this role of Nazi officer, misunderstandings could arise about what actually happened to you during the Second World War?' Van Gasteren replies that it never crossed his mind. 'I attempted to elevate this case to a higher level. Taking a hider to save his life and then having to take that life, that's a terrible conflict and a deep philosophical problem about the beater

and the one who is being beaten, and their horrifying interdependency.' Again several years later, Rudolf van den Berg questioned Van Gasteren about the exact same scene, asking him what he meant with this performance. 'I wanted to put myself in that position, I was looking for explanations.' Van Gasteren adds that what he felt in that position was the essence of Nazism as a 'lust for power.' So, the philosophical ethical, and existential questions of the relation between life and death, power relations between victim and executer and their fatal interdependency, are the deeper and philosophical dimensions that Van Gasteren wanted to address in this scene in THE HOUSE. But it is a scene that is easily misunderstood. Perhaps this is because the concrete and literal dimensions of filmic images are hard to take beyond a first level of representation, especially when a scene like this is taken out of the context of an entire film that is itself a philosophical reflection on time, life, death and the meaning and memories of a house and its inhabitants (as discussed in Chapter 1). But perhaps this scene also becomes more confusing with time. When the film appeared in 1961 Van Gasteren's own performance was hardly noticed. But after 1989 the past returned with a vengeance, retrospectively making his performance in a Nazi uniform in THE HOUSE suddenly suspicious.

Thirdly, the 1989 interview in which Van Gasteren recalled his powerlessness at the end of the war by comparing himself to Osewoudt and Dorbeck from the Hermans novel set into motion an avalanche of accusations that publicly transformed him into a two-faced and highly controversial figure. In the novel and film Osewoudt/Ducker tries to come up with evidence for the existence of Dorbeck, which would prove he was indeed a member of the resistance. Ducker's final and only remaining proof is to develop a picture that he once took of himself with Dorbeck, both of them standing before a mirror. 'It's too dark in here,' Dorbeck tells Ducker when he takes the photo. When, at the end of the film, Ducker gets his camera back and manages to develop the film, the negative shows nothing but vague flecks in the place where the picture in front of the mirror should have been. And so there is no evidence, neither of Dorbeck's existence, nor of his inexistence. In an almost eerily similar way, since 1990 when several publications questioned the liquidation as an act of resistance, Van Gasteren has been to court to attempt to prove the inaccuracy of the accusations.[50] In 1993 the High Court sided with Van Gasteren and the former resistance organization reconfirmed his act as the consequence of an act of resistance.[51] But the indictments have never stopped; in any case, they have tainted his name and, as he tells Ad 's-Gravesande IN A CHAINSAW FOR THE PAST, they have made him relive the liquidation a million times. As a secondary trauma the spirit of Ducker and Dorbeck came to haunt him once more. The war is still an 'open nerve,' both for Van Gasteren and for Dutch society.[52]

In his documentary HAMARTÍA, Rudolf van den Berg turns Van Gasteren's

wartime experiences into a matter of '*hamartía*', an ancient Greek concept signifying 'tragic error', which he defines at the beginning of the film as 'error, mistake, lapse, crime.' While Van den Berg in voice-over refers to Oedipus who would have done better not to marry his mother, he conceives the word not as a tragedy (which would have been appropriate) but rather as a Christian story of guilt, punishment and possible redemption. Van Gasteren tries to explain that his deed has followed him all his life on an existential level, having had to live with the fact that he had to push aside all his normal ethical boundaries to kill another human being. But, he adds, under the circumstances there was no other option. Therefore he assumes responsibility, but since he explored every other option and they all seemed to involve more dangerous consequences, he does not feel guilty for not having acted in another way. And so he cannot accept the gesture of redemption that Van den Berg seems to offer: 'Why don't you forgive that twenty year old boy of the past,' he urges Van Gasteren at a certain point in the film, while taking him on a surprise boat ride to the canal where, 70 years previously, the corpse of the hider was found. Van Gasteren is visibly shocked and disappointed that Van den Berg, as a Jewish filmmaker whom he trusted and respected for his previous films,[53] does not seem to understand or see the deeper level of the immense problem that Van Gasteren wants to address (and relentlessly keeps on addressing); namely, the deep complicity between victims and perpetrators in any kind of war and the fact that every choice is always made in a complex network of ever-changing micro-political circumstances. This is not to say that everything depends solely on the system, but that choices and the consequences of choices, even if they are not foreseeable, have to be taken into account in their full complexity. But the weight of history and the continuing burdens of the past that we can see in the enduring and escalating conflict between Israel and Palestine make this an issue that is perhaps too heavy and too painful to address for all parties involved.[54]

Attempting to raise the issue in yet another way, Van Gasteren tells Van den Berg that he considers the human race as an absurd species, captured in and limited to a three-dimensional frame of reference, while we actually live in many more dimensions. 'And because we are powerlessly caught in these three dimensions, and miserably fail to see other dimensions, we have to reach out to the concept of God and religion,' he explains while he pleads for a loosening of Jewishness (or any form of religious identity for that matter). Again, this is an explosive thing to say in the light of history, and once again it can easily be interpreted as an anti-Semitic message. Hans Beerekamp argues in his review of HAMARTÍA that Van Gasteren's plea should rather be seen as a classic Freudian case of self-hatred.[55] After all, Van Gasteren's mother had Jewish roots, even though as an active communist and registered with the Dutch Reformed Church she never practiced any religion. A Freudian explanation might be

partly true; however, I think that Van Gasteren's words address a dimension that tries to go beyond any psychological or psychoanalytic explanations, trying to reach out to something even more fundamental in human beings, a molecular or perhaps even atomic dimension that escapes the entrapments of religious or national identities that, ultimately, are the cause of so many wars and even genocides. In fact, Van Gasteren proposes what Deleuze calls a 'line of flight' that breaks the stratifications of religion and other group identities but that in itself also has its own danger; that is, the danger of the black hole of self-destruction.[56] As Van Gasteren declares in HARMATÍA, perhaps this is indeed the price to pay for being a relentless anti-fascist. In a way there is an originary drive in Van Gasteren as a character in the film of his life that could be compared to what Deleuze describes in relation to the characters in Joseph Losey's films. Losey's characters are all driven by an originary violence, 'which dwells in them and which impels them to go to the limit of a milieu which the impulse explores, but at the price of making them disappear themselves with their milieu.'[57] I am not saying that it is an originary violence that drives Van Gasteren; rather, it is an originary relentlessness of looking into the depths of the mirror (of his own reflection and that of humanity more universally) and crossing to another dimension with a different logic. This is something that he has tried to discover both through the lenses of his camera eyes, scrutinizing the (illusionary) powers of the image, as well as, as he states in A CHAINSAW FOR THE PAST, experimenting with the corners of his psyche by trying out everything extreme, from parachute jumping to sensory deprivation tanks and LSD. These are all aspects of Van Gasteren's oeuvre that will be explored further in the next chapter.

In mapping some mediated moments of a very complex history in this section, I realize it is impossible to retrace everything in exact micro- and macro-political detail and proper (historical, political and philosophical) weight. Moreover, subsequent events and knowledge continue to influence and colour memory. As psychologist Willem Albert Wagenaar has demonstrated in several studies on the recollection of war events, post-event information and reconstructions of knowledge fundamentally influence and calibrate what and how we remember.[58] At the time of writing, seventy years after the Second World War, it is hard to imagine the extreme pressures of fear, distrust, chaos, madness and confusion of life in wartime. Of course, historical documents give us important facts, and novels and films can give deeper insights into the affective experiences, ethical dilemmas and existential ambiguities of this period in history. This is why these documented traces of history and mediated forms of the past are so important. But history itself is impossible to reproduce in all its details like in a Borgesian map that would cover the entire territory of the map. We only (and with respect to the Second World War increasingly so)

have mediated access to the past. Erik Hazelhoff Roelzema, one of the most well-known resistance fighters whose war memories were filmed by Paul Verhoeven in SOLDIER OF ORANGE (1977), even declared in a documentary in 1988 that history becomes more like a fairytale.[59] This is perhaps too strongly put, but the fact is that as historical events occur and slip into a past that is further removed and traces of the past in daily reality are no longer visible, their full implications become hard to grasp for subsequent generations that live in a totally different world. Nevertheless, these mediated memories and thoughts contain important lessons that are worthwhile revisiting and reworking.

SORROWS OF A PAST NEVER LIVED

The transformation of history into 'stories' is inevitable and to a certain extent also a healthy process; turning a traumatic memory into a story might be helpful to contain, process and situate those events. But it is also important to learn from history and understand its lessons and complex entanglements with deeper questions of life. It is precisely these more intangible dimensions of history that often get lost. At least this is the somewhat scornful and worried observation of Reinier, the youngest son of camp survivor Joop Telling, whom Van Gasteren filmed in the heartbreaking documentary THE PRICE OF SURVIVAL (2003). Reinier is a history teacher at a high school and at the beginning of the film he shows some student papers. For schoolkids, 'Auschwitz' has become a topic of the same weight as 'Pearl Harbor, the movie' or 'Attila, the Hun.' THE PRICE OF SURVIVAL, however, makes painfully clear that for camp survivors and their families nothing has turned into just another story, fairytale or Hollywood film. Joop Telling passed away in 2000 and, on that occasion, Van Gasteren (who always remains in touch with the people he films or encounters) returned with his camera crew to the Telling family. While at the end of NOW DO YOU GET IT, WHY I AM CRYING? there was a glimpse of hope that the therapy would help, it now becomes clear that it offered only a temporary relief and that the war kept on returning, terrorizing his entire family. Three children were born after the war, two of whom eventually became estranged from their parents. They did not want to be filmed. The youngest son, Reinier, and his mother, Dina, were willing to share their devastating experiences in front of the camera. THE PRICE OF SURVIVAL is just as soberly constructed as the NOW DO YOU GET IT, WHY I AM CRYING?, some scenes of which are re-presented to recall the situation forty years earlier. Reinier and Dina are filmed separately, framed in static shots. Their words are alternated with the words of the other two children, written in black intertitles. The film begins with Joop's funeral while the ontological facts of birth and death are emphasized by combining

the images of the funeral rites with the sounds of the beginning of life (the cry of a baby) and Hans Eissler's music *Anrede an ein neugeborenes kind* ('Salutation for a new born baby').[60]

During the course of the film it becomes painfully clear how the war experiences of the father penetrated the family life in every detail. As Reinier recalls, 'Everything was always focused on sparing my father. A scraped and bloodied knee was nothing compared to the suffering of my father and his comrades in the camp. [...] Everything called for an association with the war: bananas – "we did not have them during the war"; a school work with pieces of rope –"they used that to hang people in the camp." [...] Literally everything recalled the war, so in the end you simply stopped talking.' The other children explain in their written statements that they became small experts on the war, model prisoners who were simply not recognized by their parents as children with emotional needs of their own. Most devastating is Reinier's recollection of the Cuba crisis. Reinier, born in 1954, explains that as a history teacher he always has difficulties in discussing the Cuba crisis because for him it still recalls a personal childhood anxiety: that his father would shoot him. During the Cold War in the early 1960s, Joop continuously told his children he would never be caught again and that at the first sign of a new war he would first kill his wife and children and then himself. In contrast to his brother and sister, who broke with their parents in order to be able to create emotional room for their own family lives, Reinier and his wife remained in touch with the parents. But they made a conscious choice not to have any children, not wanting to take the risk of passing on the psychic misery that Reinier and his siblings were spoon-fed. 'We had no idea we have poisoned our children to this extent,' mother Dina confesses. She travels to Sachsenhausen to scatter the ashes of her husband in the place he never left. The camera frames her standing all alone in the 'guilty landscape' that determined her fate just as much as that of her husband.[61] 'My mother became my father,' Reinier comments. She lived the memories of her husband. But she was perhaps even more alone. Camp survivors developed extraordinarily deep bonds with one another, but as a wife she remained 'an outsider.' 'We have been living together for 60 years,' Dina says. 'But he belonged with his companions in the camp, not here.' Perhaps even more telling than all the intrusive words, the quietly witnessing framed scenes and the sparse use of musical themes, are the sadness in the eyes of the wife and mother, and the barely noticeable vibrations around the mouth of the son, even when he smiles. On many levels this follow-up film to NOW DO YOU GET IT, WHY I AM CRYING? insightfully reveals how immense the price of survival is.

Van Gasteren would return explicitly to the long-lasting effects and enduring grief of the Second World War once more, in the four-part television series

and film ROERMOND'S SORROW (2006). The documentations and recordings for this project took place between 1975 and 2004 when the final interviews were filmed. Here, too, we see how tenaciously and relentlessly Van Gasteren is in researching his topics, following the people whose fate he wants to record and recall during extended periods of time. In ROERMOND'S SORROW he retraces a horrific event at the end of the Second World War when, in September 1944, Roermond, a city in the south of the Netherlands, became a frontline city after the Allied Forces liberated the first Dutch territories in the south. All men in the city between the ages of 16 and 60 years were in December called up for forced labour in Germany ('*Arbeitseinsatz*') but most of them refused and some went into hiding. They were betrayed and fourteen men were executed on boxing day following a drumhead court martial. The youngest, Mathieu Sevenich, was only sixteen years old. Van Gasteren talks with eye witnesses and family members of the executed men, many of whom he filmed in 1975. Jacobus Sevenich, father of the youngest victim, roams the streets of Roermond. His toothless and grief-stricken face holds all the sadness in the world. The Nazi commander-in-chief at the time was Ulrich Matthaeas. He escaped during a transport to the Netherlands shortly after the war, never served any sentence and died in 1994 at the age of 83 in a luxurious rest home in Germany, not too far from Roermond. Van Gasteren interviews investigators, lawyers and other officials to retrace the baffling trajectory of a largely forgotten piece of history and the remaining sorrow of the people of Roermond.

'In my films, art projects and focused research, on the one hand I try to get a grip on my own existence, on the other hand I try to bring across some aspects of my observations of human existence more generally. Because this is my main concern: the location, the human being on this location, his actions, and the consequences for himself and his environment.'[62] These words are descriptive of all of Van Gasteren's work, but they have a particular salience with respect to the traumas of the Second World War. The films that I have discussed in this chapter explicitly deal with the sorrows and the price of surviving the unimaginable events of war. While they are coloured by his own war experiences and his own survival trauma, the films go beyond the personal and address the collective deep and long-lasting effects of history, always with a deeply felt desire to understand. Van Gasteren would continue to do this in the two important films he made on the rebellious generation of the 1960s that will be elaborated upon in the next chapter.

CHAPTER 4

Young Rebels and Doors of Perception

As everywhere in Europe, after the Second World War people in the Netherlands picked up life and started to rebuild the country, attempting to leave the past behind as soon as possible. During the same period that freedom and sovereignty was restored in Europe, in many 'overseas territories' the decolonization movement started to emerge. Demands for independence in the colonies were most often met with violent responses from the different European nation states. Between 1947 and 1949, while recovering from five years of German occupation at home, the Dutch government ordered military actions ('*politionele acties*') to keep the Dutch Indies from independence. After numerous bloody battles a truce was signed; Indonesian sovereignty was granted in December 1949. Both the terrible and still fresh recollections of the war at home and the violent actions overseas had an effect on the young post-war generation of artists who started rebelling against all forms of authority. In the arts in the Netherlands the first reactions came from a group of writers, the Fifties Generation ('*de Vijftigers*'). They were closely connected to artists of the COBRA movement.[1] Writers such as Lucebert, Gerrit Kouwenaar, Remco Campert, Hugo Claus and Simon Vinkenoog and painters such as Karel Appel, Corneille, and Constant Nieuwenhuys started to break with all conventions in writing and painting respectively.[2] They replaced formal aesthetic rules with spontaneous, sensuous and free forms of expression, loosening the conventions of poetry and painting. They wanted to break free from the narrowness of all conventions and normative behaviour that had slipped back into generational relationships and power structures after the war. They denounced the military actions overseas. And they resisted the status quo by smoking hashish, listening to jazz and reading existential philosophy.

In 1947, Van Gasteren came to live among this bohemian group of writers of the Dutch post-war generation, rebelling against the narrow mindset of the

post-war society. In a way, Van Gasteren envied his cohabitants' simple, yet powerful way of expression by means of just pencil and a piece of paper.³ Van Gasteren had opted for the (certainly at that time) more complex medium of film. In his attic he wrote many film scripts, he prepared experimental cinema programmes for the Amsterdam Film Liga, he started to write and lecture about film history and learned the technology of the film apparatus at the Polygon Journal Company until he had enough skills to begin making his own films. As mentioned earlier, in the 1950s Van Gasteren actually experimented in all genres, ranging from ethnographic documentary (BROWN GOLD) and travelogue (ACROSS THE SAHARA), to publicity for coffee (FLYING SAUCERS HAVE LANDED), to soviet-style montage film (RAILPLAN 68), industrial film (ALL BIRDS HAVE NESTS), to fiction films (THE STRANDING and THE HOUSE). During the journey through the desert for BROWN GOLD and ACROSS THE SAHARA in 1952 Van Gasteren had a life changing experience:

> The Sahara brought about a personal event. I was lying there in the sand on my back, and saw the star littered sky, knowing that in a radius of 200 km there was nobody. I raised my hand and shook hands with God after all. When I returned home in the Marxist environment of my parents, they did not know what to do with that. It was only much later that I looked for that experience again, with mescaline.⁴

Meanwhile, he had learned to write with the camera and by the mid-1960s he always had a camera on standby. And his environment had changed into a rebelliously searching artistic environment where encounters with higher dimensions were found beyond the church. As a participant observer who was a little older than most of the young post-war youth rebels, Van Gasteren witnessed and filmed important events and people of the rebellious youth culture that wanted to break free from the generation of their parents. Photographers Ed van der Elsken and Johan van der Keuken also captured that spirit of an emerging rebellious youth culture in their photo series of Amsterdam in the 1950s. In *Jazz,* Ed van der Elsken photographed jazz concerts and jazz musicians between 1955 and 1959, most famously the night concerts in the Amsterdam Concert Hall. The musicians were seen as courageous, bringing with them the spirit of liberation, dance and a bohemian lifestyle. They also imported marihuana from the US into the Netherlands (Amsterdam was a leave centre for American troops). Johan van der Keuken, too, photographed his peers (all aged 17) in ways that, at the time, were very controversial. The youngsters in his photobooks were shot staring out of a window, or smoking a cigarette, making a dance movement, or just looking straight into the camera. In any case, they were not rebuilding the country. Rather, they had put them-

selves on hold, looking for new ways of living and understanding the world. A new generation announced itself.

Van Gasteren captured the spirit of the time in his short film JAZZ AND POETRY (1964), filmed in the Amsterdam nightclub Sheherazade, where writer Simon Vinkenoog introduced the American poet Ted Jones. Jones read his own work, 'Jazz is my religion,' accompanied by Dutch jazz musicians. It is a sort of hiphop *avant-la-lettre*, combining rhythmically pronounced poignant texts with music. The film starts as a documentary and Vinkenoog explicitly acknowledges the presence of Van Gasteren and his camera. But with Jones' second poem, 'Ice Freezes Red,' a penetrating poem about racism, the registration style of the camera transforms into a visualization of the poem. While his performance in Sheherazade is audible in voice-over, we now see Jones in an ice-cold urban landscape heated only by racial hatred, indicating in a succinct but powerful way how jazz and poetry are connected to political resistance to the status quo and re-establishment of stereotypical power relations after the chaos of the war. In JAZZ AND POETRY, as well as BECAUSE MY BIKE STOOD THERE (1966), the short film that exposed police violence during the opening of a Provo photo exhibition in Amsterdam, Van Gasteren captured the essence of the drastic changes in culture in the 1960s. And perhaps no other film gives a deeper insight into Amsterdam's subculture in the late 1950s and early 1960s than HANS LIFE BEFORE DEATH (HANS HET LEVEN VOOR DE DOOD, 1983), especially when combined with the three-part television portrait ALL REBELS (ALLEMAAL REBELLEN, 1983). For many years, Van Gasteren interviewed and filmed all the players in the Amsterdam underground scene of the time; he spent additional years selecting and combining all this material into a meaningful whole. In this chapter, I will return to the tumultuous 1960s, mainly by looking at HANS and ALL REBELS respectively. In HANS the question of generational conflicts, ideals and disillusionment are the leading principles of a whole generation of youngsters of the 1960s. ALL REBELS takes us into the psychedelic dimensions and experimentations and the desire for change and expanded consciousness of the 1960s and to what became of those dreams by the 1980s, the time when both the film and television series came out. The final part of this chapter will discuss Van Gasteren's further exploration of perception by means of camera technology and electronics in the experimental film OUT OF MY SKULL (1964) and the artwork SUNNY IMPLO (1970); and in two short analytical films about image manipulation in DO YOU GET IT NR. 3 (1975) and DO YOU GET IT NR. 4 (1978).

GENERATIONS, EXISTENTIAL ROLES AND CIRCLES OF LIFE BEFORE DEATH

In 1963, Van Gasteren's friend, the young artist Hans van Sweeden, committed suicide by shooting himself. He was 24. Van Sweeden was a sort of James Dean of the Amsterdam subcultural scene. He was a composer but he was also an actor and a writer. Many were attracted to him, many envied him, and few knew how unhappy he was, haunted by destructive demons. The funeral of this talented and tormented young man, attended by a crowd of about three hundred 'bohemians' made a big impression on Van Gasteren: 'I really had the feeling that all these people represented something of Hans van Sweeden.'[5] The police were present, too. Many at the graveyard that day were convinced that the authorities were secretly taking pictures from behind a hedge. Evidence of such photos has never been found, but Van Gasteren immediately thought that an image capturing all the people that, at that time the narcotics brigade was so interested in, would be a perfect starting point for a film about the subcultural generation of the 1950s and 1960s; a film that would be centreed on recollections of Van Sweeden, the absent presence of this group's key figure.[6] Everybody held indelible memories of Van Sweeden. Van Gasteren soon began collecting ideas and material for his film. In 1964, he recorded Misha Mengelberg playing a haunting composition entitled 'In Memoriam Hans van Sweeden.' Mengelberg would play the score during Fluxus happenings in the 1960s in which Van Gasteren would smash old pianos and other instruments. He interviewed Mengelberg again in 1973 where the latter explains that 'In Memoriam' was a 'materialization of the uneasiness'; of the nagging memory of the meaning of the unfinished life of Van Sweeden.[7] Between 1973 and 1976, Van Gasteren visited practically everybody who had known Van Sweeden, asking about their memories of their remarkable and lost friend. He soon discovered that these memories were intermingled with personal recollections and deeply existential questions and gradually the word HANS came to stand for human existence in general. Joke Meerman and Remmelt Lukkien, and later Wim Louwrier joined the production. The hundred hours of material took another few years to select and edit. Twenty years after Van Sweeden's untimely death, HANS LIFE BEFORE DEATH won the prize for Best Dutch film in 1983. It was an acknowledgement of the universal qualities of the film, its aesthetically balanced composition and the historical value of this portrait of a whole generation.[8]

Indeed, HANS LIFE BEFORE DEATH is not just a search for the life and death of a lost friend and remarkable person but is also an aesthetically strong essay film and an invaluable chronicle of a generation of the Amsterdam subculture that preceded the Provo and Hippie culture of the mid- and late-1960s.[9] Most striking is the level of Van Gasteren's personal engagement. One can see

immediately how much time and concerted effort it must have taken to interview all these people, not just for ten minutes to get a quick quote, but for an extended period, leading to in-depth conversations. It is clear that Van Gasteren is not so much an interviewer, but rather a trusted friend and respected partner in dialogue with whom the interviewees not only share memories of Hans and other moments of the past but to whom they also confess their deeper thoughts, frustrations, fears, hopes and more mature insights into life, love and death. While they are all real persons, Van Gasteren introduces them in the credit titles as characters that have played a role in the life of Hans van Sweeden, the figure that remains the absent kernel of the film. Hans's authoritarian father, Nico van Sweeden, is presented in the role of father; his incurably sad mother, Truda Dijkstra, in the role of mother, his older brother, Ton, as brother, and Jan Vos van Marken's voice represents the voice of Hans. Others play a role as last contacts, girlfriends, classmates, police officers, the mother of his child, teachers and friends. In this way, Van Gasteren injects an element of performance into the documentary reality that opens up the direct historical references to Hans and his surroundings, and that allows more existential investigations into the different roles we as humans perform in life. Van Gasteren himself is part of this 'theatre of life' as well. Not only do we see him regularly in conversation with his interviewees and in set photos of the registrations that return at regular intervals throughout the film, but we also see him at several instances in front of a mirror, shaving his characteristic moustache and beard that he wore throughout the 1960s and 1970s, symbolically ending a role that coincided with the generation he portrays. Van Gasteren explains:

> A beard and a moustache [...] As son of a theatre actor I have seen them being glued on all my life. [My beard and moustache] certainly had a theatrical aspect, behind that mask apparently another person was hidden, a person that was more in harmony with the Van Gasteren that completed this film project. The beard and moustache happened when I, after I showed Fellini in Rome THE STRANDING and THE HOUSE, went on honeymoon in Sardinia. There I was grabbed by a sort of inner liberation [...] that made me decide not to shave at all anymore. Back in Amsterdam I had to trim the wilderness and my moustache became more and more stylized [...] also a form of self-examination. And an aspect of vanity slipped into it. Vanity is a nasty habit that I got from my father. I have to fight it. And I think I conquered it in large parts when I finished this project.[10]

Both the personal engagement of the director and the role-playing presentation of all the characters turn the interviews into an investigation or self-examination of intentions, expectations and dreams, and what became of them. All are coping with disillusionment, especially in terms of relationships between parents and children, lovers and friends, authorities and rebels. Hans van Sweeden, too, was very conscious of the different roles people play in each other's lives, the relations between people and the various degrees of power and misunderstandings that they imply. In his text 'How am I really?' ('*Hoe ben ik werkelijk?*'), quoted by the voice of Jan Vos van Marken in the film, Van Sweeden lists five categories of people that will 'see' him in a different role.[11] The first that have an impression of Van Sweeden are the 'teachers'. He calls them a harmful group of people who are never able to forget their role as teacher. They just see their pupil Hans as a lazy and unintelligent rebel that is good for nothing. The second group consists of the people that are indicated as 'parents'. In general, his mother and father considered their son as intelligent, equipped with a good set of brains. But the atmosphere in the house became unbearable, father and mother quarreling about their respective share in these high qualities. Tired of playing the 'good son' following his father's directions, Hans picked up the role of 'bad son'. The parental image of their son changed accordingly. The third group of people is defined as 'girls'. They can torture a man and most are cruel without knowing it. Girls see the masculine gender as 'an object they can amuse themselves with' and 'they never understand the music one plays,' Van Sweeden complains.[12] He actually considers girls poison. The fourth group consists of 'real friends', mostly musicians and others that understand him, but this is also the most critical group of people, easy to disappoint. Still, this is the group that Van Sweeden likes best. The fifth group is a group of people that only exists in his fantasy, the group of people that can see him as he really is. 'I have not met this kind of people but I hope that one day this will happen.'[13]

By quoting the words of the young Van Sweeden in fragments throughout the film (it is hard to believe he was only fifteen when he wrote these words), Van Gasteren presents representatives of the first four groups who will all evaluate in their own way 'who Hans really was' (while at the same time evaluating 'life before death' more widely). And perhaps, by bringing together all these perspectives, the film turns into the fantasmatic fifth group of people gathered around the tragic absence of Hans's life. Dramaturgically it is also the death of Hans van Sweeden and how this came about that builds a suspenseful narrative in the overall structure of the film. It is as if each interview is a stone in a pond. Sometimes it is not immediately evident what this person had to do with Van Sweeden, although it is clear they all shared the same time and space of the city. Hans always appears to be the stone of the first circle that

causes the ripples of personal stories in the water. All these circling and partly overlapping circular movements together advance towards the moment of the tragic and inevitable suicide of Van Sweeden; towards insights into the drives, dreams and disheartenings of a generation; and towards Van Gasteren's clean-shaven face, 'naked before the inclement nakedness in which things appear, love and friendship disconcerted.' These diary notes by Van Sweeden, written in 1961, are voiced at the beginning of the film over a black screen. The despair and loneliness of the dead protagonist are thus at the dark centre of the film.

Another important role in HANS is played by the city of Amsterdam. The film opens with a bird's eye view of the city, the camera actually following a seagull over the rooftops and streets, accompanied by the music of Brian Eno. Like the image of Van Gasteren shaving, this image of the city and Eno's entrancing music is another audio-visual motif structuring the film. Not only do we recognize here Van Gasteren's preoccupation with the city and its inhabitants (in fact, during the editing process for this film Van Gasteren also worked on the metro project and the NAP monument discussed in Chapter 2). The particular role of Amsterdam is also an important reference to the significance of the city for Hans Van Sweeden. In a short story, 'The Beautiful City', he described Amsterdam as follows:

> This beautiful old city, this beautiful small city; where you know everybody and everybody knows you, and where all people are friendly and helpful, give each other food and lend money; but where one can perish more irretrievably than in Paris or London, more irretrievably and more irrationally. […] The city is round and round and everything returns to the same place, the same people, and the same houses; in London people are strangers in their own city, if they perish in Bloomsbury they can heal in Hampstead. But where can one heal in this city? The hospitals are filled with friends and acquaintances who suffer from the same disease. Every street is a marker and a memory.[14]

Amsterdam in the 1950s and 1960s was a city where, from the cramped spaces of bad housing and suffocating parents, the generations that grew up during the war moved to the squares and streets of the city. One of the few fiction films made at the time that translates the resistance of the post-war youngsters is THAT JOYOUS EVE (MAKKERS STAAKT UW WILD GERAAS, Fons Rademakers, 1960). The film deals with three families on the eve of the most typical Dutch family winter celebration 'Sinterklaas'.[15] However, the coziness of the traditional family values that this celebration is supposed to symbolize is under pressure in all three families: a couple that has just separated; another couple with a

husband of the adulterous type; and a father, a mother and their insubordinate son. While Rademakers was a typical theatre director, giving much attention to his actors in staged scenes, there are a number of elements in the film that are rather documentary-like. The film contains a scene shot at a local meeting point (the so called 'Poffertjeskraam' at the Weteringplantsoen) of the rebellious youngsters. Here, cheered by his friends, (among whom Hans van Sweeden who figures in the film as an extra), the son for the first time openly resists his parents (he refuses to come home for 'Sinterklaas'). This location was the actual hangout of the Amsterdam youth called *'nozems'*.[16] Other people from the actual writers', actors' and artists' scene were invited to play cameos and thus this fiction film is an interesting document of the times, announcing the generational conflict that was about to happen.[17]

Mostly shot in the 1970s, Van Gasteren, for his part, presents this period between 1955 and 1965 with hindsight; from a future perspective, years after the events took place. HANS LIFE BEFORE DEATH is a film that is impossible to summarize. The quantity of characters and the many details and layers in their conversations with the director, combined with the circular structure of the editing, make it hard to do justice to its richness. I will take the motif of 'the circle' as my guiding principle and mention a few more striking elements of the film. I have already mentioned the idea of the circle as the virtual pattern of the many different personal stories around the dark centrer, Hans. In other places the circle is also a recurrent motif. We learn that Hans had a circle tattooed on his arm. The way the story is told, the narration, is circular as well: first we hear about Hans' death and then we trace back to his life, to return again at the end of the film Hans' suicide, discovering more details. The narration begins with the requiem of Misha Mengelberg and mother Truda, who recalls how she heard the terrible news about the death of her son on the phone. It is an impossible memory: 'I just thought [...] everything, everything is dead in the world. Everything turned cold. I lost my sense of smell. [...] Everything is dead. There are no more flowers.' Then we also see father Nico with his new wife, brother Ton, and Hans' 'last contacts', among whom are the singer Ramses Shaffy and the actor Willem Nijholt and several of Hans' ex-girlfriends in the Netherlands and in England where Hans had been to school. And then we move back in time, to all kinds of memories of Hans' life. The kind of child he was, how his teachers saw him, recollections of several girlfriends, friends and police officers. We learn that Hans' grandmother on his father's side died in Auschwitz at the age of 74 (she was Jewish; the grandfather died in 1940, sparing him the horrors of the war); and that his grandfather on his mother's side was deported because he was a communist. We learn that Hans was a brilliant student but consumed by internal demons, which made him unreachable to others; that he was able to quote existential philosophy and poetry at

any given time, and was obsessed by Claude Debussy, Arthur Rimbaud and especially Georg Trakl, the Austrian poet who was preoccupied with death and also died young; and that he had an addiction problem, always looking for another stimulating drug, but never experiencing any kind of pleasure from it.[18] In February 1962 he handed himself in at a police station in the centre of Amsterdam (bureau Leidseplein) with a tiny piece (420mg) of hashish and a pipe, asking to be detained. He was in prison for six months. The police officer, Rein Verhaaf, recalls this event as Hans' cry for help to find a way out of his darkness. It would soon appear to have been in vain. The circle of his life closed a year later.

Photographs play an important part in all the interviews and they introduce the idea of the circle as 'cycles' of life. Obviously there are many pictures of Hans in private albums, old shoeboxes, and in photo frames of his family and girlfriends. In the houses that Van Gasteren enters with his camera the walls are covered with family photos. There is a point, at the beginning of the film, where Van Gasteren is in conversation with a friend (Henny Spijker) about the parental responsibilities. The camera captures Dunja, the young daughter of Henny, and scans the wall covered in photographs. Van Gasteren explains that he is asking about this 'because in this film that I am making, I see so many people, who all have pictures with babies in their arms; who all started full of hope and good intentions. You can see it [...] all breast feeding, and everywhere fathers happily smiling. [...] What is this process, that people all begin; in the houses of all these divorced people we find the same pictures?' Then Misha Mengelberg's 'In Memoriam' returns on the sound track, while we see another photo album opening: family outings, a married couple, and parents with children. On the reverse of one of these photographs we read a message from the photo studio: 'We guarantee that this picture will never fade.' But in reality the pictures do fade, as do all the steps in life. While we see more of these generic family portraits covered by the sounds of 'In Memoriam,' Van Gasteren voices the words that could be considered the essence of the filmic investigation:

> This music left a deep impression on me at the time. Because in it, I recognized universal human processes. Processes that we all go through during our lifetime. Fights – parents (the nest) – looking for your own identity – choosing your partner – your job – your ideals. [...] Processes that are repeated in everyone and that find a solution, or not. Until you die. I think it was no different for Hans van Sweeden.[19]

Everybody in the film that Van Gasteren is in dialogue with has something to say about these cyclical processes. Some are happily married with children,

most are not. One of Hans' former English girlfriends, Elspeth Pattenden, for instance, surrounded by her small children, openly confesses that her marriage does not work. Her husband has affairs with other women, just like her father did. She is disturbed by the fact that she is repeating the same cyclic pattern. 'You know, it's just unbearable […] the repetition of one's parents' life into your own life, it makes you want to scream. […] And this is something I want to protect my children from […] by some conscious effort. But the unconscious is so much more powerful than the conscious, that I don't know how I can avoid […] avoid it all happening again.'

Another remarkable conversation that returns throughout the film is with Joan van Heyningen. She talks about her youth. The daughter of a Nazi collaborator, after the war it was traumatic for the young child to go back home to a plundered house and to be scorned by all her classmates at school. When her father finally returned home after his sentence, she and her siblings presented him with a piece of (rare) chocolate they had saved for him; they knew it was his favourite. A few weeks later, the father met a woman that he fell in love with. He left his wife and children. For the young Joan it was another rejection. Her own marriage ended badly, too. At the time of the interview in the late 1970s both her children are addicted to heroin. It is only at the end of the interview that we find out that Joan van Heyningen had a relationship with Hans and actually 'plays the role' of 'final contact'; she talks about her fear for the darkness inside him. She had locked herself into her room when, on that fatal evening in 1963, she heard a shotgun from the atelier and called the police. With the police, she found Hans – with a hole in his chest.

All the stories of the people that Van Gasteren portrays are multilayered, addressing memories of the war, dysfunctional parent-children relations, and recollections of Hans van Sweeden who embodied all of these layers. The traumas of the war are still palpable in the post-war cityscape and in the post-war generation who had not yet found a good way of creating alternatives, but who were resisting by escaping into jazz, poetry and narcotics. These are the collective affects that can be felt in all the conversations. At the end of the film we return to the shaving scene from the beginning, Van Gasteren's hand is cleaning the razor. Then Joan van Heyningen says: 'I think it is worthwhile to continue living. I have really good experiences as well as awful ones. But I am very glad I have them. And that I am here.' These words are immediately followed by Van Gasteren, clean shaven, looking at his naked face in a mirror. The mirror has a circular form. Without talking directly about his own life, Van Gasteren has also investigated his own existential questions.[20] Then we return to Misha Mengelberg and Van Gasteren at the graveyard. They express the general incapacity to deal with death. Van Gasteren is standing in front of Van Sweeden's tombstone. He looks to the left, to something off-screen. He

(and we) see(s) Hans as a child in a home movie, running and playing in the streets. Mengelberg playing at the piano his requiem for Hans van Sweeden, completes the many circling movements of the film and turns Hans into 'HANS' or life before death in a portrait of a generation looking back to its youth, trying to escape the cyclical patterns of repetition and failing, but also 'failing better'[21] in a desire to live life before death.

STIRRING THINGS UP AND PSYCHEDELIC ESCAPES

The references to drugs are fairly limited in HANS. Van Gasteren did not want to put all the emphasis on such a controversial issue and distract from the more fundamental questions asked by the film. However, it is common knowledge that youth culture in the 1960s also meant the rapid rise of the use of all kinds of psychedelics and narcotics. The documentaries THE SUBSTANCE (Martin Witz, 2011) and MAGIC TRIP (Alison Ellwood, 2011) contain interesting historical footage about the introduction and expansion of the use of LSD. Invented in Switzerland by Albert Hofmann during the Second World War, the mind-altering chemical substance was initially only used in medical contexts, to treat mental illnesses as in the therapeutic treatment of war trauma in NOW DO YOU GET IT, WHY I AM CRYING? (Van Gasteren's film, discussed in the previous chapter). But soon enough mind expansion became an important tool in the counter-cultures that started to emerge in the late 1950s and early 1960s. In the US, writers like Ken Kesey and scientists such as Timothy Leary used LSD and other psychedelic substances extensively. Kesey and the Merry Pranksters drove through America disseminating youthful rebellion, marijuana and LSD.[22] Timothy Leary, who as a scientist started experimental research with psilocybin and LSD at Harvard and later continued his psychedelic mission at the Millbrook estate, advised a whole generation to 'turn on, tune in, and drop out.'[23] Beyond the original medical context, chemical substances such as LSD were initially also meant as instruments to obtain different levels of consciousness, insight and wisdom. Timothy Leary compared it to a microscope that allows you to see different dimensions of reality that are not visible with the bare eye. And even Leary, known for his seemingly unlimited enthusiasm for psychedelic substances, initially argued for strict licensing and training to learn how to deal with these newly opened doors of perception.[24] But the popularization of these mind-benders also increased the risk of abuse (ranging from bad trips to psychotic breakdowns and even suicides). In 1967 LSD was forbidden by law.[25]

Mind-altering substances played an important and destructive role in Hans van Sweeden's life, too. In the subcultural scene of Amsterdam in the 1960s

the use of LSD, marijuana, mescaline, peyote and psilocybin mushrooms as well as alcohol, endless parties, wild dancing, happenings and confrontations with not only parents but also the police played an important role. When the film about Van Sweeden was finished, Van Gasteren still had hours and hours of film that addressed these wild aspects of youthful resistance more directly. From this material he composed three episodes for Dutch television, entitled ALL REBELS (ALLEMAAL REBELLEN, 1983). ALL REBELS contains interviews with many of the same people that feature in HANS as well as some new faces and with more emphasis on the rebellious and resisting nature of the period that spawned the beatnik generation. As already indicated, much of the resistance of the 1960s generation was a reaction to the Second World War and the subsequent colonial wars. Very soon the Cold War and especially the Vietnam War would be added to the frustrations and anger of youngsters around the world. As the Dutch beatnik poet Simon Vinkenoog remarks in ALL REBELS, this whole new generation was troubled by the war and its consequences. Jazz and poetry were a guerilla fight against authoritarian society and against unjust warfare. In Europe, a remarkable event in June 1965 that marks this collective spirit of resistance was the International Poetry Incarnation in the Royal Albert Hall in London.[26] Seventeen Beat poets from different countries (among whom were Alan Ginsberg, Michael Horovitz, Ernst Jandl and Simon Vinkenoog) recited their poems during a happening, a sort of 'poetry rave', in a more than sold out concert hall. Adrian Mitchell's performance of 'Tell me Lies about Vietnam' most strongly expressed the feelings that were at the fore, powerfully captured in the Peter Whitehead's film WHOLLY COMMUNION (1965).[27] In the documentary film A TECHNICOLOR DREAM (Stephen Gammond, 2008) this Royal Albert Hall happening is recalled not only for its significance in making visible a widely shared like-minded attitude against the (Vietnam) war expressed in underground art, poetry and music, but also because of the heavy use and abuse of alcohol and drugs. Mind-expanding substances of all kinds were part of the rebellious strategy to break free, both among the poets and the audience. However, it also clearly spoiled some of the performances. Alan Ginsberg and Harry Fainlight, for instance, were hardly able to read their work in a convincing way. The destructive potential of substance abuse is painfully present as an element that would grow larger during the course of the 1960s.

By the time Van Gasteren interviewed the underground rebels of the 1960s in the later 1970s and early 1980s, the visionary and often also playful expressions of frustration and resistance against society had turned into disappointment in a much more nihilistic and grim atmosphere. In a foreword to the written publication of ALL REBELS, Duco van Weerlee acknowledges the remarkable form of double-track contemporary history that the series offers: broadcast in 1983 on national television, ALL REBELS is primarily a reconstruc-

tion of the 1960s but also says quite a lot about the 1980s. Van Weerlee elaborates:

> Of course, there is a big gap between the massive and desperate use of drugs in the 1980s and the romantic experiments with mind-expanding substances of twenty years earlier. While at the time the young generation rebelled against menial labor, today there is no work at all. If at the time the idea was to create an adventure, a fantasy, now all one seeks is an anesthesia, a protection against a future that consists of nuclear warheads, acid rain and diminishing social welfare.[28]

In A PHOTOGRAPHER FILMS AMSTERDAM (EEN FOTOGRAAF FILMT AMSTERDAM, 1982), filmmaker Ed van der Elsken portrays the city in the 1980s by observing rebellious adolescents in punk and new wave outfits, street musicians and all kinds of other people that fascinate the photographer. There is a strikingly prominent presence of junkies, hustlers and dealers in the centre of Amsterdam. Van der Elsken's camera is trained on a slogan written on a wall near Dam Square: 'I'm kicking my habit, I'm sick as a dog. And no-one sees my sadness.' It is a telling sign of the way drug addiction had become widespread and completely desperate and destructive. It is interesting to watch this film in relation to the work of Van Gasteren because it sketches the contexts from which the rebels in his films from the 1980s look back to their 1960s. As Van Weerlee argues:

> Retrospectively the (sometimes fatal) psychedelic experiments are rather touching. [...] Even in the most daring experiments there was a form of idealism. [...], the hope that chemical substances would give deep insights and would lead to a new and better society. A lump of LSD sugar in Chroetsjow's tea and [...] ffftttt [...] bye bye atomic bomb![29]

This somewhat romantic idealism had completely disappeared by the 1980s. And the effects of substance abuse are also visible and audible in the faces and often stumbling search for words of the 'old rebels' that Van Gasteren has in front of his camera. Van Gasteren filmed not only the main counter-figures, but also the police officers and lawyers at the time. And so his film has great historical witness value combined with visionary insights. The words of Duco van Weerlee about ALL REBELS written in 1983 still sound remarkably topical today. Looking at the problems of the rebels who abandoned all constraints and plead for individual freedom, Van Weerlee argues that while in the West we may have banned religion, rituals and mystical experiences from our dictionaries, the consequence is that we 'stare in bewilderment at the booming

rise of Islamic fundamentalism for which apparently hundreds of thousands want to give their life.'[30] According to Van Weerlee, in the 1980s Europe and the US was quivering under a gigantic drug problem, the consequence of trying to fill the void of spiritual emptiness with narcotics. At the time of this writing in 2015 the drug problem may be less visible in the streets of Amsterdam and other gentrified globalized cities, but it is still there in the fringes of society, and otherwise replaced by another drug that has been around for a long time: the continuous desire for more money. After 9/11, the bewilderment of the 1980s regarding Islamic fundamentalism has turned into a new war, the war on terrorism.[31]

Returning to ALL REBELS, I would like to highlight a few of the many remarkable moments in the series. First, it is interesting to mention a few of the key players. Each episode opens with some eloquently expressed eccentric reflections and recollections of Robert Jasper Grootveld, who would become one of the founders of the Provo movement in 1965. Grootveld was an artist and playful provocateur, who was actually cautious enough not to take the psychedelic experiments too far. He staged himself as the 'Anti-Smoke Magician', organising ritualistic happenings to ban smoking in his Smoke Temple, an old workplace in the city centre that would soon burn down. While everybody enjoyed their cigarettes, chain smoker Grootveld included, he invited the participants of the happening to cough/chant imploringly 'Ugh ugh ugh'. He was arrested for painting the words 'cancer' ('*kanker*' or just a 'k') on advertisements for tobacco products. Robert Jasper Grootveld returns in each episode of ALL REBELS, commenting, for instance, on the word 'drug' that would have been derived from the word '*droog*' in Dutch, referring to the dried herbs that the merchant ships in the seventeenth century carried to Amsterdam; or talking about the lasting influence of parents, and about his mistrust of LSD, which did not have a natural background and tradition like marijuana. As he explains at the beginning of episode three, 'LSD has been invented in the 1940s by some pointed heads with some bottles and test tubes; it was radically different from the more natural marijuana.' During the happenings at his Temple, Grootveld was often accompanied by Bart Huges, a student in medicine who called his daughter Maria Juana, and who experimented in another way with opening the doors of perception. In 1964 he became famous for performing a trepanation on himself. I have already mentioned the film THE OPERATION, which Van Gasteren shot the day after Huges performed his radical act. ALL REBELS contains excerpts from this film, where Huges, in an apparently rational and 'scientific' way, explains why and how he did it, declaring that the world would be much better off if everyone were permanently high. Yes, there was idealism in the 1960s. Van Gasteren interviews Huges again in the 1980s on a heathland, while his girlfriend is standing on her head. They

are both still convinced that more brain blood volume is better for humanity. The singer Ramses Shaffy is another remarkable figure from 'the scene' who returns regularly. He recalls the endless parties where he sometimes stripped naked just to stir up the press, to create some motion in an otherwise ossified societal environment. Poetry slammer Johnny van Doorn (a.k.a. Johnny the Selfkicker, Electric Jezus, or Master of Chaos) performs his observations with intense passion, translating the desire for fire and change in powerful streams of sounds and words, such as in the poem 'A magisterial radiant sun' ('*Een magistrale stralende zon*'; the powerful alliteration gets lost in translation). We hear Simon Vinkenoog describe a psychedelic experience in the multi-colours of a green labyrinth. Others talk about the way one could literally only move 'tile by tile' towards belonging to the scene that was hanging out at the Leidseplein (Steef Davidson); about the wild parties in the houses of the rich whose son or daughter wanted to belong to the group (Ilse Monsanto); about the stolen food and booze; and about the infamous robberies of pharmacies and the subsequent jail sentences (Rik van Zutphen). Some recount childhood memories of the war, having witnessed public executions in the streets of Amsterdam (Gerrit Lakmaaker), or having lost a father who was shot during the war, apparently by accident (Fred Wessels). Others discuss the need to break away from the strangling norms of society and the power of jazz music, dancing, and sniffing ether to establish this escape. Yet another talks about his manufacturing of LSD, and the paranoid psychosis that it provoked in him (Onno Nol). He now survives on medication, just like his girlfriend whom he met in the mental hospital.

There are many more witness reports from different participants, but in one way or another they all express the absolute need for this rebellion to happen and the acknowledgement that in all its playful yet dangerous extremities it could not last forever. But it was the beginning of profound changes in the Netherlands. In *Nieuw Babylon in Aanbouw,* his book about the societal changes in the Netherlands in the 1960s, historian James Kennedy notes how remarkable and big these changes were. While the Dutch were traditionally known for their conservative religious society combined with a far from exuberant and pragmatic merchant spirit, within a decade Holland developed into the most anti-traditional country in the West. Kennedy quotes a British journalist who in 1967 already remarked laconically: 'The Dutch have stopped being dull.'[32] Kennedy observes that the 'cultural transformations were in many ways more far reaching than in the United States, and yet they were associated with much less violence.'[33] The Netherlands had no violent resistance movements such as the Weathermen in the US, the RAF in Germany, or the Red Brigade in Italy, he argues. The most violent moments were the riots in 1966 in Amsterdam, filmed by Van Gasteren in BECAUSE MY BIKE STOOD THERE. One of the reasons

for this low level of violence (both on the side of the state and on the side of the citizens), according to Kennedy, is the fact that the Netherlands had no Vietnam War. As I remarked at the beginning of this chapter the military actions in Indonesia did play an important role in the immediate post-war period, but those actions had officially ended by 1950. For a long time they were a forbidden topic, but they never had the immensely polarizing effect on society that the Vietnam War had in the 1960s. Kennedy mentions another and more important reason for the remarkable and rapid changes in the Netherlands. This is the fact that Dutch governors and rulers, united in a common fight against water, external threats and regional pluralism, had always learned to compromise (see also Chapter 2 on the so-called 'polder model' related to Dutch water management that has attracted Van Gasteren's attention in many of his other projects). Kennedy explains how the traditional institutionalized pluralism was of vital importance for the developments in the 1960s even if the exact explanations for the shifts in the mechanisms of power and cultural changes are debatable.[34] Kennedy's main point is that politicians, rulers and law enforcers had a very pragmatic and negotiation-oriented attitude that allowed for many changes and changed the country quickly.

The people filmed in ALL REBELS were all part of these changes, including the policemen and prosecutors that Van Gasteren, conscious of the power dynamics and relations between different groups in society, also managed to get to speak freely about their recollections of the time. Thus, it is rather moving to hear Rein Verhaaf of the narcotics brigade talk about the first appearance of marijuana in the Netherlands and the fact that the police also had to learn to deal with it.[35] Or to hear retired policeman Dirk Kuijper explain his strictness in applying the law, but always according to the principle of first trying to see the human, and only then the criminal. They might seem 'soft' law enforcers in the eyes of many, but it is this attitude that Kennedy described as being part and parcel of the liberal climate that Amsterdam and the Netherlands had at the end of the 1960s. Together, the players in ALL REBELS give a deep historical and psychological insight into the changes that the rebellious post-war generation brought about. The Netherlands would become known for its liberal political and cultural climate, even if by the 1980s both the rebellious youth culture and confrontations with the police had become grimmer. The death of another Hans, another young rebel, symbolizes the changed atmosphere. Squatter Hans Kok, guitarist in a punk band and drug addict, was arrested in October 1985 when he was occupying a house in Amsterdam with a group of other squatters. He was put in a police cell. The next afternoon he was found dead. The suspicious circumstances of his death were investigated several times and led to demonstrations against the police and the mayor of Amsterdam.[36] It is possible to say that the death of these two young rebels,

Hans van Sweeden in 1963 and Hans Kok in 1985, marked and symbolized the changes that had taken place within two decades. With his filmic research around the death of Hans van Sweeden and the portrait of all the rebels around him, Van Gasteren captured both the 1960s and the 1980s and the transformation of the youthful rebellion that had changed the city, culture and politics of the Netherlands.

ELECTRONIC BRAINS AND AUDIO-VISUAL INVESTIGATION OF PERCEPTION

As indicated earlier, Van Gasteren was a participant observer in this artistic counter-cultural scene in the 1960s. He tried everything to explore the borders of his consciousness and the frontiers of self, ranging from parachute jumping, to sensory deprivation tanks, to hashish, mescaline and LSD. He had LSD sessions at his house. Van Gasteren never took these drugs for a 'kick' but always for the purpose of investigating and finding out what the blockages and releases in the doors of perceptions are.[37] As an artist he was interested in exploring what one can see when new doors of perception are opened, either by translating inner vision and visual experiences, or by reflecting upon the powers of the medium in relation to what we (are able to) perceive. The experimental film OUT OF MY SKULL (1965) and the artwork SUNNY IMPLO (1970) are coloured by the LSD and other psychedelic experiences of the 1960s. In the DO YOU GET IT-films Van Gasteren investigates the nature of perception and how filmmakers can approach reality and create different perspectives on reality.

In 1964-1965 Louis van Gasteren spent time as visiting professor at the Carpenter Center at Harvard University. During this period he met, among others, Marshall McLuhan, Timothy Leary and filmmaker Robert Gardner. He made a short experimental film with Gardner, OUT OF MY SKULL (1965). The soundtrack of OUT OF MY SKULL was made to be reproduced by four speakers, positioned in the front, back, left and right sides of the theatre, with sound emanating from different speakers at different times. The images were accompanied by stroboscopic effects from a stroboscope that was switched on after the credit titles and flashed at different speeds, according to a precise script. No other light sources (such as exit signs) were supposed to distract or orient the viewer other than the film installation itself. From the screen and soundtrack we see and hear images and sounds from American radio and television in the 1960s (advertisements for cars and toothpaste; fragments of American television; Elvis singing 'Return to Sender'; and radio messages about the war in Vietnam). These elements all represent the loud and fast pace of American life and the role of consumerism and politics. They are intercut with the face of Van Gasteren himself moving in slow motion. He reacts slowly,

muscle by muscle, as pies are thrown in his face; Robert Gardner throws them from different angles. With this film, Van Gasteren wanted to investigate the deconditioning of perception that is comparable to the use of hallucinogenic drugs such as LSD. Conscious of the dangers of psychedelic substances, Van Gasteren wanted to create a safer way for mind-bending experiences, which he deemed important for understanding more about the multi-dimensionality and countless perspectives on reality that the world and human existence and experience is composed of. The film installation with psychedelic sounds and images was shown several times in Amsterdam in the Stedelijk Museum, sometimes accompanied by performances by Misha Mengelberg, Simon Vinkenoog and Johnny van Doorn.[38] Interestingly enough, in 1967 the Ministry of Social Affairs and Public Health investigated whether the film experience of OUT OF MY SKULL would be a danger for public health (beyond the obvious dangers of epileptic seizures that stroboscopic images can induce). In the report for the Board of Health (Gezondheidsraad), Van Gasteren explained:

> We are all bound to conditioned experience. If I put a cup on a saucer, I hear its sound. When I hear somebody say 'yes', I see his mouth opening. If I jump out of the window, I fall. If I hear the sound of a car, I know that if I look out of the window I will see it passing. However, there are experiences that are not conditioned, such as the passing away of a loved one. In such circumstances perception is altered. The mourning visits, the funeral, we experience it as if it were dreamed-up [...] Hallucinogenics such as LSD, marihuana, etc. liberate one from the conditioning of everyday perception and experience. [...] [They] are a short-cut to these altered experiences, although they are not without dangers.[39]

The report was inconclusive, but the film was censored by the Board of Film Examiners. The argument was that they had not been able to see the film as it was supposed to be seen (with the disorienting sound and light effects). Van Gasteren objected in a letter arguing that the Board of Film Examiners also never experiences screening conditions such as out of focus projection, the selling of ice cream and drinks, the torch light of the usherettes, the emergency exit lights, or nebulas of perfume. Moreover, at none of the screenings was revolution proclaimed, nor had anyone been hospitalized. He felt the prohibition of his film was a blocking of artistic experimentation. If there were to be any future screenings of OUT OF MY SKULL, Van Gasteren declared to the committee, he would use changing artistic means:

> Besides the stroboscopic effect, I intend to have 63 Provos marching across the screening room, and I will leave it to the public – for reasons of

artistic interactive participation – if they want these Provos to be expelled by the police, or if they can smoke a cigar and put on 63 (rented) police uniforms, which will then give them the power to flog the audience out of the room. Image and sound track remain the same, obviously.[40]

By 1967, LSD was forbidden and prohibition, caution and warnings became part of the national discourse. Moreover, other films that were addressing the LSD experience more directly contained disclaimers. Roger Corman's cult film, THE TRIP (1967), for instance, is a perfect illustration of the spirit of the time.[41] The film starts with a written and read out warning that 'you are about to be involved in a most unusual motion picture experience that deals with LSD' and ends by saying that 'this picture represented a shocking commentary on a prevalent trend of our time and one that must be of great concern to us all.' In THE TRIP, Peter Fonda takes LSD for the first time and we experience his trip in all its dimensions of colours, in the moment he makes contact with the sun, but also when it becomes scary and paranoid feelings of being persecuted capture him. Dennis Hopper is his hippie friend who, at a certain moment, worriedly asks him: 'You saw that for real, I can't tell whether you're being straight with me or if you're out of your skull.'[42] The film ends with Fonda's head in close-up, the image breaking open like a mirror, indicating the 'out of skull-ness' of the experience. But the point of it all is, of course, that these 'out of skull' experiences are real as well. They are just from another dimension that we cannot always see from behind the doors of our habitual perceptions and conditioned experiences. The need to break those conditions open was widespread in the 1960s and Van Gasteren investigated this impulse by artistic means.

Van Gasteren made another interesting art work (featured on the cover of this book) that aimed at a safer, non-chemically induced trip. SUNNY IMPLO (Van Gasteren & Fred Wessels, 1968-1970) consisted of a huge orange polyester ball (2,40 m diameter) suspended 1,35m above the ground, with an opening of 80 cm at the bottom that allowed somebody to enter its spherical interior, where one could experience light, sound, and colours from 125 light points and four speakers, driven by an 'electronic brain'. Visitors would be disoriented at first but then experience an 'isolated moment of rest in an otherwise increasingly overloaded society,' the press release said. SUNNY IMPLO was meant as 'a tool for auto-therapy.'[43] It could be placed at street corners or in psychiatric wards. It was shown at the Stedelijk Museum in 1970 and bought by the Municipality of Amsterdam. Unfortunately, it was stored in a warehouse that was remodelled in the 1980s, after which SUNNY IMPLO could not fit through the smaller, narrower door. In 1986 Van Gasteren had to destroy the work, thus closing a beautifully creative door of perception.[44] As indicated before, in the outside

world the experiments with altered states of perception had got out of hand and so perhaps the destruction of this playful and imaginative artwork in the 1980s was a symbolic gesture of the end of an era of experimenting with mind expansion. Yet, after a period of severe restrictions and total ban, the possible benefits and therapeutic value of chemical substances such as LSD are slowly back on the agenda in medical and legal contexts.[45] And the electronic brain is still functional and stored in Van Gasteren's house. Perhaps SUNNY IMPLO could be revived one day as well. Besides being a symbol of Van Gasteren's most productive artistic period and a colourful era in the city of Amsterdam, it is also possible to see SUNNY IMPLO as a symbol of the power of art to intervene in our perception of the world in an imaginative and lucid way that nevertheless has a serious engagement with the world behind it. The fact that it no longer exists, except in parts and in images, is all the more significant for the many artistic interventions that need to be kept alive to be passed on to subsequent generations.

In the 1960s and early 1970s Van Gasteren explored in several other films the problem of perception and the ways in which film can be used not only to record but also to analyze perceptual dimensions. The short film BECAUSE MY BIKE STOOD THERE (1966), which is also known as DO YOU GET IT NR.1, shows how during a demonstration in Amsterdam the police used violence against a man passing by. The raw footage was shown that same evening on national television. Later, Van Gasteren added an interview with the man who was hit and he slowed down and repeated the images, laying bare its more hidden dimensions. This analytic treatment of the image was appreciated by scientists who used it to study human perception and behavioural psychology.[46] But the Board of Film Examiners then censored the film and it was banned for the next ten years until 1977. The argument for banning the film was that by slowing down and repeating the images and by adding an interview with the man that was hit, Van Gasteren made the film tendentious, manipulative, undermining of authority, and a threat to public order.[47] In both cases of censorship of Van Gasteren's work (for OUT OF MY SKULL and BECAUSE MY BIKE STOOD THERE) the problem was one of perception: individual perception and mental health or collective perception and public order were both considered to be at stake. In both cases, Van Gasteren demonstrated what a powerful tool the camera is.

Van Gasteren continued to put the image itself on the dissection table, analyzing what an image can do both in terms of people reacting to a camera and in terms of his power as an image maker. In DO YOU GET IT NR. 3 (1975), Van Gasteren takes a shot, filmed in an Italian harbour city, and carefully analyzes each image. The shot is 42 seconds long and contains 1048 images.[48] Shown 'just like that' the shot is nothing special, just a scene in a busy street, with passersby, a worker with a shovel and a police officer regulating traffic. But when

Van Gasteren, from behind the editing table, in the next thirteen minutes shows us image by image what actually happens, how people react to the camera and how this alters and influences behaviour, the viewer of DO YOU GET IT NR. 3 has to start wondering about the manipulative power of the camera, even of the so-called documentary camera. It is a question that has only obtained more pertinence in our contemporary camera- and image-overloaded world. A similar question of perception and interpretation of reality is asked in DO YOU GET IT NR. 4. Here, Van Gasteren filmed a scene from a window of a house in a little village, Teulada, in Sardinia. The film starts with Van Gasteren reflecting on his power as director:

> I monopolize / based on what kind of right / I wonder
> I thought / when I was standing there / How can I show this to others /
> As participant in these events / as observer of the reality / in which I then determine / the processing of time / and what happens.
> Just for a moment I thought / from what kind of source of information / do I understand what I see / or do I see what I understand.

In the following fifteen minutes we see what the director sees from his window, a street in a village, some people walking by, cars arriving. We hear in voice-over his reflections on altering the mise-en-scene for the film he has in mind (taking away or changing a sign, getting rid of the cars, etc.). And we see how the scene alters, still looking highly authentic but with details omitted and added, and is manipulated. In reality, Van Gasteren used documentary registrations of the same place, taken from the same window, but with a time lapse of six years. The first recordings were made in 1971, the second in 1977. The filmmaker created his storyline out of the superimposition of both documentary recordings. Again, as spectators, we are left with nagging questions about the dynamically changing ways of perceiving and understanding the world and the role of cinematography (including camera, editing, mise-en-scene, voice-over) to influence this perception. The films and artworks that have been discussed in this book all deal with these questions and with the search of human beings for a way of breaking free from conditioned experiences when they become too confining. They include experiments with inner and outer vision that do not always end well, but in which filmmakers, writers, musicians, artists as well as scientists have an important role to play.[49] In the 1970s, Van Gasteren would continue to explore the power of the camera, but his focus would shift to Europe and, more explicitly, to producing films for television. This will be discussed in the last chapter.

CHAPTER 5

Europe, Politics and Multinationals

The immense cruelties and sufferings of the Second World War had a traumatic impact on the psychology of post-war generations, as was discussed in the previous chapters, but there were additional repercussions. On a political level, it also foregrounded the need for a stronger and more unified Europe. In 1952, six European countries (France, Belgium, Luxembourg, the Netherlands, West Germany and Italy) formed the European Coal and Steel Community (ECSC). The aim was to make any new war between European countries (especially between France and Germany) 'not only unthinkable but materially impossible.'[1] Creating a safe and economically integrated Europe would become the first step. In 1957, the ECSC was extended with the European Economic Community (EEC) and the European Atomic Energy Community (EAEC or Euratom). The ECSC, EEC and EAEC are the three pillars that form the basis of the European Community. In 1973, the United Kingdom, Denmark and Ireland joined as member states, followed in the 1980s by Greece, Spain and Portugal. In 1998, Europe became a monetary union with the establishment of the European Central Bank (ECB) and the introduction of the Euro as common currency among member states that joined the Eurozone in 2001. At the time of writing in 2015, the European Union consists of 28 member countries and has become an increasingly complex organization. In some national parliaments and populations Euroscepticism has become an important political voice, and the extension of supranational forms of government is debated. Nevertheless, the ideals and aims of the European Union for a stable, sustainable and peaceful Europe remain more important than ever. While many policies or treaties have had unexpected complications and consequences, some of which will be addressed in this chapter, and while the risk of a supranational institution turning in to a too powerful super state is not purely imaginary, it is important to continuously re-evaluate the idea of

Europe in a globalized and hyper capitalist world with quickly changing balances of power.

In 1969, Louis van Gasteren founded the production company Euro Television Productions to make programmes in and about the European Community. Conscious of the fact that, at the time, many people were mainly informed by means of television, as a creator of images he felt it was his duty to take responsibility as a European citizen, entering into dialogue with fellow citizens about the intricate questions of the European communities. From the late 1960s and during the 1970s Van Gasteren left his studio and artistic practices to become a deeply engaged 'participant reporter'. Fluent in Dutch, German, Italian, French and English, he travelled throughout Europe with a microphone in his hand, accompanied by a small camera crew. He made a great number of reports from many different European regions asking, for instance, small farmers in France and Germany what they thought of European agricultural policies; talking with politicians, union leaders, and industrials; and even (in a more tongue and cheek way) asking the rock band The Who in London about what the UK membership of the EEC would entail. Van Gasteren met Sicco Mansholt in the late 1960s when he interviewed Mansholt in his role as European Commissioner for Agriculture; over the years they developed a deep friendship. Van Gasteren often accompanied Mansholt on his journeys in Europe, regularly interviewed him in Brussels and other locations, including Sardinia, where Mansholt had built a house. Sardinia had a special significance for Van Gasteren as well. In 1960, he visited this special island in the Mediterranean for the first time. The ancient geology, the cultural history and the raw authenticity of the Sardinians immediately captured his fascination and his curiosity. In the course of the 1970s he made three films in and about Sardinia. These films can be considered as anthropological studies of the island but they also touch upon the political issues that Van Gasteren addressed in his television work of the late 1960s and 1970s: Europe as a region and as a cultural and political body, as well as the increasing influence of multinationals, migration and tourism. This chapter will start by investigating the Sardinia trilogy, comprising the films CORBEDDU (1975), TO YOUR HEALTH AND FREEDOM (SALUDE E LIBERTADE, 1976) and THE SARDONIC SMILE (IL RISO SARDONICO, 1977). The middle of this chapter is devoted to CHANGING TACK (OVERSTAG, 2009), a portrait of the life and work of Sicco Mansholt. The last section moves beyond Europe: MULTINATIONALS (1974), REPORT FROM BIAFRA (1968) and REPORT FROM KARTHOUM (1971) will take us to the continuing and increasingly devastating legacies of colonial politics and neo-colonial global capitalism.

SARDINIA, EVOLUTION OF ONE OF THE OLDEST 'HOMES' OF HUMANITY

In the documentary portrait A CHAINSAW FOR THE PAST we see Van Gasteren walking among the sheep in the rocky pastures of Sardinia. He takes the director Ad 's Gravesande to a deserted shepherd's cottage (a so called 'ovile'): a hut made out of rocks, branches and twigs. In this place Van Gasteren spent some time as assistant to a shepherd, sleeping on the dirt floor, making a fire in the middle of the hut, experiencing for himself what it means to be a Sardinian shepherd. Van Gasteren recalls that one night while they were sleeping in the protected shelter of the deserted cottage there was a loud knock on the wooden door. 'I thought, all right, now it is happening, now a Dutch filmmaker will be kidnapped,' Van Gasteren recalls. Kidnappings take place quite frequently in Sardinia, especially in the mountainous inland region. Luckily, that time it was just a drunken shepherd from a nearby flock who was looking for another drink. For Van Gasteren, always searching for the essence and deep roots of everything, ranging from the first life on earth to his own inner psychology, the harsh conditions of life and the primitive roots of human civilization that he found in Sardinia were of special attraction. For 40 years, Louis van Gasteren and his wife and longtime collaborator Joke Meerman have spent a few weeks in Sardinia every year. When he first visited the island in 1960 (on his honeymoon with former wife, Jacqueline), Van Gasteren had a desire to leave the confinements of his family and his surroundings in the city of Amsterdam, the beautiful but also inescapable city of Hans van Sweeden and the artistic subcultural scene described in the previous chapter. Van Gasteren took a map of Europe and randomly chose a location to escape to: his finger landed on Sardinia.

He immediately fell in love with the atavistic authenticity of the Sardinians and was intrigued by the level of crude violence on the island. Sardinia is one of Europe's oldest inhabited lands. Situated between Africa and Europe, the island has been invaded by many different peoples. The Phoenicians, the Greeks, and the Romans drove the native Sardinians into the inland mountain regions, where they kept their traditions, built a network of intriguing towers, so-called Nuraghi, and lived off the products of the land. The Sardinians still consider the mainland Italians (especially the Italian military police, the *carabinieri*) as intruders. Betraying someone to the Italian police is a betrayal of the code of silence (*omertà*); the Sardinians have their own system of unwritten justice. Around the time of Van Gasteren's first visit to Sardinia, Vittorio De Seta made BANDITS OF ORGOSOLO (BANDITI A ORGOSOLO, 1961), a fiction film that shows the beauty and hardship of the island and the tragic fate of shepherds turning to banditry as their only option for survival. BANDITS OF ORGOSOLO is a film shot in black-and-white compositions that frame the Sar-

dinians in their inhospitable and unforgiving landscape. The film opens with a group of men hunting in the mountains while a voice-over explains that the Sardinians have remained with their own laws, not moving into the modern world save for the guns they use for hunting, defence and attack. The voice-over states that these men can become bandits at any moment even without realizing it. The protagonist of De Seta's film is the shepherd Michele who, together with his much younger brother Peppeddu, earns a sparse but honest living by herding sheep and making cheese. One day, some bandits that have stolen some pigs take shelter in Michele's sheep cottage. Then the much hated carabinieri arrive. The bandits escape, leaving Michele with a stolen pig. In an arrogant and scornful way the carabinieri accuse him of theft. But the shepherd's omertà keeps him from telling the truth. This leads to a series of tragic events in which he loses his entire herd, his home and his hope for an honest life. At the end of the film, Michele sees no other option than to steal the herd of another shepherd. He has become a bandit himself.

Besides the tragic story of Michele's fateful recourse to banditry, BANDITS OF ORGOSOLO also gives a beautiful impression of the nature and customs of the Sardinians, who had largely kept their age old traditions of clothing, preparing food, rituals and dialects. After his first visit in 1960 Van Gasteren returned to Sardinia in the 1970s and then made three films about this island. The Sardinian trilogy was shown on Dutch television between 1975 and 1977 and, as film critic Bertina at the time said in his review, the films of Van Gasteren could very well be seen in combination with FATHER, MASTER (PADRE, PADRONE, Paolo and Vittorio Taviani) that won the Golden Palm in 1977.[2] The film of the Taviani brothers is based on the autobiographical book by Gavino Ledda, the son of a poor shepherd family in Sardinia who, at the age of six, was taken out of school by his father to herd sheep. He grew up lonely and illiterate under the reign of terror of his violent father. When Gavino was twenty the family was forced to sell their farm (after a severe winter destroyed the olive trees) and he managed to leave the island by joining the army. There he learned to read and write and became a linguist and author. The Taviani brothers made a powerful fiction film out of this true story, combining realism and authentic locations with Brechtian distancing and almost surreal intimacy of inner-voices (in one sequence we even hear the thoughts of a recalcitrant sheep). Breathtaking landscapes and devastatingly violent relationships permeate all images. Both De Seta's and the Tavianis' film contain elements that Van Gasteren would uncover in his deeply engaged Sardinia films in a more ethnographic and documentary way.

CORBEDDU (1975), the first part of the trilogy, centres on the Sardinian Robin Hood of the nineteenth century, Giovanni Corbeddu, the legendary bandit from Oliena who stole from the rich and gave to the poor. The film

starts in Barbagia, the mountain area of the inner island, where we first meet some of the shepherds that guided Van Gasteren in many of his explorations. Van Gasteren and his film crew enter the cave of Corbeddu that served not only as his refuge and his home but was also the place where Corbeddu held trials according to the unwritten Sardinian laws of justice and codes of honour. Local Sardinians recount the legendary tales of their bandit hero Corbeddu, the uncrowned King of Sardinia. We also meet a pair of Dutch-American scientists, the paleontologists Hans de Bruijn of the University of Utrecht and Mary Dawson of the Carnegie Museum of Natural History of Pittsburgh. They discovered in Corbeddu's cave the fossil skeletons of the Prolagus Sardus, a prehistoric hare that is a remnant of extinguished life and one of the oldest forms of mammal life in Europe. The Prolagus sardus lived 30 million years ago. Van Gasteren not only brings his camera and cabled equipment over the mountains into the grotto, but also films speleologists who climb the most difficult places and a flute player who demonstrates the beautiful acoustics of the cave, the tones of the flute rhythmically edited over the dripping of water, forming stalagmites and stalactites. Combining all these elements, the grotto of Corbeddu not only comes to stand for the atavistic Sardinian way of life and the shelter of one of its remarkable inhabitants, but also, in a way, becomes the oldest house of humanity. At the same time, there is a more pessimistic implication in the film. The perspective of the paleontologists looking for the remains of extinguished life points to the possible extinction of the Homo sapiens as well.

This pessimistic and worried aspect is reinforced by another strong element of the film, which is the introduction of the (petro)chemical industry and the tourism industry, which are slowly but surely breaking down old forms of life and the environment: factories and flats, waste and rubbish disturb the serenity of the surroundings. Japanese factory workers explain why they have come to work in the chemical industry on Sardinia. One scene in CORBEDDU perhaps best captures this idea of rapid change and modernization: One day, as Van Gasteren and his crew were driving on the island to film farmers working the land, they entered a small village where they saw a funeral. The deceased was a man of 48, a labourer in the petrochemical industry who died of cancer, a disease of the last century that has everything to do with human evolution. He was brought to the graveyard in a Mercedes Benz and not carried by the villagers as was customary, a symbolic image that for Van Gasteren stood for the next invasion of the island (and of humanity): the multinationals that buy out the farmers and shepherds to build large polluting industries. 'Because of the sea wind on the island, they are not polluting at all,' the mayor of the village where the chemical plant is located argues in the film. Van Gasteren wanted to raise awareness of the devastating ecological effects of

the industry, but he also realized that his film could stimulate tourism to the island, which can have similarly destructive effects.[3] This was an unavoidable paradox, though he intended for his films to create a more aware and critically conscious form of tourism. In TO YOUR HEALTH AND FREEDOM (1976) Van Gasteren further elaborated an informed perspective by investigating the ancient cultural history of Sardinia. For instance, he visited the mysterious networks of Nuraghi that date from 1500 BC. Spread across the island, 11,000 of these edifices still remain. These towers served as fortresses, storehouses, or as holy places of worship. In 1968 an underground temple from 900 BC was found in a grotto, indicating a cult of the dead and the underworld. TO YOUR HEALTH AND FREEDOM emphasizes the ancient traditions of baking bread, wine (and the traditional toast is to drink to both health *and* freedom), and the matriarchal structure of inland Sardinian culture. At the same time, this episode of the trilogy begins and ends with migrants returning to Sardinia by boat and tourists arriving mostly by plane, all on a brief vacation.

In THE SARDONIC SMILE (1977), the engaged anthropological search continues, this time focusing on the old rites that are considered to have magic powers that might be connected to the famous 'sardonic smile.' In common parlance, a sardonic smile has come to mean a bitter or scornful smile. But the roots of this expression go back to pre-Roman Sardinia where a bitter honey elixir or special herb was used as a neurotoxic to put people in trance. Sometimes, during these ritual trances elderly people who could no longer support themselves were killed by being thrown off the rocks. The elixir (used by both the performers and 'willing victims' of the ritual) caused a muscle spasm that provokes the typical grin of what we have come to recognize as a sardonic smile, which was passed on heretically over the ages. Another magical ritual that Van Gasteren captured in THE SARDONIC SMILE is the annual Mamuthones feast in the village of Mamoiada. Once a year, the men dress in black sheepskins, black masks and cow bells, dancing and lassoing in rhythmic movements in the streets of the village. In this 'pre-logical' way they chase away evil spirits and protect the women. One of the men participating in the ritual, the black hairy skin on his shoulders but without a mask, tells Van Gasteren that, as a man of 70, when he puts on the ritual clothing, he feels empowered, full of courage, and it is as if he is 25 again. Van Gasteren registers the rituals and records the insights and knowledge of the local shepherds, politicians and scientists (Professor Carlo Maxia), and observes closely. Among the dancing men, tourists are taking pictures.

Perhaps it is ironic that Van Gasteren won the so called ANWB prize for his trilogy. The ANWB is the Dutch roadside assistance organization that nowadays gives awards for best camping sites, most popular car, or best travel insurance deals. But they used to have a film prize for Dutch filmmakers as

well. In 1977, the ANWB awarded Van Gasteren a prize for 'understanding tourism' and for making an ideal and idealistic travel film.[4] In a way, Sardinia is a metonymy for general development across the globe, where multinationals and tourism have become dominant factors in the economy and pollution (as well as the exhaustion of energy resources) has exponentially increased. The rampant power of multinationals and ecological concerns for the globe would return in other instances in Van Gasteren's work for Euro Television Productions in the 1970s and in the film he made about Sicco Mansholt in 2009 that contains a wealth of archival footage from this period of time.

SICCO MANSHOLT AND THE EMERGENCE AND EVOLUTION OF THE EUROPEAN UNION

On 25 March 1957 the Treaty of Rome was signed, marking the beginning of the European Economic Community. For politically strategic reasons the EU has three places of work: in Strasbourg, Luxembourg and mainly Brussels.[5] For a long time, however, Europe was not a widely known concept among citizens in the different European member states. Louis van Gasteren saw it as one of his tasks, and more generally as a task for television (which by the end of the 1960s had reached most households), to help inform the public about the state of affairs concerning Europe and European collaboration. With his company, Euro Television Productions, he started work on a series of television reportages from different European regions, investigating and informing the European community. REPORTS FROM EUROPE NR. 1, for instance, explains the main European institutions at the time (European Council, European Commission, European Parliament and the European Court of Justice).[6] Van Gasteren interviewed European politicians and citizens in their own language. The many languages are obviously one of Europe's charms but, at the same time, also one of its problems, rendering intercommunication more difficult, translations laborious and not always available. Van Gasteren starts REPORTS FROM EUROPE NR. 1 by asking a passerby on the Dam in Amsterdam: 'What do you know about the EEC?' The man answers in Dutch with a Flemish accent: 'I am not from Amsterdam, I have no idea, I'm from Brussels.' And in Rome only one person in a group of European tourists knows that the Treaty of Rome was signed there. Van Gasteren also shows trucks and cars queuing at the border for passport control, asking drivers what they would think of just continuing on their road without those checkpoints. The Treaty of Schengen in 1985 and the Treaty of Amsterdam in 1997 would regulate a borderless Euro-zone but in the early 1970s this seemed like wishful thinking and a distant prospect. REPORTS FROM EUROPE NR. 1 ends with Sicco Mansholt, the first European

Commissioner for Agriculture, who introduced agricultural politics, one of the most important pillars of the European Community. Van Gasteren interviewed Mansholt on many occasions, at many different locations throughout Europe. Many of these interviews, dispersed among various REPORTS, were brought together in a new composition in CHANGING TACK, a biographical documentary film about Mansholt as visionary politician that Louis van Gasteren and Joke Meerman presented in 2009. A year before, on the occasion of the hundredth anniversary of Mansholt's birthday, they had presented a short film, SICCO MANSHOLT, FROM FARMER TO EUROCOMMISSIONER (SICCO MANSHOLT, VAN BOER TOT EUROCOMMISSARIS, 2008). But it is the longer film CHANGING TACK that is not only a respectful and moving tribute to a friend, but also a historical document that gives insight into an important period of post-war European history that remains relevant today and that contains some visionary truths.

CHANGING TACK opens with black-and-white images of the sea filmed from a helicopter, which feels like a fast sailing ship, and the voice of Jacques Brel who sings his famous song 'Le plat pays'. As soon as the shore is reached, instead of water we now see the 'flat land' of the polders, the fields, the villages and trenches. Then, there is a transition to colour, as we see a boom with a sail, tacking. While the title and opening credits appear, Sicco Mansholt appears on the other side of the boat, the image zooming in to a close-up of his face, Brel's voice ending his song with '*le plat pays qui est le mien*' ('this flat land that is mine). The film then opens with footage from the national television news announcing Mansholt's death in 1995. The news item summarizes his public life, thus introducing Mansholt's significance at the beginning of CHANGING TACK. Mansholt (born in 1908) was just like his father and grandfather, a gentleman farmer with a socialist heart. Immediately after the war, from 1945 until 1958, he became Minister of Food and Agriculture in the Netherlands with a keen eye for small farmers and agrarians. From 1958 until his retirement in 1972 he was Commissioner for Agriculture in the EEC. In this capacity he managed to regulate the agricultural policies between the European member states, which led to stable prices and modernization. This policy, however, also had the unforeseen and undesired side effect of overproduction and bio-industry. When Mansholt realized these consequences of the logic of the system, he was the first to acknowledge the problem and made a turnaround, calling for a solution to adapt to the situation, but the mechanisms set in motion were hard to combat. In his free time, Mansholt was an avid sailor who loved to spend time on the water, alone or with family or friends. The Dutch title of the film, '*Overstag*', is a typical Dutch term related to the sea and water, meaning to tack. But metaphorically, '*overstag gaan*' also means making a turnaround, changing one's mind, which was the most remarkable and courageous move that Mansholt made in his life.

After this introduction, which concisely captures the essence of Mansholt's legacy, CHANGING TACK then follows the unfolding of Mansholt's life and work in chronologically ordered chapters. As with HANS LIFE BEFORE DEATH, the film brings together many different formal elements: interviews with ministers and politicians, collaborators, farmers, and his children; audio commentary in voice-over by Van Gasteren himself; sequences from the many different interviews and REPORTS that Van Gasteren made with Mansholt in the 1960s and 1970s; archival news footage; as well as photos from family albums and home movies that the Mansholt family made available. Brel's song 'Le plat pays' played on the piano (by Gijs Leegwater) returns as a musical motif at regular intervals. The music not only connects the different visual elements and gives a rhythm to the diversity of images but also creates a melancholic atmosphere and expresses a deep bond with both the flat farmland and the sea. It expresses in a musical way something of the energy below the surface that gave Mansholt his characteristic relentless drive to work for a better future.

This connection to water as well as the regained land and polders, the attention to both the small (the home, the farm, the land) and the globe, the concern for Europe and the unbridled energy to engage with the world, are certainly characteristics that Mansholt and Van Gasteren shared. It is not surprising they became intimate and trusted friends. One can sense from the countless interviews that we see in CHANGING TACK that Mansholt always took his time talking with Van Gasteren, who sometimes caught him at the strangest moments. Typically, Mansholt would address Van Gasteren's microphone first, even after long meetings of hours and hours with the European Council; he would talk about the offices and locations of the EEC in front of the Berlaymont building, the headquarters of the European Commission in Brussels, which was under construction in 1969. In the same year, Louis van Gasteren was with Mansholt in Kiel (Germany) where thousands of angry farmers who did not understand the reforms that Mansholt proposed were shouting and screaming. Mansholt sits behind a desk on stage, unable to speak because the farmers make sure he cannot be heard, waiting. Van Gasteren crouches beside him on stage, addressing Mansholt with his mic: 'What are the grounds for this protest?' Van Gasteren asks. 'Lack of wisdom, wrong information and quibbling politics,' Mansholt replies calmly, explaining with controlled anger and disappointment that he finds it deplorable he cannot resolve the misunderstandings about his plan to reduce the overproduction of agricultural products. Contrary to the perception of many farmers, Mansholt's plan to reduce overproduction was not at the cost of the small farmers for whom he proposed a very attractive social plan that was barely understood. In the next interview, Mansholt explained that his plan was boycotted by those people

who had an interest in keeping the situation as it was: political forces as well as big farmers who profit from the many small farmers who keep the price guarantees high, giving them huge profits. There are also other unexpected moments where Van Gasteren brings his cameraman and mic: sailing on the water, Mansholt talks about the risks they as Euro Commissioners had taken in regulating the market policy on agriculture, or about the production of wine in Italy, and the need for local manufacturing of rice in Asia; Van Gasteren even questions Mansholt the moment he gets out of the sea after a swim in Sardinia. While grasping a towel Mansholt prepares himself to answer when they both start to laugh about the unusual circumstances for a serious discussion. Because of the obvious friendship between these two men, many of these interviews are very different from those we commonly see with politicians; they form the lively heart of the film.

There is much more to say about CHANGING TACK and the significance of Mansholt, but let me just highlight and elaborate on a few moments that are illustrative of other issues that I have raised in this book and which are telling of aspects of Dutch and international political history.[7] In the first part of the film, which deals with the early years of Mansholt's life from 1908 until 1945, we come to know that he came from a family of gentlemen farmers in Groningen, in the north of the Netherlands. His grandfather, Derek Roelf Mansholt, was befriended by Douwes Dekker, better known as the writer Multatuli, who worked for the Dutch government in Indonesia. In his book *De crisis* (1974), Mansholt describes how his grandfather and Dekker played chess via letters that took eight weeks travelling by boat.[8] But chess was actually politics and each move was accompanied by political commentary that the two men shared. Mansholt recalls his grandfather reading these letters aloud and later, the visits of Dekker when he had returned from the Dutch-Indies, as Indonesia was called at the time. Under the name of Multatuli, Dekker wrote the novel *Max Havelaar*, first published in 1860, which is one of the most famous books of Dutch literature and the first open criticism of colonial politics.[9] After his schooling in colonial agriculture in the Netherlands, Mansholt also went to the Dutch-Indies to work on a tea plantation, where he remained between 1934 and 1935. In CHANGING TACK this episode of Mansholt's life is illustrated with private photos and film footage, while Mansholt's daughter Theda reads from *De crisis* how he felt imprisoned by the colonial system: big plantations, large factories, and not a penny for medical care for the local workers. In 1935, Mansholt returned from what he called an absurd system of colonial madness.[10] Upon his return to the Netherlands, he was allocated a farm in the just reclaimed Wieringermeer Polder, on which he laboured literally day and night (necessary to pay off his debts as quickly as possible). In CHANGING TACK we see images of Mansholt on his tractor, always carrying a gentlemen's hat. He mar-

ried Henny Postel in 1938. They would have four children before the end of the war. During the war years, Mansholt took care of food supply chains and the organization of the resistance movement. His farm gave shelter to tens of Jews and resistance members fleeing Nazi persecution. Three weeks before the end of the war, the Nazis blew up the Wieringermeer dike and the polder land was inundated; Mansholt's farm was completely destroyed. The war years and its aftermath had a lasting impact on Mansholt.

A few months after the end of the war, Mansholt was called to The Hague to become Minister of Food Supply and Agriculture. In the period immediately following the war Mansholt's main concern was to eliminate famine and make sure there would always be enough food. After the terrible and devastating Hunger Winter ('*Hongerwinter*') in the west of the Netherlands during the last year of the war (between November 1944 and April 1945 more than 20,000 people died of famine and cold), the primary goal was to make sure nobody would ever be hungry again. Mansholt collaborated internationally with the UN's Food and Agriculture Organisation (FAO) and was involved in the negotiations and implementations of the Marshall Plan, the large scale financial aid plan from the US to help rebuild Europe. In CHANGING TACK we see newsreel footage of Mansholt distributing soup. One means of safeguarding the food supply in the future was the industrialization of agriculture and guaranteeing farmers a stable income by increasing production (many small farmers lived below the poverty threshold) and regulating the price of agricultural products. Mansholt carried out this vision of modernization and market stability with passion and success on a national level. In the meantime, as mentioned before, the Dutch-Indies had proclaimed themselves independent and the Dutch government executed military operations (*politionele acties*) there between 1947 and 1949. Mansholt protested, but as member of the government he nevertheless assented to those operations. He did not resign. All his life he would regret acceding to an operation he did not want to support, calling this the black page of his political career and something unforgiveable.[11]

Between 1958 and 1972, Mansholt took the position of Europe's first Commissioner of Agriculture, initially with the same vision of modernizing agriculture and stabilizing the market, this time on a European scale. Several politicians and collaborators in CHANGING TACK emphasize what a miracle it was in those early years of the European Union to establish a common policy on anything, but especially on agriculture. De Gaulle's France was not keen on European collaboration and the Germans had very different views on what Europe should be. But Mansholt was a man with charisma and persistence. His English, French and German were far from perfect, he threw complete Dutch sentences into his speeches in other languages, but his performance was always convincing and everybody always perfectly understood what he

was saying. 'With Mansholt in the room you had to take care, because he was able to talk money out of your pocket,' ex-minister and diplomat Bernard Bot told Van Gasteren in 2009. Mansholt was famous for his marathon meetings, sometimes lasting the entire night with people falling asleep at their desks. At seven in the morning Mansholt, still fresh and awake, would then give a press conference, announcing the agreements. He managed to get France and Germany on board with his modernization plans, combined with a market policy for increased agricultural production in Europe, in this way pushing forward other fields of collaboration as well, especially the economic union. Small farmers borrowed money from banks and family members, bought machines, increased their production, and thrived thanks to the stable 'miracle prices'.

Soon enough, though, the logic of the new system had negative consequences that Mansholt neither foresaw, nor intended: by the late 1960s the production of milk, butter, meat, as well as olive oil and other agricultural products had taken on monstrous proportions creating a surplus that did not even fit in the warehouses. The surplus was dumped on third world markets, having a negative effect on economies outside Europe. To turn the tide, Mansholt wanted to lower the prices to reduce production, but this was met with heavy protests. Also, his plan to reduce the number of farmers by offering support to those who wanted to retire early or do something else was neither understood, nor implemented, as mentioned earlier in connection with the demonstration in Kiel. In CHANGING TACK we see Mansholt explain his plan on many different occasions, but footage of protesting farmers in Germany and in Brussels illustrate the heavy resistance he encountered. In 1971 a first draft of the *Report of the Club of Rome* appeared.[12] For Mansholt it confirmed his own observations of the consequences of unlimited growth of production, growth of population and of the exploitative use of natural resources. According to the Report of the Club of Rome, pollution, exhaustion of resources, overcropping, bio-industry and other unpleasant consequences of ever increasing industrialization formed a global problem. Mansholt was increasingly alarmed by all the effects of mechanisms that he himself largely helped to set in motion but that could no longer be stopped. In 1972, Mansholt wrote an open letter to Franco Malfatti, the president of the EEC, to plead for a new policy in line with the ideas of the Club of Rome, slowing growth and paying more attention to ecologically-friendly farming. Van Gasteren in voice-over states the response of Mansholt's colleague commissioners: 'Sicco, are you becoming a hippie?' The letter, which was widely distributed, was simply ignored.[13] A 1972 French television broadcast of Van Gasteren's SANS TITRE is used again in CHANGING TACK; here Mansholt's concerns are introduced by Jacques Brel's voice singing 'Le plat pays'. Mansholt would continue to express his concerns, but he became increasingly pessimistic about Europe's willingness to make changes

for the better. And even though Van Gasteren presents in CHANGING TACK a few farmers who did take Mansholt's concerns to heart and who made a transition to more ecological farming, it is clear that much still remains to be changed.

In the context of Mansholt's policies and his turnaround it is interesting to mention another film that was made in the wake of the Report of the Club of Rome, THE FLAT JUNGLE (DE PLATTE JUNGLE, 1974) by Johan van der Keuken. The film is about the Wadden Sea in the north of the Netherlands, an area that contains several islands and famous shallows. The Wadden Sea is sometimes called the nursery of the North Sea. For instance, millions of plaice larvae that are hatched in the North Sea are carried by the tide towards the Wadden Sea. There they grow up. In a long underwater sequence, THE FLAT JUNGLE shows how these tiny larvae meet the macoma shell fish that serve as their food. Van der Keuken switches perspective between the fishermen and the sea and the farmers and the land, mainly on the island of Terschelling, one of the islands in the Wadden Sea. Modernization in both farming and fishing is happening everywhere. Traditionally, clover extracts nitrogen from the air and helps the grass to grow. But industrially produced fertilizer contains more nitrogen which means more grass, more cattle, more milk, more business and more money. This, in turn, means more investments, larger farms, more cattle, more milk, more money, etc. A young couple explains how their farm has grown from seven cows to 45 and is still expanding. For them, modernization means producing as much as possible per hectare with modern machines and doing this with as few people as possible. Their discourse is contradictory. On the one hand, they are proud to grow and want to grow more; on the other hand, they also confess it is a rat race and a financial nightmare because of the high investments. Moreover, the young man acknowledges that he sometimes regrets that he is working only to produce a surplus. But still he does not intend to produce less, the investments have been made. The same goes for the fishermen, who have to grow bigger, borrow more money and get more fish or perish.

On the other end of the spectrum, Van der Keuken also interviews locals who are working to counter this non-stop growth and unlimited exploitation, such as an ecological farmer who grows clover (he is only seen in shadow), a cheese farmer who produces on the island, and a fisherman who began using more selective stationary nets and lower cost boats. But it is clear that in general, small and labour intensive farms have largely disappeared and large chemical factories are now providing the only job security for many. At the end of the film, Van der Keuken's voice transports us into the future:

> Never seen again: the fields of seaweed, sea horses, nude gasteropods, sea stickle backs, pipefish anemones, adders and broad-nosed pipefish,

oyster, sea trout, anchovies, dolphins, zuiderzee herring, porpoises, sturgeon. As for the blue sea holly, seals, cormorants, purple herons, storks, bitterns, sparrow hawks, barn owls, stone owls, dab chicks, spoonbill, garganeys, marsh harriers, Kentish plovers, sandwich sterns, dwarf sterns, and common sterns, they were only seen rarely. But hey, I didn't know what they looked like anyhow.

THE FLAT JUNGLE is a case in point with respect to the consequences of Mansholt's politics of growth and modernization. And like the Mansholt who read the Report of the Club of Rome, the film calls for more sustainable alternatives and shows what will happen if we fail to protect what needs to be protected. And while ecological movements and calls for more local and sustainable food have grown, the industrialization of our food production has not been turned around. Robert Kenner's revealing and troubling documentary FOOD. INC (2008) only confirms Mansholt's pessimism. American and, increasingly, global food production is in the hands of a few aggressively controlling corporations.

After Mansholt's retirement in 1973 he was present in London when the United Kingdom, Ireland and Denmark signed up as members of the EEC. In CHANGING TACK he points out the fruits and shoes from Italy in the shops and markets of London. He admits that this moment of expansion of the EEC is a great point at which to leave active politics, expressing his hope for continued collaboration on other levels in a sustainable and also politically more unified Europe. It is clear though, that Europe is still not a topic in the minds of many Europeans. Louis van Gasteren, who is with Mansholt in London, collects opinions from the members of The Who on the advantages of the European Union: 'Europe, well, it's more women around, isn't it,' and 'there is no harm in it, as long as it does not affect the price of contraception,' the pop singers muse. Nevertheless, both Mansholt and Van Gasteren have contributed to more political consciousness about the large issues at stake in European collaboration. After his retirement Mansholt would continue to be interested in and express himself on political issues. But he also worked on his dream of sailing the world. With his eldest son Gaius he built a boat, Atalanta II, and went on a one year sailing journey, all the way to the Amazon. At the end of the film, Cees Veerman, another Dutch ex-minister of agriculture who is a farmer himself, argues that it was typical of Mansholt to keep thinking about the small: one's own piece of land in one's own country and at the same time addressing problems of global scale and world politics. Mansholt was a man with a vision, but he also had the exceptional courage to act on second thoughts and new developments and insights that demanded a turnaround and change. From combatting famine beginning in 1945 and facilitating a pact between industry

and farmers in the 1950s and early 1960s, he saw that subsequent overproduction, combined with overpopulation, the growth of multinationals and the exhaustion of natural resources demanded a drastic new policy that still today needs to be implemented more widely. In the last images of CHANGING TACK we see an elderly Mansholt on his boat, communicating with Indians in their small boats on the Amazon river. The piano sounds of 'Le plat pays' accompany a zoom in to close-up and freeze frame on his face, while in voice-over Van Gasteren bids farewell to his friend: 'Sicco Mansholt died on 29 June 1995. A great citizen.'

GLOBAL CAPITAL AND NEO-COLONIAL WARS

One aspect of modernization that worried both Mansholt and Van Gasteren was the rise of multinational corporations as transnationally operating economic superpowers transcending the reach of sovereign nation states. In 1972, Mansholt went to the UNCTAD III conference in Chile to plead for more evenly balanced access to international markets and more equal distribution of wealth, debt relief and support for underdeveloped countries. Although he returned a second time to Santiago, his negotiations did not succeed.[14] In 1974, Van Gasteren made a report for television on this global phenomenon of multinationals. In an episode of the news programme PANORAMIEK with the title MULTINATIONALS he investigated the significance of the multinational corporation. Van Gasteren interviewed a number of scientists, politicians and industrialists, such as Gianni Agnelli (head of Fiat Automobiles) and trade unionist Charles Levinson, with whom Van Gasteren had a lengthy interview, spanning the second part of the programme. A few observations in the first half of MULTINATIONALS make clear that already in the early 1970s (in the midst of the global oil crisis) it was evident that very soon about 200 to 300 multinational corporations would dominate about 80% of the world market with a power beyond that of any national government. Some of these multinationals are of Dutch origin (Shell, Philips, Unilever, Akzo), though most of the production, exploitation and legal bases of those companies were already outside the Netherlands by the 1970s. A few other big players that are mentioned or shown via billboards and electronic signs include Ford, Nestlé, Siemens, ITT (International Telephone and Telegraph Company), General Electric and oil companies such as BP and Texaco. They all operate in global markets, with increasing power. Nat Weinberg, an American automobile industry unionist, remarks in MULTINATIONALS: 'Who actually are those corporations who govern world events? Governments, at least in democratically chosen societies, still have a responsibility towards their people, but who has elected the corpora-

tions to be our kings?' Other striking elements in Van Gasteren's multinationals portrait are the suggestions of a 'Eurodollar', which point to an interest in a monetary union as early as the 1970s and an analysis of the relationship between dictatorships (Pinochet in Chile, Franco in Spain) and big corporations that profit from the controlling stability totalitarian states create.[15]

Charles Levinson, secretary general of the International Federation of Chemical and General Worker's Unions and author of *Capital Inflation and the Multinationals*, discusses in the second part of MULTINATIONALS the problem of what he calls the Vodka-Cola companies.[16] Multinationals are ahead of politicians, Levinson argues. He uses Pepsi's exclusive deal with the Soviet Union as a prime example. In exchange for Pepsi's access to the Soviet Union, Russian Vodka was allowed on the American market. In the midst of the Cold War, multinationals were creating their own deals that bypassed any politics. This is in itself not problematic because peace is the best condition for much of this international trade (the Vietnam War was ended partly because that was better for business). Rather, the danger of the Vodka-Cola companies is that of a new global totalitarianism of a few extremely rich corporations, bankers and billionaires such as the Rockefeller family and the Rothschild family, determining world politics through the power of global capital. Levinson emphasizes that multinationals are here to stay and that investment in new technologies can certainly be used positively. But he warns that the dangers of concentrated power must be met with countervailing forces that can be formed by international alliances of workers and by controlling powers from inside the companies. In general, Levinson is very wary of the global corporate developments. This wariness is reinforced by the changes in the financial world of the 1970s. Gold as a numerical standard for money was slowly but surely replaced by what Levinson calls 'telephone money', which escapes the control of any minister of finance. In I LOVE $ (1987), Johan van der Keuken investigated this new global financial market, filming in the financial centres and stock markets of Amsterdam, New York, Hong Kong and Geneva. Van der Keuken talks to brokers and bankers on the one hand, and lay people dreaming of a small business on the other. Debt and money, defined as a means to make more money, telephones and, increasingly, computers have come to govern the world.

In 2015, we are forced to admit that Levinson, Van Gasteren and Van der Keuken correctly predicted the intricacies of the current financial system that even bankers themselves no longer understand. It is a system that is so automated and fragmented that nobody feels the need to take responsibility for the 'butterfly effects' of a system full of perverse stimuli that, at the end of streams of virtual shifts and complex fluctuations, have devastating effects in the real world. The financial crisis of the US housing market in 2008 is one of

the most appropriate examples of this effect. Between 2011 and 2013 journalist Joris Luyendijk interviewed all kinds of workers in The City, the financial heart of London, and his columns in *The Guardian* about his findings upsettingly prove the negative effects of global financial markets that are multinationals in themselves, trading purely in virtual money ruled by unpredictable and floating exchange rates, hedge funds and automated high frequency trading.[17] The already mentioned multinationals have remained strong and have expanded, and agricultural multinationals such as Monsanto now govern large portions of the food supply chain (down to patenting the seeds of grain planted by small farmers in India). And some new players of the digital world (such as Facebook and Google) operate according to the same logic. Under this new logic of hypercapitalism, debt (of individuals and complete states) has become a political tool that even keeps everybody inside the European Union under a firm grasp.[18] How devastating and dangerous this can be has been proven by the financial crisis of Greece and other Mediterranean member states in the European Union who are depicted as lazy profiteers or PIGS (Portugal, Italy, Greece, Spain), but who are in large part victims of complex high risk lending practices that, in fact, destroy complete economies. The US national debt clock is simply staggering.[19]

Besides the investigation of transnational and multinational global capital and the economic, social and political problems of Europe, Van Gasteren also made two television documentaries in Africa that addressed both local and transnational politics: REPORT FROM BIAFRA (1968) and REPORT FROM KHARTOUM (1971). Biafra is a region in Nigeria mainly populated by Christian Igbos. In 1966, many Igbos from other parts in Nigeria fled back to Biafra after thousands of them were killed by Islamic Haussa-Fulani. In 1967, Biafra declared its independence from the central government in Lagos. A bloody war would follow that lasted until 1970 when Biafra capitulated. In the meantime, millions of people were killed or starved to death. Biafra, cut off from the world and food supplies, became synonymous with starvation and deprivation. In the midst of this war Louis van Gasteren made for Dutch public broadcaster NTS a documentary about what was going on in this complicated battlefield. Van Gasteren asked two other filmmakers, Johan van der Keuken and Roeland Kerbosch, to come with him. Because of the potential dangers involved he wanted to have a crew, each member of which could operate independently. In 1968 they went to Biafra for a week. All three filmmakers returned shaken and devastated by the amount of misery they had seen.[20] Johan van der Keuken would later declare that this film had changed his life: 'After eight days in famine and panic, I understood how the world operated. […] I found my way to a more directly politically engaged cinema that seemed absolutely crucial to me at that time.'[21] The film REPORT FROM BIAFRA opens on board of a

Dutch Transavia aircraft on its way to Sao Tome, an island in the Gulf of Guinea that served as a springboard to Biafra. The plane was carrying 60,000 cans of condensed milk and the pilot explains to Van Gasteren how much money he earns making this flight ($32,500 per flight). On Sao Tome, Van Gasteren interviewed representatives of several charity organizations (Charitas International, Red Cross, Diakonisches Hilfswerk) who flocked to the island and the pilots who carried food and weapons in dangerous but lucrative flights. Then, Van Gasteren, Van der Keuken and Kerbosch take one such flight and arrive in Biafra themselves. In an interview they would later describe their experience of arriving in Biafra:

> The transit over Nigerian territory by air is mainly a tragic experience. Up in the sky in a darkened airplane, one only sees flashes of guns. You can see how deep down people are shooting each other. It looks like ants eradicating each other [...] In the darkness you see these flashes of light, and you become conscious of the earth. Only then the words Biafra that one reads in the newspaper become meaningful. The ants become people who kill each other.[22]

What is most striking in REPORT FROM BIAFRA is the fearlessness with which the three filmmakers move though the war zones. Van Gasteren interviewed many different Igbo people: refugees, doctors, pilots, aid workers, their Igbo translator, Christian leaders and soldiers who trained, deprived of any real means of actually defending themselves. We see how the soldiers shoot their guns without ammunition, making the sound of the guns themselves, shouting 'babababababam'. 'It transpierces your heart,' Van Gasteren comments.[23] The non-uniformed soldiers march towards the camera, which becomes incorporated in the training; the camera is the point at which the group splits off into two different directions. This is an indication of the close engagement of the whole film crew, which moves on to different areas of disaster. In the city of Aba they talk to one of the few remaining inhabitants. Of the 4.5 million citizens, 90% have left the city. 'But what's the point,' the hollow eyed Igbo man asks Van Gasteren. 'The Nigerians will kill us everywhere.' The crew's translator Noem sings an Igbo song that has been outlawed. A judge in Biafra's high court explains that the British, as ex-colonizers who would have been in the best position to negotiate, instead supply Nigeria with arms and Russia sends in Iljushin fighter bombers with the similar aim of gaining more control over the oil in Nigeria. Along the sandy roads, millions of emaciated people are on the move with a few belongings or with nothing at all, not even clothes. Most devastating is a sequence in a hospital where a doctor explains the effects of malnutrition, demonstrating all the stages of decline by pointing out the

physical symptoms in the bodies of the children around him: edema, swollen feet and hands, loss of pigment in skin and hair, lizard skin, ulcers, loss of muscles... the words alone are horrific, the images are much worse. Another remarkable encounter is with the former Minister of Defence of the central government in Lagos, Mbu. He defected to the Biafran side and became Minister of Foreign Affairs in the government of Independent Biafra. In his previous life as Nigeria's Minister of Defenc he closed a deal with the Dutch Minister of Defence to get weapons from the Netherlands. Distressingly, he must now witness the attack of his homeland by the weapons he ordered himself, he tells the Dutch reporters.

In one of the training camps Van Gasteren and his crew met Rolf Steiner, a German mercenary who fought for many years in Korea, Vietnam and Algeria. Steiner explains that he is not paid to fight in this war, but that he volunteers to help the people of Biafra. He is the leader of the Southern commandos, teaching them guerilla tactics he learned in Algeria and Vietnam, supporting their fight to avoid complete extermination. 'This war will cost four to five million lives,' Steiner tells Van Gasteren. It will last another few months, and then it's lost for Biafra. The war would last a little longer that Steiner predicted, until 1970, but other than that, he was correct. On their return Van Gasteren and Van der Keuken explain the terrifying war in colonial and neo-colonial terms in an interview:

> The colonial British Empire brought in missionaries who got hold of the Igbo tribe. They Christianized them completely. The British must have known what the long term effects would be, once they released the country. The Igbos with their Christian mentality and development will stay in close contact with the colonial rulers, Igbo sons went to England to study, they became the Nigerian intelligentsia, occupying administrative and higher functions. The Islamic Haussa, who form the majority of the people, have not accepted this. Moreover, the Christian values are reinterpreted according to local customs, turning their leader Ujukwu, into a sort of Moses, God of the Biafrans.[24]

In the same interview, Van Gasteren also acknowledges that Rolf Steiner made him revise his image of mercenaries. Instead of the rogue soldier who fights purely for money, Steiner is more idealistic and more a guerilla fighter who, as he declares to Van Gasteren, wants to fight the right war ('*la guerre propre*'). Actually, Steiner is more like a bandit, a Robin Hood soldier, comparable to Corbeddu in Sardinia. And so it is not so surprising that Van Gasteren, whose habit it was to keep in touch with most of the people he had in front of his camera, would not forget about Steiner when, a few years later, the latter was

accused of providing military support to the Anyanya rebels in the South of Sudan. Steiner went on trial in the capital of Sudan, Khartoum. Van Gasteren filmed the process and interviewed lawyers and politicians and reported from the court room where the trial took place. In REPORT FROM KHARTOUM, broadcast in 1971 on Dutch television, Van Gasteren follows the trial, which, in fact, was a political show trial, set up to settle things for once and for all with the evil white mercenary. The courtroom was open to the public and was transformed into a film studio with cameras everywhere and large numbers of international journalists. Van Gasteren provides commentary in a soft voice-over, almost as if he is reporting on a billiard game. Steiner, who had become a Buddhist in prison, is bald-headed and calmly replies to the examination, fully aware that the outcome has been predetermined. This fact is declared by his lawyer whose interview with Van Gasteren is intercut with the trial sequences. Steiner's lawyer also declares that he believes Steiner is an idealist who really wanted to help the Sudanese people. He left Biafra after a conflict with the French government (from whom Steiner received a pension for having served over 20 years in the French army). Steiner did not want to mediate between the French and Biafra's leader with respect to the French effort to gain control over the oil fields. After leaving Biafra, Steiner went to South Sudan as volunteer, helping to build hospitals and then becoming a military advisor to the rebels; this ultimately led to his arrest. Van Gasteren, for his own part, was not interested in Steiner's faith solely because of his freelance idealism, but also because he saw in Steiner something deeply human. Explaining that he watched the sequence in REPORT FROM BIAFRA where he interviews Steiner again and again, listening repeatedly to his voice he discovered a lot of ehs, ohs, and hesitations that made him a searching human being, somebody who wanted to belong somewhere: 'Steiner is in a situation that unfolds an underlying universal human drama of the role playing that we constantly are performing. [...] I actually pity him enormously.'[25] Steiner would indeed be convicted in this show trial. After two years he was released and returned to Germany where he was born and where he would marry and write his autobiography.[26]

South Sudan became an independent state in 2011, but the conflicts with North Sudan, especially over the oil fields in the region, led to new conflicts and especially to neo-colonial exploitation by foreign countries, which continues. The South is still considered missionary territory by Americans, and the North now has an ally in China, who has sent many oil workers. And following a sad global pattern, the common people live in a state of deprivation. In WE COME AS FRIENDS (2014), the Austrian filmmaker Hupert Sauper (known from his impressive and shocking documentary DARWIN'S NIGHTMARE, 2004) travels to the border regions between South and North Sudan around the time of the referendum for independence.[27] Because most areas are very difficult

to reach he built an airplane himself and flew with a small crew from France to this region. Just like Van Gasteren and his crew, who arrived by plane in Biafra 40 years earlier, they discovered that the reality on the ground was devastating. The same colonial structures remain in place: the South of Sudan was Christianized by evangelists from Texas who want to create a New Texas in South Sudan. 'The climate is the same,' one of them declares to Sauper who notes how quotes from the Bible are used almost as military drills. Everywhere people are suffering from the exploitation of oil, which is sold very cheaply to foreign companies by incredibly incompetent leaders. Drinking water is polluted by oil, houses are destroyed, and entire villages are forced to live on garbage belts and cemeteries. Sauper arrives at a Chinese oil rig, driving through a wasteland of litter and trash. The driver explains that the Chinese do not feel responsible for taking care of the environment. China has teamed up with the Islamic North Sudanese to do business. One of the workers quotes an old saying: 'don't colonize, just take the energy.' Another explains their reason for being in North Sudan to Sauper's camera: 'You cannot go to space without arms. If we want to survive we need to be prepared. Life means competition, competition means conflict, and for conflict we need arms. We will have the strongest weapons, weapons with intelligence.' Let us pause for a moment to think about the chilling implications of these repeated neo-colonializing strategies of 'coming as friends' and the oil workers' line of 'reasoning' ... Things have not improved since the Biafra War. As philosopher Slavoj Žižek in THE PERVERT'S GUIDE TO IDEOLOGY (2012) would say, we still have not changed our ways of thinking, our ways of dreaming and fantasizing. We keep on dreaming along the lines of an idealized image of society as it is; always at the expense of one group over another (the Chinese want to win the space war when humanity must leave the planet Earth when it faces extinction, like the Prolagus sardus). As Žižek argues: 'The first step to freedom is not just to change reality to feed your dreams. It is to change the way you dream. And this hurts because all satisfactions we have, come from our dreams.'[28] Referring to the big cultural revolutions in Russia, China, and Cuba, Žižek continues:

> One of the big problems is that they did change the social body. But the egalitarian communist society was never realized. The dreams remained the old dreams and they turned into the ultimate nightmare. Capitalism has turned out to be the true revolutionary force, even if it serves only itself. How come we can imagine more easily the end of planet earth (an asteroid hitting the planet) than the modest change in our economic order? We have to become realists by way of demanding what is impossible in the economic domain. Occupy, Greece, Tahrir, all potential for a different future. There is no guarantee, it depends on us. [...] Never forget

that every revolution is not only directed toward the future but it redeems also the past failed revolutions. All the ghosts of the past revolutions which are roaming around unsatisfied will finally find their home in the new freedom.

Corbeddu, Sicco Mansholt and Rolf Steiner are all in their own ways the figures that have guided Van Gasteren in his own search for a new dream to feed our political reality. While Corbeddu has turned into a myth whose ghostly spirit is still wading in Sardinia, the dreams of the turnarounds of Mansholt, and even of Steiner, continue to be more necessary than ever. The role of Europe with respect to the current crisis of massive migration from Africa and the Middle East, financial bankruptcies of entire countries, and new cooling relations between the West and the East, and the increasing power of China will keep us vigilant and actually demands a renewed engagement in reports for Euro Television Productions.

CODA

Feedback Loops in Time without Final Cut

When in the early 1960s Federico Fellini was making 8½ (1963) Louis van Gasteren spent some time with him in Rome. Van Gasteren considered staying in Rome but many practical considerations, such as lack of finances to entertain 'la dolce vita' in Rome and family life in Amsterdam, kept him from making that choice. Nevertheless, there is an affinity between Van Gasteren's style and that of the Italian director. While Fellini found Marcello Mastroianni, who functioned in many of his films as his alter ego, Van Gasteren became his own Fellinesque double in many of his films. As discussed in one of the previous chapters, we see Van Gasteren performing in the role of himself in HANS LIFE BEFORE DEATH. Van Gasteren also often features in his own films more generally, sometimes at the margins as journalist or investigator, sometimes as a participant observer of the historical events and existential questions he sought to express through his art works and films. During the 1960s he started work on his autobiographical film NEMA AVIONA ZA ZAGREB, in short ZAGREB. References to this film 'under production' would turn up in many interviews from the mid-1960s onward. Many reels of material for this film were on the shelf, several versions waiting for a final cut.[1] Only in 2012 would the film find a theatre audience when it was screened on the occasion of Van Gasteren's 90th birthday at the EYE film institute in Amsterdam. In a way, ZAGREB is comparable to 8½ in that we see a filmmaker reflecting on episodes of his life and wondering in a very associative and intuitive way about existence, film, art and human relationships. But in its finalized form ZAGREB probably has more in common with Fellini's INTERVISTA (1987) where we see Mastroianni and Anita Ekberg, the actors of LA DOLCE VITA (1960), in their old age, reflecting on their youthful selves. ZAGREB is also framed by Van Gasteren at the age of 90 looking back at the five years of his life between 1964 and 1969.

ZAGREB is explicitly autobiographical, featuring home movie clips of Van

Gasteren's personal family life and the cultural scene in Amsterdam. In 1978, Van Gasteren explained that he was still working on this film, which he had started more than ten years previously:

> My ex-wife Jacqueline, and my daughter Mardou and I are playing the lead roles. I have strived to address the larger global problems, relating to the ideas on LSD-transformation processes expressed by Timothy Leary to Marshall McLuhan's global village and Meher Baba as guru from India. That is the planet Earth that reaches me in all its extremities. And somewhere on that globe, Van Gasteren with his wife and child are pottering about, having great difficulty in accepting the world as a believable structure, coping with disillusionment, too.[2]

Here, we recognize how Van Gasteren has always tried to relate his life, his wonders, struggles, and sorrows to the larger existential and political questions that we are all entangled with. In addition, because of its temporal feedback looping structure, looking back from the future (his old age) to moments of the past (when he was the younger version of himself), ZAGREB is also a film that is very telling about Van Gasteren's style and his way of working. Very conscious of the passing of time and of the potential historical value of occurring events, he has always kept a meticulous archive of all letters, newspaper articles, contracts and other documents for future consultation. His films, too, have been obsessed with this idea of the passage of time and the conception that past, present and future constantly influence one another from all sides. Already in THE HOUSE Van Gasteren demonstrated this reflexive attitude towards the co-existing layers of time that can be composed and recomposed in a complex and non-chronological order. And many people that Van Gasteren captured on camera stayed in his mind, like a particle, a spark of the possibilities and impossibilities of life. Often, he would return years later to visit the people he once filmed. He sometimes did so just out of interest for what had become of them, but sometimes he brought his camera once more in order to look back with knowledge from the future, as in the documentary THE PRICE OF SURVIVAL about the devastating psychological effects of generationally transmitted traumatic experiences. Wondering and despairing about his own role in life, Van Gasteren has investigated via his camera eye the dreams and disappointments of human life in general, the workings of perception, and the ravages of time. By way of concluding this journey along this remarkable career of cinematographic and artistic documentation, a few observations about ZAGREB and the existential and philosophical questions this film, and Van Gasteren's oeuvre in its totality, arise.

JOIE DE VIVRE AND DISILLUSIONS OF LIFE

In the first images of ZAGREB we see black-and-white documentary footage of a street in Amsterdam. Garbage collectors are emptying trash cans in a truck. The truck trailer tilts and in the space that emerges, we suddenly see a young Van Gasteren in a long black leather coat standing in front of a canal in the background. In voice-over Van Gasteren comments: 'Here I am, 42 years old, it is 1964. As a 90 year old man I find it quite special to look back at myself with the knowledge of what happened afterwards. Yes, it's me – but it also isn't.' We then move to an aerial shot and we see the same garbage truck from above, from the point of view of the Westerkerk tower. The camera zooms out, showing the entire city from above. We move to a close-up of Van Gasteren at the age of 90 looking at the images of the film we are watching on an editing screen and the title sequence starts over the black-and-white images of the city. The next sequence (in colour) brings us to the heart of the annual fair at the Nieuwmarkt in Amsterdam in 1964 where Van Gasteren and his wife and young children are paying a visit to the Fat Ladies. They eat cotton candy and climb the merry-go-round. Van Gasteren's voice comments: 'At the time I wanted to make a film about my memories, my perceptions and experiences. As filmmaker I have the means to make this visible.' The merry-go-round holds in close-up freeze frame the faces of all the protagonists of Van Gasteren's life at the time, while he continues in voice-over from the future: 'Actually I wanted to document everything, including the children of my first marriage, Louis and Dominique. As well as my new family life with my second wife Jacqueline and our new born daughter Mardou. I couldn't stop watching my child as it was discovering the world.'

The next sequence of the film brings us to Van Gasteren's parents. Via recordings of his mother's singing voice, photographs and a news item in the Polygon Journal of 1962 about the funeral of Van Gasteren's father, Louis van Gasteren Sr., we move back to the sequences shot for ZAGREB. These consist of a mixture of authentic home movie material (first steps of the baby girl, conversations at home with friends, family holidays in Spain), combined with clearly staged scenes that stand for certain autobiographical episodes. At the beginning of the film, for instance, we see 'Van Gasteren' (playing himself) meeting a woman (played by an actress) in a *coup de foudre* at the airport in Zürich. They exchange glances, follow each other to the ladies room, and in the next scene we see Jacqueline (the real wife), feeding baby Mardou (the real baby). The style of ZAGREB is characterized by this elliptical form of storytelling and the mixing of fact and fiction. The opening sequence at the fair is actually a very apt metaphor for the film itself which actually takes us on a roller coaster ride through five years of Van Gasteren's life, full of strange encounters,

hilarious optimism and *joie de vivre*, highly original art projects and staged and authentic family scenes. But we are also taken through more symbolic scenes that indicate that besides being a merry-go-round and a roller coaster, life can be confusing like a labyrinth, sometimes leading to dead ends. We see Van Gasteren running around in a maze-like garden, unable to find the right passage or the exit; we also see him at a crossroads where he does not turn left, or turn right, but choses to go straight ahead – hitting a granite wall...These moments indicate the searching nature of a human being who does not seem to find the ultimate ways of exploring and expressing the depths, wonders, and disenchantments of human existence.

However, along the way ZAGREB gives us unique documents of slices of life in the 1960s, not only in Amsterdam but in the global village of the planet Earth. In many scenes and sequences we see how Van Gasteren investigated the basic idea that life is largely built on illusion: 'I am convinced that life is one big illusion. At an early age I stopped believing that parents and teachers are always right. Also the idea of a happy marriage and one partner for life soon turned out to be an illusion,' he comments on the images from the point of view of his older self. At the end of the film Van Gasteren explains that in 1969 his wife Jacqueline left him and took their daughter with her, and that he is only still in touch with his oldest daughter. But the ideas of illusionary perception and deception are also explored in other ways that are more directly related to his profession as artist and filmmaker (as he also explored them in the DO YOU GET IT –films discussed in Chapter 4). In ZAGREB Van Gasteren mocks himself for having believed for two years that he could hit the carillon of the Zuiderkerk tower by shooting it with an air gun from his rear window, making it produce different tones. In fact, his neighbour would hit a glass cup with a spoon, producing the illusion time and again. But of course, this scene itself is also an illusion, or at least it might well be. In another scene, Van Gasteren is driving his car in a snow covered landscape, his son sitting next to him. They cross a village with two churches. 'Look, Dad,' his son tells him pointing at the churches. And soon the car is in such a position on the road that one tower is covered completely by the other, as if there is only one church. These kinds of moments lead to Van Gasteren's further reflections about the nature of perception: how freely can we look and see, how much is determined at birth, how much effort does it take to push aside all these preconceived notions and positions and to adopt another perspective? In a nutshell, these are the fundamental questions addressed in artistic research (as well as in science and philosophy) more generally. In ZAGREB they are addressed in a playful but nevertheless serious and probing way. The knowledge that Van Gasteren's family life would soon break up makes the images of father and son laughing about the strange deceptions of their eyes and having a snowball fight seem deceptively happy and deeply painful.

A large part of NEMA AVIONA ZA ZAGREB is dedicated to this deeper search for the dimensions of experience and shows how, in the 1960s, this was a larger global phenomenon. Van Gasteren introduces this search as follows:

> In how many dimensions is a human being able to see, think, and feel? To answer this question I started to experiment with LSD. I used LSD to investigate what this substance could do with me and with my environment. But I was especially looking for answers to the question: is the human species, which has the power of self-reflection and only knows a few dimensions, sufficiently equipped for life?

The film then takes us around the hotspots of the counter-culture in the 1960s, including its dangerous sides. Via radio reports we hear about the tragedy of Vernon Cox, a young man who fell out of a window after using LSD. After images of hippies in San Francisco's Haight-Ashbury district looking into Van Gasteren's camera in various states of ecstasy or haziness, he takes us to the mourning parents of Vernon Cox who talk about their son. Van Gasteren also filmed in Millbrook, the estate where Timothy Leary practiced his spiritual LSD lessons, addressing the camera with the words: 'Why do you bother to talk when God's message is all around us?' There is no need to compete. We're here in a Garden of Eden. Turn on, tune in to this wonderful nature, and drop out of society, warfare, competition.' We also hear Leary comment on the tragic death of Vernon Cox saying that he hopes the parents can come to see their son as an astronaut who crashed or as someone who had fallen in the line of high spiritual duty. Van Gasteren simply registers, he does not judge, but curious about the divine connections that LSD might impart he departed for India where we see him in an encounter with the non-speaking guru, Meher Baba, who was very popular at that time. Finding no answers and recognizing the dangers of LSD, Van Gasteren acknowledges the possible therapeutic functions of the substance, confessing in his old age that he is sure of one thing: without LSD he would have taken his own life, following in the footsteps of his mother (who committed suicide after the death of his father) and his grandfather.

In the same spirit of an exploring mind and perception we see excerpts from Van Gasteren's experimental film OUT OF MY SKULL, which he shot with Robert Gardner at the Carpenter Centre for the Visual Arts at Harvard University in 1965. This is followed by staged studio scenes of Van Gasteren crawling over the floor to find the orange spheric SUNNY IMPLO globe that he proposed as an artwork for the general public to connect electronically to other dimensions. There are many more scenes associatively connected to this idea of the possibility of art changing perception and globe consciousness, such as a

hilarious sequence that leads to the exposition in the Vondelpark featuring a car wreck, Marshall McLuhan's opening of Van Gasteren's exhibition of Globe Conscious paintings via (a staged) Early Bird satellite connection (though it is the real Marshall McLuhan filmed in an elevator in Montreal who is speaking to the crowd in Amsterdam), to the rescue of a sea turtle in a Spanish fish market by Van Gasteren and his children; and an exhilarating sequence in Belgrade (where Van Gasteren was a guest at a film festival). Together with film critic Luigi de Santis they try to buy a plane ticket for Zagreb, but the answer is: '*Nema aviona za Zagreb*,' 'There is no plane for Zagreb.' '*Nema aviona za Zagreb*! What a beautiful language,' the filmmaker and the critic exclaim, while chanting the words into the night. The expression became the enigmatic title of the autobiographical film that for many years remained unmade, and the word '*nema*' came to signify much more for Van Gasteren, as I will explain momentarily. Here, let it suffice to remark upon the incredible number of explorations of private and public life and global culture that NEMA AVIONA ZA ZAGREB brings together. All this happened during the period between 1964 and 1969 when his marriage was over and Van Gasteren found himself unable to finish the film. Even the existing film that he made almost 50 years later cannot be seen as 'the final cut.'

CUTTING AND RE-ORDERING, TEMPORAL LOOPING AND 'NEMA'

As mentioned in the introduction to this chapter, there are grounds for considering Van Gasteren as a Fellinesque character in his own films. Like Fellini, Van Gasteren is obsessed with time, the passing of time and the power of cinema to reconstruct time. It is interesting, therefore, to briefly return to one of Fellini's last films, which I mentioned previously. In INTERVISTA Fellini actually uses many of the same stylistic techniques as Van Gasteren in NEMA AVIONA ZA ZAGREB. Not only does Fellini himself appear in the film as himself, looking back at his younger self (albeit this younger self is performed by another actor, Sergio Rubini), he also mixes fact and fiction in ingenious ways. Fellini and some of the other actors play themselves while being interviewed for Japanese television and it is hard to draw the line between reality and illusion. Let us zoom in on a moment in INTERVISTA where Fellini, along with Marcello Mastroianni and the Japanese television crew, visit Anita Ekberg at her house. Together they watch on a (magically produced) white projection screen Mastroianni's and Ekberg's performance as young actors in LA DOLCE VITA (1960). Mastroianni, the aged actor in INTERVISTA in the 1980s, addresses Sylvia on screen, the 30 years younger version of Ekberg in LA DOLCE VITA, while the now much older actress is sitting next to him. Philosopher Bernard

Stiegler calls this moment a 'properly cinematographic event,' as this visible layering of time is only possible in cinema.[3] The scene is very moving, precisely because of the psychic and collective experience of time that it presents to us. Moreover, as a sort of YouTube mash-up *avant-la-lettre*, Fellini has re-cut and re-edited the scenes from LA DOLCE VITA. In this way, Fellini comments upon the particular significance the film has acquired in our collective memory, which, seen from the moment the original film was made, is a point in the future. Mastrioanni and Ekberg will live on as iconic lovers despite the fact that this is certainly not how they were presented in the original film. They have been re-cut from the point of view of the future. The mediated layers of time also anticipate another future, namely the future of old age and death. We see the actors as radiant adults *and* when they are in the autumn of their lives. Implied in this is death. Watching the film in 2015, Mastrioanni died in 1996, Ekberg passed away in 2014. Death in general is what lies ahead for us all. Our conceptions of present, past and future are the resultant complex interplays of temporal dimensions that are built in anticipation of (our own) ageing and eventual death. It is a similar temporal looping, going back and forth in time from old age (the future) to the younger forms of self (the past) that NEMA AVIONA ZA ZAGREB displays with its complex structure.

 The fact that Van Gasteren cut and re-cut his film countless times and kept it on the shelf as an unfinished project for many years makes a comparison to another film worthwhile. THE FINAL CUT (Omar Naim, 2004) could be considered as a meta-film that thematically addresses quite explicitly the problem of 'the story of our life' after we die. Naim's film presents a world where 'the problem of forgetting' has been overcome by unobtrusive and pervasive camera and computer technology implanted in our brain at birth, a 'solution' offered by a multi-billion dollar company called EYE-Tech (so not available for everybody). Alan Hakman (Robin Williams) is a so-called cutter whose job it is to edit the footage taken from the brain implants of deceased people. In a way, Hakman can be seen as the ultimate director: he is the one who, after somebody's death, will select, cut and compose a life into a 90-minute film to be shown to the deceased person's loved ones in a 'Rememory Ceremony'. Throughout the film there are many references to ethical concerns for psychic well-being that are implied in the implant. These ethical and political implications are important, but here I would like to focus on the temporal dimensions of telling a story from the perspective of our future disappearance and looking back at our lives, the choices we have made, the roads not taken.

 In the first chapter I discussed Van Gasteren's film THE HOUSE as a Deleuzian time-image, very much akin to Fellini's ways of portraying the mixing of past and present. But when we start seeing time not only from the past, but also explicitly from the future, as Fellini does in INTERVISTA and Van Gas-

teren implicitly proposes in many of his films (and in particularly in ZAGREB), we might need yet another category of images or a new temporal mode to understand this particular form of constructing time cinematographically. Elsewhere, I have suggested calling this mode of cinematography the neuro-image.[4] The details of this type of image are not important for my argument here, but to summarize what has been said in the first chapter of this book, recall that movement-images have a firm foundation in the present; in this classical way of filming even flashbacks are anchored in a present that is stable and that we can always recognize as our spatial and temporal point of orientation. Modern cinema of the time-image (such as HIROSHIMA MON AMOUR) has the past as its dominant temporal colour. Here, the past (as the co-existence of all its layers), begins to speak for itself. Variegated moments of the past pop up without warning, without firm anchors in the present, as in the confusion of both individual and collective pasts and presents.[5] As already indicated, in the time-image narration already becomes more complex since the virtuality of the (traumatically) returning past is sometimes indistinguishable from the actual, as is clear in Fellini's films. However, in the third temporal mode of the neuro-image the future dominates the cinematographic form.[6] This does not mean that in the movement-image or time-image there is not an idea of the future (thinking the future from the present is related to habitual anticipation that we can oversee from the present moment; the future conceived as based on the past presents itself often in a cyclic repetition).

But in the future conceived as future proper, things are less certain. It does not follow directly from what we know of the present or of the past and there is a speculative and destabilizing dimension that enters the temporal ordering principles.[7] Deleuze argues that if we think from a point in the future that has not yet happened we can 'cut, assemble, and re-order' to make possible the 'eternal return' of that which (slightly) differs, of that which we have not yet seen or thought even though it is already part and parcel of history.[8] It is worthwhile noticing that Deleuze's conception of time (that I suggest is relevant for our contemporary image culture) is a modern conception of the future, akin to that proposed by Niklas Luhmann as a modern temporal structure that only emerged, and had to emerge, in highly complex and highly technologically mediated modernity; hence, a time that is related to the extension of the cinematographic apparatus (and the expansion of screens everywhere in culture). Luhmann asserts that the future has now becomes an open future: 'Future itself […] must now be conceived as possibility quite different from the past […] It may contain, as a functional equivalent for the end of time, emergent properties and not-yet-realized possibilities.'[9] Luhmann calls for a complex systems theory conception of time in which an open conception of the future allows 'possible divergence of past states and future states.'[10] Even without

completely unfolding Luhmann's complexity-in-time, one can see how this complex synthesis of time contains all other times *and* opens up to all possible (not-yet-realized) pasts, presents and futures that present themselves as serialized sequences. Complexity, however, has to be reduced in order to make sense, but, seen from various different points (or scenarios) in the possible future, things could have been different.

Let us make this more concrete by returning to THE FINAL CUT and ZAGREB and Van Gasteren's work. The future is dramatically and ontologically related to the event of death (and re-beginnings). In THE FINAL CUT it is only at the moment when a person has died that the cutting and ordering is done as a 'rememory' from the point of view of what we want to remember for and from the future. However, since the future as such is always speculative and involves many options, remixing can happen *ad infinitum*. It is always possible to imagine a different future scenario from which to fold back in time, re-order, and recut the events of a life into a different story, and end up with a remixed version of the past. Alan Hakman, at work on his computer with the database of all the events in the life of the deceased person, has to choose which story he will tell. Clearly, depending on the kind of future memory he (or his client) wants to retain, he cuts, re-orders and reduces in different ways. Moreover, as Maria Poulaki has pointed out, THE FINAL CUT presents reflexive feedback loops of complex narration where narrative closure is no longer possible:

> [F]ilms such as the FINAL CUT appear concerned not just with the technological incarnations of information, but also, and perhaps even more, with their own ability to communicate as potential information entities. Complex films are self-reflexive regarding their own cyborg nature – which has for long been underlying modern narratives – and 'make explicit, to varying degrees, the technological underpinnings of narrative mechanism.[11]

And, as she further indicates, when Hakman accidentally discovers that he has an implant himself, the feedback loops enfold even further and in ever more complex ways when he returns to his own 'database of memories' where he discovers 'a different past' than the one he was replaying in his traumatized childhood memories.

This self-referential looping and modulating of time can be viewed as an allegory for our time of ubiquitous computing, where all the events of our lives, of world history even, can be captured and tagged with metadata only to become subject to re-assembly into new life stories and world histories. These stories become, more explicitly than ever before, parallel stories of the endless

potential stories that could be told. To put it in cinematographic terms, we see here neither just a classic flashback that fits in an anchored present and continuity logic, nor just a crystalized time of post-war cinema that brings the past as a direct layer of cyclic repetition into the present. Rather, the past now becomes like a feedback loop on parallel processors: from different points (of view) in the future we can re-order the events of our lives (or of history) into multiple stories. The tagline of THE FINAL CUT, 'Would you live your life differently', points to the endless possibilities to rewrite history in a culture where so many audio-visual documents (fiction and non-fiction) have been stored in databases.

Of course, this is also a question that haunts NEMA AVIONA ZA ZAGREB. And it is a question more generally that has haunted Louis van Gasteren all his life. Throughout this book I hope to have been able to indicate how the several themes in Van Gasteren's work return in different versions, filmed from a different perspective or from a different moment in time. As the author of this book, I could have chosen a different order to present these topics in different constellations. Van Gasteren's preoccupation with the land, the house, and the city is intimately related to his interest in the water management of the Dutch. His interest in the effects of history on human beings and the choices they make are not only part of the films that deal explicitly with the war, but also his films about Sardinia and about Amsterdam in the 1960s that have historical and anthropological value. European politics that had Van Gasteren's interest in the 1970s are not at all disconnected from his globe conscious work in the 1960s. So, at the level of composing this book I have behaved a little like an 'Alan Hakman' myself ('Hakman' in Dutch translates as 'cutting man'). If we look at Van Gasteren's own work it is clear that with every recurrent theme something new is added as well. In many films we see a repetition of an older element, something that was part of an earlier work. Sometimes, an earlier film is explicitly quoted (as in THE PRICE OF SURVIVAL where we see some used and some never before seen footage from NOW DO YOU GET IT, WHY I AM CRYING?; or in BACK TO NAGELE where we get the cinematographic memories of A NEW VILLAGE ON NEW LAND). Many projects take several decades to complete, which introduces different temporal layers in the composition of the film such as in ROERMOND'S SORROW and HANS LIFE BEFORE DEATH. Fiction is repeated in documentary forms (scenes from STRANDING demonstrate a shipwreck from the inside in MAYDAY). And sometimes we get a different point of view on the same phenomenon, such as the significance of the introduction of the telephone for the common people in the Netherlands in WARFFUM, explained more technically and media archeologically in THERE IS A PHONE CALL FOR YOU! But, in fact, Van Gasteren always filmed with the historical premonition that one day these images would become important, or would be important in a

different way than the original film. So in 'filming for the future' there is an uncertainty implied that keeps the significance of the work open.

This destabilizing dimension of filming for the future, and certainly the uncertainty of re-cutting and re-ordering his own autobiographic life in NEMA AVIONA ZA ZAGREB makes it understandable that Louis van Gasteren does not consider this film as his 'final cut.'[12] But this is perhaps also precisely what the word '*nema*' wants to express. In the film Van Gasteren explains in voice-over:

> '*Nema aviona za Zagreb*' became a concept that I succinctly put as '*nema*'. [...] Nema implies good will and great impotence. Nema, just like life, is impossible to capture integrally. You are in, and yet you are out / It is a beautiful summer day, the birds are whistling /The turtle sticks out its neck / It wants to whistle, but simply cannot.[13]

So 'nema' could be a fleeting desire to understand all the possible dimensions of life, knowing full well that we are limited and that we can only ever see partial truths, from a particular point of view. Artists, philosophers and scientists are perhaps all driven by the same desire to understand this fundamental 'particle of life' that contains everything, even though they have very different means of reaching out to a dimension that, in the end, we can probably only grasp intuitively. Its complexity and vastness extend way beyond our capacity to understand, and yet, we are living it. This common quest of art and science is very beautifully expressed in SYMMETRY (Ruben van Leer, 2015), an opera/dance film created inside the awe inspiring large hadron collider in CERN. Perhaps it is also possible to conceive 'nema' as Heisenberg's uncertainty principle or Bohr's complementarity principle, indicating that things have indeterminate values, depending on who is looking and which 'apparatuses' are being used to look at a thing. In *Meeting the Universe Halfway*, Karen Barad's study about the entanglements of matter and meaning in quantum physics, the author explains that, ultimately, particles (and larger formations, reality) are determined by the nature of measurement interaction we have with it: 'given a particular measuring apparatus, certain properties become determinate, while others are specifically excluded. [...] and it is not possible to have a situation in which all quantities will have definite values at once – some are always excluded.'[14] Without going into the complexities and implications of Barad's arguments, it is possible to argue that, for Van Gasteren, 'nema' can be considered as a quantum particle that he is trying to grasp, but that can never be fixed in its full and integral capacities, simply because the 'apparatus of measurement' (the camera, the point of view, the selection process in the editing room, the media apparatus, the public opinion, etc.) are always co-determinant, often at the expense of the other possibilities. Just as

the black-haired Dorbeck and blond Osewoudt/Ducker in LIKE TWO DROPS OF WATER are actually the same drop: depending on the apparatus of measurement (connected to the person who is doing the measuring or the looking), one excludes the other. NEMA AVIONA ZA ZAGREB is not the final cut of Van Gasteren's life and work, nor is this book. But perhaps the presented selection of Van Gasteren's work will function as a particle for a renewed feedback loop in time, bringing back something from the past that helps us understand something more for the future.

FILM-O-HAND SYSTEMS
and Edit-Ready
are registraded trademarks

The answer to the need for system and data-processing in film-lab and cuttingroom.

Comprehensive and mobile, adaptable to all working-situations.

For 16 and 35 mm.
For positive and negative.
For picture and sound.
For audio-visuals and computertapes.

Your Agent:

manufactured by
SPECTRUM FILM AMSTERDAM
Cuttingroom-consultants
49, Kloveniersburgwal Amsterdam
Telex 16580 Phone 24 60 25 or 24 19 21

Get that Film-O-Hand feeling!!

Edit-Ready FOH 01
- Film roll tray 520 x 195 x 75 mm.
- 10 compartments for film and sound material for 200 metre rolls.
- 1 x 35 mm film, negative or positive.
- 1 x 35 mm perforated magnetic sound.
- 2 x 17,5 mm perforated magnetic sound.
- 2 x 16 mm film and perforated magnetic sound.
- The unit is vacuum packed in anti-static polystyrene 2,5 mm thick.
- The profile of the separations of the compartments prevents falling over during transport.
- A sloping side provides for the attachment of write-on tape FOH 19 for the details of each compartment.
- Can be supplied in all colours.
 In stock: yellow, green, blue, orange.
- In units of 10 pieces.

Edit Ready FOH 02
Identical to FOH 01 with 18 compartments.
- 1 x 16 mm film, negative or positive.
- 1 x 16 mm perforated magnetic sound.
- 1 x 17,5 mm perforated magnetic sound.

Stand FOH 03
- Black enamelled square steel tube, length 2.400 mm - profile 27 x 27 mm, containing 6 mm holes every 30 mm over the entire length of the tube.
- Square feed-in tube 650 mm long.
- Locking pin for feed-in tube.
- Adjusting screw, equipped with a rubber foot, diameter 47 mm.
- Tension spring for the upper foot of the feed-in tube.
- Range floor / ceiling 2.60 – 3.10 m.

Support FOH 04
for 1 piece of EDIT READY (FOH 01 or 02)
- Black enamelled diagonal steel with a welded connection strip, containing a 6 mm hole, length 200 m – profile 18 x 18 mm.
- Sale per pair, inclusive of two chrome-plated bolts.

Support FOH 05
for 2 pieces of EDIT READY (FOH 01 or FOH 02)
- Identical to FOH 4
- Length 400 mm.
- For 1 piece of BOARD FOH 08; for 1 piece of UNIVERSAL RACK FOH 12

Support FOH 06
for 1 piece of BOARD (FOH 07)
- Identical to FOH 04, provided with an adjusting pin for BOARD FOH 07.
- For 1 piece of UNIVERSAL RACK FOH 11

Board FOH 07 (single)
- Hard surface white plastic board, containing underneath two holes of 6 mm, 10 mm depth for the adjusting pins of supports.
- Measurements 200 x 525 x 16 mm.

Board FOH 08 (double)
Identical to FOH 07 with measurements 400 x 525 x 18 mm.

Film-o-bile FOH 09
- Black enamelled steel transport car with four swivel-wheels.
- Can be equipped by choice with:
 - Edit-Ready's FOH 01/02
 - Boards FOH 07/08
 - Universal racks FOH 11/12
 - Film bags FOH 14/15
- Measurements: height 1070 mm
 breadth 400 mm
 length 575 mm
- Sold in single do-it-yourself packages.

Gloves FOH 10
- White linen gloves for the editor and for the negative-cutter.
- 2 average sizes: male, female.
- Sale per 6 pairs.

Universal Rack FOH 11 (single)
- Supporting FILM BAG FOH 14.
- Chromium-plated steel frame composed of diagonal and U-profile for:
- Temporary attachment of DOUBLE-SIDED ADHESIVE TAPE FOH 18 (for cuts of film and tape from the filmbag)
- Fixing the SPRING-CAN-DIVIDER FOH 13.
- Vertical storage of 120, 300 and 600 m cans.
- Temporary attachment of WRITE-ON TAPE FOH 19.
- The rack is provided with two 6 mm holes for the adjusting pin of the SUPPORTS FOH 05.
- Measurements: 200 x 520 mm.

Universal Rack FOH 12 (double)
Identical to FOH 11.
Supporting FILM BAG FOH 15.
Measurements: 400 x 520 mm.

Spring Can Divider FOH 13
for UNIVERSAL RACK (FOH 11)
- Spring can divider of chromium-plated steel, fitting into the U-profiles of the UNIVERSAL RACK FOH 11.
- The spring support serves to press against the vertically stored film cans.
- Height: 180 mm.

Filmbag FOH 14 (single)
- Linen film bag to slip in the UNIVERSAL RACK FOH 11
- Upper edge and bottom are provided with a square plastified metal frame sewn into the linen.
- The bag retains its shape and is washable.
- Recommended for 16 mm editing.
- Measurements: height 480 mm
 depth 450 mm
 breadth 180 mm.

Filmbag FOH 15 (double)
Identical to FOH 14.
- Linen film bag to slip in the UNIVERSAL RACK FOH 12.

Dispenser FOH 16 (bracket type)
for ADHESIVE TAPE
- Simple plastic holder for 3" core of adhesive tape.
- The metal bracket contains 3 holes - distance between 3 and 6 cm - for mounting on:
 - EDITING TABLE, on the metal shield either right or left of the editing screen.
 - A STAND, where this is most convenient in the cutting room.
 - A FILM-O-BILE.
- For use with the TAPES FOH 18 and FOH 19.

Dispenser FOH 17 (table model)
for ADHESIVE TAPE
- Plastic dual-dispenser, table model.
- For use with 25 mm core adhesive tape.
- For use with 3" core adhesive tapes FOH 18, 19 and FOH 20.

Adhesive Tape FOH 18 (double sided)
- For holding film and soundtrack cuts.
- For sticking onto the UNIVERSAL RACK FOH 11 and FOH 12, carrying the FILM BAG.
- Linen 6 mm/25m, 3" core.
- Standard packing 24 rolls.

Write-on Tape FOH 19 (single sided), paper
- For sticking rolls of film and sound track.
- For attaching onto the EDIT-READY for details concerning contents of the compartments.
- Paper 12 mm/25 m with 3" core.
- Standard packing 12 rolls.

Write-on Tape FOH 20 (single sided), linen
- For information on film cans.
- For information on UNIVERSAL RACK.
- Linen 15 mm/25 m with 3" core.
- Standard packing 10 rolls.

NOTES

INTRODUCTION | 145

1 In 1958 Dr. Jan Marie Peters founded the Dutch Film Academy, which was officially recognized by the government in 1960. Ernie Tee describes its history in *Professie en Passie*.
2 State Prize for Film (BIAFRA, 1969); Milky Way Cinema Award for Reality Research (1978); Golden Calf for Best Film (HANS LIFE BEFORE DEATH, 1983); Silver Carnation from the Prince Bernhard Culture Fund (2001); Dutch Film Culture Award (2002), Golden Calf for Best Short Documentary (THE PRICE OF SURVIVAL, 2003) and the Holland-Japan Prize (2004); Caveliere nella Ordine della Stella d'Italia, 2015.
3 Bert Hogenkamp, *De Nederlandse documentaire film 1920-1940*, pp. 7-8.
4 Peter Cowie, *Dutch Cinema*, p. 9. See also Rommy Albers et al, *Film in Nederland*.
5 For more about Ivens, see the biography by Hans Schoots, *Living Dangerously*, and Thomas Waugh, *The Conscience of Cinema*.
6 See Bert Hogenkamp, *De documentarie film 1945-1965*, pp. 100-105.
7 François Truffaut, 'A Certain Tendency in French Cinema.'
8 Frans Weisz, Wim Verstappen, Pim de la Parra, Nicolas van der Heyden, Noushka van Brakel and, (a little later) Annette Apon are among the filmmakers of this 'new wave' generation in the Netherlands.
9 Less than two decades after the Second World War, the fact that Claus Von Amsberg was German was a very sensitive issue that led to protests.
10 Bert Hogenkamp, *De Nederlandse documentaire 1945-1965*, p.233-234.
11 Here also the names of Jan Vrijman, Ed van der Elsken and Johan van der Keuken should be mentioned.
12 Beerekamp, *Docupedia.nl*, pp. 14-15. Bill Nichols distinguishes six different modes of documentary filmmaking: expository (voice of authority), poetic

(experimental and associative), observational (direct cinema, fly on the wall), participatory (*cinéma vérité*, filmmaker interacts) reflexive (meta-observations on perception and filmmaking) and performative (expressive engagement). See Nichols, *Introduction to Documentary* and Nichols, *Engaging Cinema*, pp. 114-126. See also Stella Bruzzi, *New Documentary*. Michael Renov argues that documentaries have at least four different functions: to record, reveal, or preserve; to persuade or promote; to analyze or interrogate; to express. See Renov, *Theorizing Documentary*, pp. 21-36. In addition, Bordwell and Thompson subdivide non-narrative cinema in categorical, rhetorical, abstract, and associational formal systems. See Bordwell and Thompson, *Film Art*, pp. 128-163. Beerekamp also mentions Erik Barnouw's *Documentary: A History of the Non-Fiction Film*.

13 Hans Beerekamp, *Docupedia.nl*, p. 40.
14 http://www.programma.eyefilm.nl/nieuws/speech-voor-90-jarige-louis-van-gasteren
15 Peter Cowie, *Dutch Cinema*, p. 119.
16 Peter Cowie, *Dutch Cinema*, p. 120.
17 Peter Cowie, *Dutch Cinema*, p. 120.
18 Fellini quoted in Gilles Deleuze, *Cinema 2: The Time-Image*, p. 99. According to Deleuze this is a very Bergsonian conception of time. According to Henri Bergson, all layers of time co-exist.
19 Gilles Deleuze, *Cinema 2: The Time-Image*.
20 Peter Cowie, *Dutch Cinema*, p. 119.
21 Nienke Huizinga, *Signaal*, p. 88.

CHAPTER 1

1 Jan Willem Regenhardt, 'Louis van Gasteren,' p. 8. These are writers who, in the 1950s, started to revolutionize poetry and writing, freeing it from traditional conventions. They were known as the 'Vijftigers'. See also Chapter 4. Jan Willem Regenhardt is currently writing a biography of the Van Gasteren family.
2 Van Gasteren developed his own editing equipment, Film-O-Hand, which has been used in many editing rooms worldwide. See the illustration opening the Notes section.
3 Peter Cowie, *Dutch Cinema*, p. 120.
4 Johan van der Keuken, *Bewogen beelden*.
5 Patricia Pisters, 'Form, Punch, Caress.'
6 My translation from the Dutch: 'Gelijk de gebroeders Montgolfier, de eerste ballonvaarders voordat zij de eerste maal het luchtruim kozen, nemen de heren Van Haren Noman en Van Gasteren afscheid van de diep bewogen menigte

terwijl ze hun eerste rondje draaien over het geplaveide hart van hun vaderstad, de vreemde verten juichend tegemoet.'

7 Indonesia was a Dutch colony (called *Nederlands-Indië*) from 1816 until December 1949 when it became an independent republic. In Indonesia the period 1945-1950 is known as *Revolusi Nasional Indonesia* ('Indonesian National Revolution').
8 Floris Paalman, *Cinematic Rotterdam* (online PhD version), p. 202.
9 Patricia Pisters, 'Form, Punch, Caress.'
10 See for instance Lewis Mumford, *The Culture of Cities* and *City Development*.
11 Lewis Mumford, 'The Sky Line'.
12 Floris Paalman, *Cinematic Rotterdam*, p. 207.
13 Ibid., Van Gasteren in conversation with Paalman.
14 Fragments of Jan Vrijman's ballad, performed in the film by Jobs van Zuylen and Henk van Ulsen. My translation from the Dutch: 'Alle vogels hebben nesten / Ook de hoge trotse vliegers op de klippen en de rotsen / Of de rusteloze trekkers die terloops bedekking zoeken / En de gevleugelde vlegels die tussen mensen wonen [...] Maar de mens is geen dier / Hij vraagt meer dan een nest / Hij vraagt huizen om in de leven / Een huis voor het kind dat geboren wordt / Een huis voor zijn eerste schreeuw / Een huis waar hij spelen en leren kan / Een huis waar hij opgroeit tot man [...] En dan wacht de grote maatschappij. De *moderne maatschappij* [...].
15 Jan Blokker, '"Alle Vogels hebben nesten",'1961.
16 Van Gasteren in conversation with Paalman, *Cinematic Rotterdam*, p. 205.
17 In 1926 a test polder, Andijk, was reclaimed from salt water. In 1930 this was followed by the Wieringermeerpolder. After the Afsluitdijk was closed in 1932, the Noordoostpolder became land in 1942. The former islands Urk and Schokland were surrounded by new land. Oostelijk Flevoland was ready in 1957 and Zuidelijk Flevoland in 1968. The final polder of the Zuiderzee Works, the Markerwaard, was never realized, mainly because of ecological and future water management concerns.
18 The name Nagele is derived from the island De Nagel, an island in the Zuiderzee that during the Middle Ages disappeared into the sea. During the reclaiming of the land many remains of former inhabitants of the land, as well as many shipwrecks were found. The islands Urk and Schokland that were still part of the Zuiderzee are now surrounded by the Noordoostpolder fields. In his film AND THE SEA WAS NO LONGER (EN DE ZEE WAS NIET MEER, 1955) Bert Haanstra shows how this changed the local communities in and along the former Zuiderzee.
19 See http://zoeken.nai.nl/CIS/archief/9.
20 Van Gasteren in an interview for Omroep Flevoland, IK MAAK HET UIT! PORTRET VAN EEN MARKANT FILMMAKER (2012). See http://www.youtube.com/watch?v=qa8EsZ6HFC8.

21 Eva Vriend, *Het nieuwe land*, p. 230.
22 Not everybody could simply come and live in the Noordoostpolder. In particular, the designation of farms and farmland was subject to a strict and hierarchical selection procedure, organized by the Dutch government under leadership of Bram Lindenbergh. Farmers were selected for their agricultural knowledge, their use of modern equipment, and their management as well as social qualities. Their land and houses were inspected; their wives were evaluated on the tidiness of their households. See Eva Vriend, *Het nieuwe land* for an insightful recounting of the stories behind these selections.
23 Van Gasteren in IK MAAK HET UIT.
24 Ibid.
25 It is interesting to mention here another adaptation of a city plan in the city of Almere, a new city in the Flevopolder, the last reclaimed land of the Zuiderzee Works. In a collaboration between inhabitants, housing association, city council, and designers, one of the city's squares (Van Eesterenplein) now features a 'digital fireplace' in the form of stone-like statues that change colour and make sounds when you interact with them. The project, glowing Marbles (by Studio Daan Roosegaarde), makes the place more friendly and inviting for people to come to the square to meet. See https://www.studioroosegaarde.net/project/marbles/.
26 Van Gasteren in Ard Hesselink, *Louis van Gasteren*, p. 20 and p. 31.
27 Not everybody at that time could appreciate this experimental narration. A functionary of the Ministry of Foreign Affairs, for instance, wondered if an explanatory booklet would not be needed. (Hesselink, *Louis van Gasteren*, p. 21).
28 Charles Boost quoted in Ard Hesselink, *Louis van Gasteren*, p. 20. My translation.
29 Van Gasteren in conversation with author (16 October 2014).
30 Josef Von Sternberg, *Fun in a Chinese Laundry*, pp. 313-314. Von Sternberg explains in a note on the same pages: 'This is a short and extremely witty film made in the Netherlands. My records fail to disclose the name of the director. It was brought to this country by the industrious George K. Arthur, who, sitting behind me in the dark theatre, distracted my attention by whispering to my wife: "Does he still like his eggs boiled exactly three minutes?" Incidentally, I take the liberty of suggesting that the directors of full length features adopt some of the superlative qualities often incorporated in many short films. They are made all over the world by many talented experimenters.'
31 Gilles Deleuze, *Cinema 1: The Movement-Image*, p. 206.
32 Gilles Deleuze, *Cinema 2: The Time-Image*, p. 264.
33 François Truffaut, Jean-Luc Godard, Eric Rohmer, Claude Chabrol, and Jaques Rivette belonged to the 'Rive Droite' of the French New Wave, closely connected to the film journal *Cahiers du Cinema*, in which they, under the editorial coordination of André Bazin, started to redefine cinema in the early 1950s. Resnais

was connected to the 'nouveau roman' novelists and filmmakers of the 'Rive Gauche' group that included Marguerite Duras, Alain Robbe-Grillet, Jacques Demi, and Agnès Varda.

34 See Patricia Pisters, 'Flashforward: The Future is Now,' for a detailed discussion of (the temporal dimensions of) HIROSHIMA MON AMOUR.
35 For more about Deleuze's relation to Bergson, see Pisters, *The Neuro-Image*.
36 Gilles Deleuze, *Cinema 2: The Time-Image*, p. 99.
37 Ibid., p. 119.
38 Charles Boost, quoted in Ard Hesselink, *Louis van Gasteren*, p. 19. My translation.
39 For a detailed description of the housing riots during this period, see also Ginette Verstraete, 'Underground Visions,' pp. 77-95.
40 From Patricia Pisters, 'Form, Punch, Caress,' p. 130.
41 THE CITY WAS OURS can be watched online http://www.youtube.com/watch?v=dfPKwFB6WpY. An English subtitled version is also available, albeit in lesser quality (of both the copy and the translation): http://www.youtube.com/watch?v=5VOTV9tcNIk. See for a full overview of filmed documentation of the squatters' movement www.iisg.nl/staatsarchief/videocollecties/dvd.php.
42 This process of city transformation along the banks of the IJ, is beautifully shown in AMSTERDAM, CITY ALONG THE IJ (AMSTERDAM, STAD AAN HET IJ, 2012), a film by Remy Vlek.
43 Seelen in Stienen, 'Elke revolutie eet zijn eigen kinderen,' p.2.
44 Louis van Gasteren in Nienke Huizinga, *Signaal*, p. 123. Translation Reinier Koch & Michael Martin (slightly modified).
45 http://www.metrokunst.nl/.

CHAPTER 2

1 For instance, Van Gasteren in Nienke Huizinga, *Signaal*, p. 139.
2 As the information in the AOD Visitors Center indicates, as a reference for the 'zero-level,' the AOD is indispensable to the design and implementation of infrastructural projects such as the construction of roads, bridges, tunnels, and viaducts. The AOD is also of the utmost importance for the regulation of the ground water level. Without the AOD the heights of the dikes, the ground water level in the polders, and the depths of water courses could not be determined. The study of the sea level rise would not be possible without a common reference surface such as the AOD. Furthermore, every day one can see surveyors with their measuring instruments working in connection with building structures. Since 1990 AOD is the standard for the United European Leveling Network (EULN) and the European Vertical Reference System (EVRS).

3 'en in alle gewesten /wordt de stem van het water /met zijn eeuwige rampen / gevreesd en gehoord'. My translation.
4 Van Gasteren reports on the film in Ard Hesselink, *Louis van Gasteren*, pp. 10-12.
5 For instance, Charles Boost, 'Tweeërlei filmdebuut' in *De Groene Amsterdammer*, 6 February 1960; and B.J. Bertina, ' "Stranding" vol beloften,' *De Volkskrant* 23 January 1960.
6 Personal conversation between Louis van Gasteren and author, 3 November 2014.
7 Henk van Gelder, *Hollands Hollywood*, p. 80, p. 86, and p. 100. RIFIFI IN AMSTERDAM did have some commercial success, mainly because popular singer Willy Alberti made an appearance, as did judoka Anton Geesink.
8 See the official site of the Royal Netherlands Sea Rescue Institution (KNRM) http://190jaar.knrm.nl/190-jaar.
9 Van Gasteren in Ard Hesselink, *Louis van Gasteren*, p. 23.
10 See Nienke Huizinga, *Signaal*, pp. 146-155.
11 In the 1950s German philosopher Martin Heidegger reflected upon the essential relation between building, dwelling, thinking, and technology. Heidegger's metaphysical system of the relation between human being (dwelling) in the world and Being (of God) does not correspond to Van Gasteren's more immanent worldview (there is no God in Van Gasteren's work). They do share, however, a concern for modern technology as profoundly related to modern man, albeit with different conclusions. For Van Gasteren, technology is part of what moves us forward, keeps us safe. For Heidegger, modern technology provokes nature to bend to human needs, and also enframes us, determines who we are. See Heidegger, 'The Question Concerning Technology' and 'Building, Dwelling, Thinking' in Heidegger, *Basic Writings*, pp. 308-363.
12 See http://www.youtube.com/watch?v=uBtuFTtvqdo.
13 The imaginary but highly influential precursor of hypertext (that became widely used in the early 1990s) is presented in Vannevar Bush's idea of the Memex, a futuristic machine that would link to an extensive archive of microfilms containing books and other documents and which would leave its trails of linking. See Vannevar Bush, 'As we May Think'.
14 For instance, in the mid-seventeenth century, during the Dutch Golden Age, merchants of Amsterdam (Hendrik and Dirk van Os) paid for the reclaiming of the Beemster and the Haarlemmermeer. See also the television series THE NETHERLANDS SEEN FROM ABOVE, episode 6: WATER, FRIEND OR ENEMY (NEDERLAND VAN BOVEN, VPRO television, 2012) http://www.npo.nl/aflevering-6-water-vriend-of-vijand/10-01-2012/VPWON_1152046. See also the television series THE GOLDEN AGE, episode 12: SEA HEROES (DE GOUDEN EEUW, VPRO/NTR television, 2013) http://www.npo.nl/de-gouden-eeuw/26-02-2013/NPS_1210676.

15 Also the pragmatic tolerance involved in sea trading benefited from this polder model. It has to be said that this model was not applied in the Dutch colonies (Suriname, Indonesia) where the local populations were not treated as equal partners.
16 Van Gasteren a.o., *Een zaak van niveau, 1000 jaar nederlandse waterhuishouding*, 1991.
17 Ibid., p. 176.
18 Ibid., p. 190.
19 Ibid., pp. 108-118.
20 On the website of DUTCH LIGHT: http://www.dutchlight.nl/.
21 Van Gasteren a.o., *Een zaak van niveau*, pp. 172-175.
22 Ibid., p. 181.
23 THE CLOUDED EXISTENCE OF LOUIS VAN GASTEREN (HET BEWOLKTE BESTAAN VAN LOUIS VAN GASTEREN, Hans Keller, 2007)
24 In his recent book, *Langs de kust: de Nederlanders en de zee,* Thijs Broer argues that the Dutch have increasingly forgotten about the water, are turning their backs on the sea; now that most of the land is in control we tend to forget about its (frightening) powers. However, he also demonstrates that while it is true that many fisher villages have disappeared and governments are imposing more and more rules that go against the spirit of freedom of the sea, the ties to the spirits of the water will never completely disappear. And in the film EPISODES OF THE SEA (2014) Lonnie van Brummelen and Siebren de Haan show how fishermen of Urk cope with the new realities of European rules and regulations and the significance of the sea in relation to their history and the land.
25 For instance, in the television series A'DAM & E.V.A. (Norbert ter Hall, 2011 and 2014) we see similar images throughout the series. This drama series follows not only the two main characters Adam and Eva, but also picks up new characters in the street that are followed for the duration of the episode, depicting in this way a portrait of multicultural Amsterdam today. (Adam is also an acronym for Amsterdam, E.V.A. stands for 'and many others' (*En Vele Anderen*).)
26 In 2011 Van Gasteren donated 4500 music documents from his mother's collection to the Dutch Music Insititute (Nederlandse Muziek Instituut). Budget cuts have made this and much of other musical heritage inaccessible. See a call to protest from Van Gasteren http://www.youtube.com/watch?v=FkvTYIMYLWo.
27 Van Gasteren in Ard Hesselink, *Louis van Gasteren*, p. 10.
28 Van Gasteren in Nienke Huizinga, *Signaal*, p. 157.
29 Van Gasteren recalls how Lien d'Oliveyra was working in a neighboring editing room. Lien d'Oliveyra was a very skilled editor who had done the editing for Van Gasteren's and Van Haren Noman's BROWN GOLD and cut many Dutch fiction films. Having no experience in editing, Van Gasteren regularly panicked over the editing table, cutting up pieces of unused film material and throwing them

around. So d'Oliveyra came in to ask how he was doing since it seemed like he was in the middle of a concrete editing problem, while in fact Van Gasteren was only thinking about the choices he had to make. Van Gasteren in Ard Hesselink, *Louis van Gasteren*, pp. 8-9.

30 Marshall McLuhan, *Understanding Media*.
31 The first satellite image of the earth as an entire planet appeared in 1967; the most famous earth picture was taken on 7 December 1972 by the crew of the spacecraft Apollo 17.
32 Steve Jobs in his June 2005 Stanford University commencement speech. See http://www.youtube.com/watch?v=D1R-jKKp3NA&t=12m45s.
33 Description derived from Nienke Huizinga, *Signaal*, p. 36.
34 A precursor to this project, Industrial Design, was created and exhibited in the Vondel Park in Amsterdam. In the film NEMA AVIONA ZA ZAGREB (2012) the production process of this auto wreck sculpture is shown. The Dutch pavilion at the Expo 1970 was presented as a multimedia installation with images from filmmaker Jan Vrijman and music by Louis Andriessen.
35 Van Gasteren in Nienke Huizinga, *Signaal,* p.41.
36 Ibid., p. 58.
37 Ibid., p. 50.
38 The Fodor exhibition also contained the model for AUTOSCULPTURE IN TELE-CREATION; MILWAUKEE INTERSPACING (1965), which was an artwork reflecting policemen firing guns at paper targets; and the giant TURTLE PAINTING (SCHILDPADSCHILDERIJ, 1967) that could never be seen in its entirety because of the use of special paint and special alternating lighting that would light up different parts of the painting. Nobody has the full perspective. Sadly the painting was not bought by a museum and because of its size Van Gasteren had to destroy it.
39 Van Gasteren in *De Volkskrant*, 24 February 1968, quoted in Huizinga, *Signaal*, p. 54.
40 McLuhan, text pronounced in NEMA AVIONA ZA ZAGREB combined with the more extended transcription printed in *Signaal*, p. 59.
41 Van Gasteren spent three days with McLuhan in and around the Habitat pavilion at the Expo 67 in Montreal in 1967. See Frans van Lier, 'Louis van Gasteren werd "broertje" van McLuhan'.
42 Marshall Mcluhan and Quentin Fiore, *The Medium is the Massage*, p. 26.
43 Now there are many different media-archaeological approaches, a discussion which goes beyond the scope of this book. See Jussi Parikka, *What is Media Archaeology?*, pp. 1-18; and Erkki Huhtamo, and Jussi Parikka, eds., *Media Archaeology: Approaches, Applications, and Implications*.
44 Ibid., p. 3.
45 http://stadsarchief.amsterdam.nl/presentaties/fotografen_van_amsterdam/jacob_olie.
46 Jan Blokker, 'De telefoon en de lijkbezorger'.

CHAPTER 3

1. My translation of 'In deze tijden heeft wat men altijd noemde / schoonheid schoonheid heeft haar gezicht verbrand' from 'Ik tracht op poetische wijze' in Lucebert, *Verzamelde gedichten*, p. 52. The poem addresses the need to change the aesthetic rules of poetry 'after Auschwitz', but also refers to the devastating effects of the war on the idea of humanity.
2. There are many references to the Cold War in ALPHAVILLE, but WWII permeates the film not only in the sadness of the dark settings (the film is shot entirely at night), but is also direct references via 'SS buttons' in the elevator, numbers stamped on people's foreheads, and a public execution of dissidents in a swimming pool.
3. See Thomas Elsaesser, 'Subject Positions, Speaking Positions'; Frank van Vree, *In de Schaduw van Auschwitz*; Frank van Vree and Rob van der Laarse, *De Dynamiek van de Herinnering*; Rob van der Laarse, *Nooit meer Auschwitz*.
4. More on the relation between the war and the rebellious youth culture of the 1960s in the next chapter.
5. Westerbork was initially built as a refugee camp for Jews that fled from Germany to escape from Nazi terror in Germany in the 1930s. During the war it was transformed into a transit camp for Dutch Jews (and also some resistance fighters, Sinti and Roma). Immediately after the war the Westerbork camp was used to imprison Nazi collaborators before their trial; in the course of the decolonization of the former Dutch Indies (from 1945-1949) the barracks were used to house repatriated Dutch nationals; and between 1950 and 1970 Westerbork was renamed Kamp Schattenberg, to house citizens from the Maluku islands, which were formerly part of the Dutch Indies. During that time some barracks were sold to farmers and others were gradually destroyed. In 1969 parts of the Westerbork terrain was used to place fourteen huge Radio Telescopes (Westerbork Radio Telescope Synthesis) that are still there. It is now a memorial site with several monuments and a museum. See http://www.kampwesterbork.nl/en/geschiedenis/index.html#/index and Rob van der Laarse, 'Kamp Westerbork,' in *Een Open Zenuw*.
6. Van Vree proposes this term analogue to James Young's analysis of Holocaust memorials in *The Texture of Memory*.
7. See Thomas Elsaesser, *New German Cinema* and Thomas Elsaesser, *Fassbinder's Germany*.
8. The most famous of these is the Teufelsberg ('Devil's hill') which covers the entire Nazi military school designed by Albert Speer. This building appeared too strong to be blown up and was completely covered.
9. This hill is now called Grosse Bunkerberg. It is constructed around a destroyed bunker that was filled with 2.5 million cubic metres of war debris.
10. See Nienke Huizinga, *Signaal,* pp. 105-115.

11 Frank van Vree, *In de Schaduw van Auschwitz*, p. 8.
12 Ibid., pp. 57-88.
13 The 26 volumes of Loe de Jong's standard reference work were published between 1969 and 1994. See also http://www.niod.nl/nl/koninkrijk.
14 Another historically based film about the courage of the resistance is THE GIRL WITH THE RED HAIR (HET MEISJE MET HET RODE HAAR, Ben Verbong, 1981) about resistance fighter Hannie Schaft. See also DUTCH RESISTANCE HEROES (DE NEDERLANDSE VERZETSHELDEN, DVD with documentaries compiled by NIOD (Nederlands Instituut voor Oorlogs-, Holocaust- en Genocide Studies). THE ICE CREAM PARLOR (DE IJSSALON, Dimitri Frenkel Frank, 1985) refers in a fictional way to the fights between communist thugs and Nazi collaborators (NSB-ers) in a Jewish ice cream parlour in Amsterdam that led to the only large public and organized resistance against the treatment of the Jews, the February Strike in 1941. This strike would lead to the first razzias in the Netherlands and the revelation of the true cruel intentions of the occupiers. One of the most famous Dutch war films is Paul Verhoeven's SOLDIER OF ORANGE (SOLDAAT VAN ORANJE, 1977), based on the memoirs of resistance fighter Erik Hazelhoff Roelfzema.
15 Just to mention a few examples from cinema alone, Paul Verhoeven's controversial documentary about the leader of the Dutch collaboration PORTRAIT OF ANTON ADRIAAN MUSSERT (1968) could be mentioned. His more recent war film, BLACK BOOK (ZWARTBOEK, 2006), gives a bleak portrayal of the War where everybody (who survives) is guilty. In German cinema the war has equally been seen from many different angles, as so richly analyzed in the work of Thomas Elsaesser. See for a comparison between Verhoeven and Fassbinder in their ways of portraying history through the fate of women Patricia Pisters, 'Lili and Rachel'. Elsaesser also discusses the ways in which Verhoeven has introduced the traumas of Nazis in a displaced form and cultural transfer in his Hollywood films such as TOTAL RECALL and STARSHIP TROOPERS. See Thomas Elsaesser, *European Cinema Face to Face with Hollywood*, p. 313.
16 Frank van Vree, *In de Schaduw van Auschwitz*, pp. 71-72.
17 See also www.annefrank.org. Also Etty Hillesum's letters written from Camp Westerbork should be mentioned here.
18 The internationally acclaimed works of important Jewish writers such as Primo Levi's *If This is a Man* (1947) and Elie Wiesel's *Night* (1958) were translated much later in the Netherlands.
19 Both Anne Frank's diary and Marga Minco's *Bitter Herbs* were much later transformed in filmic adaptations. Marga Mico distanced herself from the film BITTER HERBS (HET BITTERE KRUID, Kees van Oostrum, 1985). Also Frans Weisz's films CHARLOTTE (1981), LAST CALL (HOOGSTE TIJD, 1985) and MALICIOUS PLEASURE (LEEDVERMAAK, 1989) address the war and memories of Nazi occupation from a Jewish perspective.

20 Deleuze refers to Primo Levi in an interview with Toni Negri: 'I was very struck by all the passages in Primo Levi where he explains that Nazi camps have given us "a shame at being human." Not, he says, that we're all responsible for Nazism, as some would have us believe, but that we've all been tainted by it: even the survivors of the camps had to make compromises with it, if only to survive. There's the shame of there being men who became Nazis; the shame of having compromised with it; there is the whole of what Primo Levi calls this "grey area". And we can feel shame at being human in utterly trivial situations, too: in the face of too great a vulgarization of thinking, in the face of TV-entertainment, of a ministerial speech, of "jolly people" gossiping. This is one of the most powerful incentives toward philosophy, and it's what makes all philosophy political.' *Negotiations*, p. 172.
21 More about this film in the Coda of this book.
22 Van Gasteren in Ard Hesselink, *Louis van Gasteren*, p. 30.
23 After many years of prohibition some experiments in the therapeutic use of LSD are emerging again. See for instance, THE SUBSTANCE: ALBERT HOFFMANN'S LSD (Martin Witz, 2011).
24 Van Gasteren reshot some scenes with Bastiaans with a small crew (the cameraman was Jan De Bont); Bastiaans gave an introduction to the film. See also Bram Enning, *De Oorlog van Bastiaans*, pp. 110-145 for more detailed background of the film and its aftermath.
25 Later it would appear that the effects of the treatment were only temporary and the ending of the film too hopeful – even if the message that unbearable suffering can be transformed into bearable suffering was important at the time. I will return to the long-term effects in the last part of this chapter.
26 Ard Hesselink, *Louis van Gasteren*, p. 30.
27 The Coornhert-Liga group for pragmatic reformation of justice claimed that imprisonment that no longer serves the goal of protecting society should be ended. About the public hearing and the emotional responses in the public tribunal see A.J. Heerma van Voss, 'De strafrechthervormers stonden met lege handen' and other articles in the dossier 'Drie van Breda' in *Haagse Post*, 1 March 1972, pp. 8-17. In this dossier the chairman of the parliament, Mr. A. Geurtsen, describes how he started to change his opinion about releasing the prisoners after seeing NOW DO YOU GET IT, WHY I AM CRYING? (p. 10).
28 Newspaper articles, 'Minister ziet film over syndroom' in *NRC Handelsblad* (24 February 1972) and 'Emoties maken veel indruk op Van Agt' in *De Volkskrant* (24 February 1972). The film was shown in Nieuwspoort, the press center near the parliament in The Hague.
29 Van Tol worked with Bastiaans at the Jelgersma Clinic of the University of Leiden. The other two psychiatrists were Professor J.A. Weijel and medical advisor of the Foundation Stichting 1940-1945, Dr. P. Hugenholtz.

30 'Meer dan 800 telefoontjes' *Parool* 28 Februari 1972. See also Bram Enning, *De oorlog van Bastiaans*, pp. 140-141.

31 See an interview with Telling, 'Slachtoffers willen begrepen worden'. *Vara Gids Extra*, 1972.

32 http://www.centrum45.nl/nl.

33 One of them, Josef Kotälla, died in prison. The other two, Franz Fischer and Ferdinand aus der Fünten, were released in 1989, shortly after which they both died.

34 Van Gasteren in Hesselink, *Louis van Gasteren*, p. 30.

35 Telling wrote a letter to CBS asking to receive copies of the reactions of viewers. These letters were sent to him and after Telling died his son handed the letters over to Van Gasteren who keeps them in his archive.

36 See Chris Vos, *Televisie en Bezetting*. In 1966 a summary of Loe de Jong's THE OCCUPATION was shown on German television, followed by some images of LSD treatment by Bastiaans filmed by At van Praag.

37 Participants in the discussion were Professor Eugen Kogon, Dieter Frettlöh, Hermann Langbein, Professor Paul Matussek, Professor Erich Wulff, and Louis van Gasteren.

38 In 1978 the WDR reflected on the peculiar development of the discussion in a program entitled CAN I INTERRUPT HERE? THE DISTURBANCE OF A DISCUSSION (DARF ICH HIER UNTERBRECHEN? DIE ZERSTÖRUNG EINER DISKUSSION). Here Alexander von Cube, program director of the WDR, analyzed with Bodo Lehmann what went wrong in the discussion. A case of meta-reflection and self-analysis of the medium that is interesting to compare to talk shows today.

39 The omnibus film *Germany in Autumn* shows the mood in Germany in the autumn of 1977 when the RAF (Red Army Faction) kidnapped a businessman. The RAF and the Baader-Meinhoff group were exponents of a post-war generation that rebelled violently against (among other things) the silence of their parents.

40 Reitz quoted in Thomas Elsaesser, *New German Cinema*, p. 272.

41 The films of this trilogy consist of THE MARRIAGE OF MARIA BROWN (1979); VERONIKA VOSS (1982) and LOLA (1981). Fassbinder's LILI MARLEEN (1981) is set during the Second World War.

42 See for instance Patricia Pisters, *The Neuro-Image*, p. 271-298 for a discussion of PTSD in Iraq war films.

43 Hans Beerekamp, 'Het verzet is ons motief'. In a personal interview (1 May 2015) Van Gasteren declared that after he read *The Dark Room of Damocles*, he immediately traveled to Groningen to meet Hermans and asked to film the book. Hermans agreed and they met several times; Hermans also had an LSD session at Van Gasteren's house. However, when beer magnate Freddy Heineken offered money for the production of the film (and wanted his mistress to play a role in the film), Hermans closed a deal with Fons Rademakers as director. Obviously

Van Gasteren was more than disappointed and for some time he and Hermans were not on speaking terms. Ten years later they settled their dispute.
44 See for an English summary of the book http://www.complete-review.com/reviews/hermansw/dkamerd.htm.
45 The collaboration between Hermans and Rademakers was not always an easy one. Hermans did not like that the 335 page novel had to be cut in order to fit the length of a feature film, although the real reason for the conflict between Rademakers and Hermans remains unclear. Also, Heineken proved to be a difficult partner who for many years prevented the rerelease and broadcasting of AS TWO DROPS OF WATER. See for the interesting background story of this film Mieke Bernink, *Fons Rademakers*, p. 46-61.
46 *De donkere kamer van Damokles*, post-script, p. 335. My translation from the Dutch. 'Ik kan hem zoeken als hij er niet is, maar hem niet ophangen als hij er niet is. Men zou kunnen willen zeggen: "Dan moet hij er toch ook zijn als ik hem zoek." – Dan moet hij er ook zijn als ik hem niet vind, en ook als hij helemaal niet bestaat.', p. 335.
47 Hans Beerekamp, 'Het verzet is ons motief' (my translation). Besides Van Gasteren, filmmaker Jan Vrijman and journalist Henk Hofland participated in this interview.
48 See o.a. 'Van Gasteren in vrijheid en gerehabilliteerd', *Het Parool*, 28 January 1946. Based on the advice of the Great Advisory Committee of ex-Illegal Resistance (Grote Adviescommissie der Illegaliteit). Also described and reconfirmed in the official investigation report by the Committee of Stichting 1940-1945 (dossier 45926) in 1993.
49 His first camera was a Baby Browny that he bought in Luxembourg where he spent his summers during his youth. He paid for the camera with money earned from fishing. See A CHAINSAW FOR THE PAST.
50 Bart Middelburg, 'Moord in de Beethovenstraat,'; Annemieke Hendriks, 'Louis van Gasteren de liquidatie van de twijfel,'; Eric Slot, *De dood van een onderduiker*.
51 Dossier 45926 Stichting 1940-1945.
52 See Madelon de Keizer and Marije Plomp, eds., *Een open zenuw*.
53 For instance, the at the time controversial documentary THE ALIEN (1979), in which Van den Berg shows understanding for the situation of the Palestinians. Or STRANGERS AT HOME (1985), another documentary in which Van den Berg travels with his Palestinian friend, the artist Kamal Boullata, through Israel. Or more recently, SÜSKIND (2012), a fiction film based on the true story of Walter Süskind who during the war saved the life of about 900 Jewish children by befriending SS officer Aus der Fünten and collaborating with the Jewish council. He was discovered and deported to Auschwitz at the end of the war, where he would die. Van den Berg also made several films that won the Golden Calf for best film, among which BASTILLE (1984) and THE EVENINGS (1989).

54 See Elie Wiesel, *Dawn*.
55 Hans Beerekamp, 'Houdt het dan nooit op die Tweede wereledooorlog?'
56 See Gilles Deleuze, *Dialogues*. And Patricia Pisters, 'Micropolitiek', p. 224-236.
57 Gilles Deleuze, *Cinema 1: The Movement-Image*, p. 138. Here Deleuze argues that it is especially in MR. KLEIN (1976) that a Losey character, played by Alain Delon, is drawn by the violence of the impulses that dwell in him and is pulled toward the 'strangest becoming: taken for a Jew, mistaken for a Jew under the Nazi occupation, he begins by protesting, and puts all his gloomy violence into a court inquiry, in which he wants to denounce the injustice of that assimilation. But it is not in the name of the law, or of a recognition of a more fundamental justice, but purely in the name of the violence within him that he gradually makes a decisive discovery: even if he was a Jew, all his impulses would still be opposed to the derived violence of an order which is not theirs, but the social order of a dominant regime. So that the character begins to assume that state of Jewishness which is not his own and consents to his disappearance among the mass of Jews led off to their deaths. It is exactly the becoming-Jew of a non-Jew. The role of the double, and the course of the court inquiry in MR. KLEIN has been widely commented on. To us these themes appear secondary and subordinate to the impulse-image, that is, to the static violence of the character, whose only outlet in the derived milieu is a reversal against himself, a becoming which leads him to disappearance, as to the most overwhelming assumption of responsibility.'
58 Willem Albert Wagenaar, 'Calibration and the effect of knowledge' and 'Misleading postevent information'.
59 Erik Hazelhoff Roelzema in I HAD A GOLDEN FUTURE BEHIND ME (IK HAD EEN GOUDEN TOEKOMST ACHTER ME, Pieter Varekamp, 1988).
60 Sung by Ernst Busch Barbarossa.
61 See also Claude Lanzmann's, SHOAH (1985).
62 Nienke Huizinga, *Signaal*, p. 157. My translation.

CHAPTER 4

1 COBRA refers to Copenhagen, Brussels and Amsterdam, the home cities of the post-war avant-garde artists.
2 Right after the production of THE HOUSE (1960) Van Gasteren was asked by Jan Vrijman (who collaborated on THE HOUSE) to make a film about Karel Appel. Van Gasteren went to Paris to visit Appel and plans were made to make a short film about the 'birth of a painter.' To Van Gasteren's dismay, Vrijman changed his mind and made the film about Appel himself. In THE REALITY OF KAREL APPEL (Jan Vrijman, 1961) Appel comments on his post-war expressionist way of filmmak-

ing as painting like a barbarian in a barbaric age: 'I don't paint, I hit. The expression of reality has to be hit into the painting.'
3. Jan Willen Regenhardt, *Louis van Gasteren*, p. 8.
4. Van Gasteren in Nienke Hesselink, *Signaal,* p. 6.
5. Van Gasteren in *Hans het leven voor de dood* (shooting script and interview), p. 119. In 1961 van Sweeden composed the music for Van Gasteren's film ALL BIRDS HAVE NESTS.
6. Van Gasteren, 'Heb meelij met mij en mijn arme volk,' *Avenue*, 1982. See also Gerdin Lindhorts, 'Louis van Gasteren, de eeuwige verwondering.'
7. Mengelberg at the beginning of HANS LIFE BEFORE DEATH.
8. Considerans of the jury (Wim van der Velde, Jan Vrijman and Ellen Waller) in *Nederlandse Filmdagen festival verslag 1983*, pp. 17-18. Archive Spectrum Film.
9. Provo was the Dutch anarchist counter-movement founded by Robert Jasper Grootveld, Roel van Duijn and Rob Stolk in 1965 until 1967. See also the film THE REBELLIOUS CITY (DE REBELSE STAD, Willy Lindwer, 2015)
10. Van Gasteren in 'Afkomen' in *Hans het leven voor de dood*, p. 125. My translation.
11. See also Hans van Sweeden, 'Hoe Ben ik Werkelijk?' in *De mooie stad*, pp. 11-13. My translation.
12. Ibid., p. 13. My translation
13. Ibid., p. 13. My translation.
14. Ibid., p. 14. My translation.
15. The Dutch title refers to the children's song 'Zie de maan schijnt door de bomen' that is always sung on the occasion of the Sinterklaas celebrations. More recently this Dutch tradition became the focus point of debates and court cases around Sinterklaas' helper, the figure of Black Pete ('Zwarte Piet'), which is based on racist stereotyping (even if many autochthone Dutch have never seen it as such). See the film BLACK AS SOOT: OUR COLONIAL HANGOVER (ZWART ALS ROET, Sunny Bergman, 2014).
16. See Mieke Bernink, *Fons Rademakers*, pp. 35-35.
17. At the beginning of ALL REBELS Van Gasteren has included some excerpts of this film.
18. Remmelt Lukkien in 'Afkomen' in Van Gasteren, *Hans het leven voor de dood*, p. 127
19. See also Van Gasteren, *Hans het leven voor de dood*, p. 37.
20. More directly these questions are addressed in Van Gasteren's autobiographic film NEMA AVIONA ZA ZAGREB (2012). See the coda of this book.
21. I am referring to Beckett's famous 'Ever tried. Ever failed. No matter. Try again. Fail again. Fail better' from his novella *Worstward Ho* (1983)
22. See also Tom Wolfe, *The Electric Kool-Aid Acid Test*.
23. See also Timothy Leary et al., *The Psychedelic Reader*; and Don Lattin, *The Harvard Psychedelic Club*. The word 'psychedelic' was invented by Aldous Huxley

and the English psychiatrist Humphrey Osmond (see *The Harvard Psychedelic Club,* pp. 64-65). Huxley was one of the first novelists to write down the insights one gets from taking mescaline or other chemical substances. See Aldous Huxley, *The Doors of Perception* and *Heaven and Hell*. Another artist who famously expressed his mescaline experiences is Henri Michaux in *Miserable Miracle*. See also Michaux's mescaline drawings in the film IMAGES DU MONDE VISIONNAIRE (Eric Duvivier, 1963).

24 See for an interview with Leary at Millbrook on this point https://www.youtube.com/watch?v=yT5sJHphTS.

25 The same happened with MDMA, the chemical that would be popularized as XTC. See for an interesting documentary about the inventor of MDMA, the chemist Dr. Alexander Shulgon, the documentary DIRTY PICTURES (Etienne Sauret, 2010). Marijuana had already been forbidden for a long long time. The film REEFER MADNESS (Louis Ganier, 1936) expresses the fear for marijuana. The film calls parents to warn their children for the dangers of 'dope addiction'. REEFER MADNESS would later become a cult film.

26 A little later, filmmaker Johan van der Keuken captured some of the demonstrations against the Vietnam War and other demonstrations in Amsterdam in his documentary SPIRIT OF TIME (DE TIJDSGEEST, 1968).

27 http://greatwen.com/2010/06/02/to-whom-it-may-concern-poetry-incarnation-at-the-royal-albert-hall/.

28 Duco van Weerlee, 'Visie en Ongenoegen' in Van Gasteren, *Allemaal rebellen*, p. 9.

29 Ibid., p. 11.

30 Ibid., p. 15.

31 This book is not a historical cultural analysis of contemporary youth culture, but briefly, it is interesting to see that in the 1990s a new drug, MDMA (XTC) came along with a new youth culture of house and techno music. One of the first films shot on a digital camera shows the Amsterdam dance-drug scene of the 1990s, WASTED! (NAAR DE KLOTE! Aryan Kaganov, 1996). In the same year Danny Boyle's TRAINSPOTTING similarly expressed the excesses of youth culture in this era. With the arrival of web 2.0 and social media, and after 9/11, things have changed completely again. In the multicultural globalized word of today, fundamentalism and jihadism are part of a youth culture that is an extremely violent, desperate, and destructive expression of youthful frustration and resistance.

32 James Kennedy, *Nieuw Babylon in aanbouw*, p. 11. The title of the book, New Babylon, refers to an art work of Constant (Constant Nieuwenhuis) from the COBRA movement. New Babylon, presented in 1965, was a model for a utopian city where people were liberated by technology and 'homo ludens' would have free play in an 'anti-functional city' were everybody creates.

33 Ibid., p. 11.

34 Ibid., pp. 14-21.
35 'In the beginning the police took every stump of kale for cannabis and they operated without knowledge nor judicial guidelines,' Van Gasteren commented. Van Gasteren 'Heb meelij met mij en mijn arme volk,'
36 See also the documentary IN NAME OF THE LAW (IN NAAM DER WET, Barbara Den Uyl, 1991) on the death of Hans Kok.
37 Van Gasteren, 'Afkomen' in *Hans het leven voor de dood*, p. 129.
38 'Out of My Skull' in Nienke Hesselink, *Signaal*, p. 24. On 3 March 2015 EYE Film Institute Netherlands organized a special live screening of OUT OF MY SKULL in the presence of the director who operated the stroboscopic lights himself. The film was shown in combination with CHAPPAQUA (Conrad Rooks, 1966).
39 Van Gasteren's words are here rendered by Jhr. Mr. G.Th. Gevers Deynoot, secretary of the Board of Public Health, sent to Van Gasteren with a letter dd. 30 June 1967 (letter nr. 408). Archive of Spectrum Film.
40 Van Gasteren in a letter of the Central Board of Film Censoring (24 April 1966).
41 Other films that translate this spirit: Fellini's GIULIETTA AND THE SPIRITS (1965) and TOBY DAMMIT (1968); and films of Pierre Clementi such as VISA DE CENSURE N X (1967-1975).
42 Hopper and Fonda, joined by Jack Nicholson, would become the American anti-heroes of the 1960s road film par excellence, EASY RIDER (Dennis Hopper, 1969)
43 Nienke Huizinga, *Signaal*, pp. 86-95.
44 Ibid., p. 95.
45 See about the renewed interest in medicinal use of cannabis, legalization in certain US states, Lisette Thooft, 'Leef beter, leef fijner met behulp van psychedelica'.
46 Nico Frijda, 'De betrouwbaarheid van ooggetuigen' mentioned in Ard Hesselink, *Louis van Gasteren*, p. 26.
47 'Filmkeuringsrapport' in Ard Hesselink, *Louis van Gasteren*, p. 45.
48 Ibid., pp. 35-36.
49 In 1968 Van Gasteren founded the Artec foundation, an organisation that aimed at bringing together scientists and artists around artistic projects that involve technology and science. Artec was active in a considerable number of projects. See Hans de Jonge, *50 Artec Contacten*.

CHAPTER 5

1 EUROPA – the Schuman declaration, 9 May 1950. See http://europa.eu/about-eu/basic-information/symbols/europe-day/schuman-declaration/index_en.htm.
2 B.J. Bertina, 'Louis van Gasteren ontdekt de geheimen van Sardinië'.
3 Van Gasteren in Ard Hesselink, *Louis van Gasteren*, p. 37.

4 'ANWB Onderscheidingen,' 23 November 1977, award report for the prizes (Spectrum Film Archive).
5 http://europa.eu/about-eu/institutions-bodies/european-parliament/index_en.htm
6 More institutions have been added since. See http://europa.eu/about-eu/institutions-bodies/index_en.htm
7 See also Mansholt's excellent biography (in Dutch) by Johan van Merriënboer, *Mansholt: Een biografie*.
8 Mansholt, *La Crise,* p. 23 and Van Merriënboer, *Mansholt*, p. 61.
9 In 1976 *Max Havelaar* was filmed under the same title by Fons Rademaker. In 2002 *Max Havelaar* was chosen as most important work of literature of the Netherlands.
10 Mansholt, *La Crise*, p. 31.
11 Van Merriënboer, *Mansholt*, p. 139.
12 Donella Meadows et.al, *The Limits to Growth: A Report for the Club of Rome*.
13 In this period Mansholt met his soulmate in Petra Kelly, who was much younger than him and who would later co-found the Green Party in Germany. They had a relationship. Mansholt's children declare in the film that they knew about it, even understood how their father and Kelly connected but that they were glad he ended the relationship and returned to their mother.
14 Mansholt supported Salvador Allende's nationalization of the Anaconda copper mines that had been exploited for a long time by American corporations, leaving the workers in poverty. The military coup d'état in 1973 by general Pinochet (which lasted until 1988) was supported by the American government. See the film NO! (Pablo Lorrain, 2012) about the end of the military junta (with the help of a television advertisement campaign).
15 One critic mentioned this in 1974 as incomprehensible nonsense. See Philip van Tijn, 'Hoop onzin in film over multinationals'. In 2001 the Euro as common European currency became a reality.
16 See Charles Levinson, *Capital Inflation and the Multinationals*; *Vodka Cola*; *International Trade Unionism*, and *Industry's Democratic Revolution*.
17 Joris Luyendijk, *Dit kan niet waar zijn / Swimming with Sharks*.
18 See also Maurizzio Lazzarato, *The Making of the Indebted Man*.
19 http://www.usdebtclock.org/.
20 Cherry Duyns, 'Een weekje Biafra,' *Haagse Post*, 21 September 1968.
21 Johan van der Keuken, 'Dertig Jaar na '68,' *in Bewogen beelden*, p. 100.
22 Van Gasteren and Van der Keuken in Cherry Duyns, 'Een weekje Biafra'.
23 Ibid.
24 Ibid.
25 Louis van Gasteren in 'Bloedbad in de Soedan,' *Panorama*, Oktober 1971.
26 Van Gasteren's extensive library contains Rolf Steiner's book, *Carree Rouge*, with

a dedication by the author.

27 Thanks to Raul Nino Zambrano and the International Documentary Festival Amsterdam (IDFA) for providing additional viewing access to the film.

28 Žižek at the end of THE PERVERT'S GUIDE TO IDEOLOGY (Sophie Fiennes, 2012).

CODA

1 For instance in Ard Hesselink, *Louis van Gasteren*, p. 40.
2 Ibid. My translation.
3 Bernard Stiegler, *Technics and Time 3*, p. 22-24.
4 Patricia Pisters, *The Neuro-Image*, 127-155. This passage is also elaborated in Pisters, 'Folding the Borgesian Map'.
5 See Patricia Pisters, 'Flash-forward: The Future is Now'.
6 There are countless ways in which the neuro-image expresses this obsession with the future. For instance, INCEPTION (Christopher Nolan, 2010) is told from the point of view of the future (old age or perhaps even death of the main characters); MINORITY REPORT (Steven Spielberg, 2002) shows us a world where crime is prevented via predictions from savants that can see the future on their brain-screens. The neuro-image is also related to the digital age that is governed by a database logic that allow pattern recognitions that lead to prediction, profiling, preemptive policing, and prevention. There is always an uncertainty factor in these predictive policies that think from the future.
7 Gilles Deleuze, *Difference and Repetition*, pp. 90-94.
8 James Williams, *Gilles Deleuze's Difference and Repetition*, p. 103.
9 Niklas Luhmann, "The Future Cannot Begin," p. 131.
10 Ibid., p. 136 and p. 140.
11 Maria Poulaki, *Before or Beyond Narrative?*, pp. 29-30. Poulaki quotes Allan Cameron, *Modular Narratives in Contemporary Cinema*, p. 25. See also Warren Buckland, *Puzzle Films*.
12 Personal conversation of author with Louis van Gasteren, 29 January 2015.
13 Van Gasteren repeats these words also in the opening of HAMARTÍA.
14 Karen Barad, *Meeting the Universe Halfway*, 19-20.

ILLUSTRATIONS

1 Louis van Gasteren, e-mail exchange with the author, 30 september 2015.

FILMOGRAPHY OF LOUIS VAN GASTEREN

Directed and produced by Louis van Gasteren
Spectrum Film/Euro Television Productions

HET BAKEN VAN WASSENAAR / WASSENAAR'S BEACON
2014, digibeta, b/w & colour, 12 min.
Camera: Jan de Bont/Kester Dixon; Sound: Peter Brugman; Editing: Ilja Lammers; Production: Joke Meerman.
A cypress tree on a road near the village of Wassenaar, hacked in the 1960s. Its meaning for those who lived there.

NEMA AVIONA ZA ZAGREB / THERE IS NO PLANE FOR ZAGREB
2012, DCP, 35 mm, b/w & colour, 80 min.
Camera: Jan de Bont/Milek Knebel/Theo Hogers/Kester Dixon; Sound: Peter Brugman/Wim Wolfs/Otto Horsch; Editing: Rolf Orthel/Bert Haanstra/Jan Bosdriesz; Final digital version: Ilja Lammers.
The discovery of the world in the 1960s, seen through the eyes of Louis van Gasteren and his little daughter. It is a vital and open world, with the urge to experiment: participation and observation.

TERUG NAAR NAGELE / BACK TO NAGELE
2011, digibeta, colour, 75 min.
Camera: Kester Dixon/Mario van den Dungen/Peter Brugman; Sound: Flip van den Dungen/Otto Horsch; Editing: Ilja Lammers; Production: Joke Meerman.
A sequel to the film A NEW VILLAGE ON NEW LAND (1960). Van Gasteren revisits Nagele to see how its unique architecture and its socio-economic situation has changed in the course of the last 50 years. Many changes are comparable to other small communities all over the world.

OVERSTAG / CHANGING TACK
2009, digibeta, colour, 80 min.
Camera: Kester Dixon; Sound: Flip van den Dungen/Otto Horsch; Editing: Ilja Lammers; Production: Joke Meerman.
A film about Sicco Mansholt (1908-1995). Using unique visual material including footage from the archives of the Mansholt family and interviews that Van Gasteren held with family and friends, the film provides a portrait of a committed man who played a large role in the construction of the European Union.

**SICCO MANSHOLT, VAN BOER TOT EUROCOMMISSARIS /
FROM FARMER TO EUROPEAN COMMISSIONER**
2008, digibeta, colour, 21 min.
Camera: Kester Dixon/Thomas Kist; Sound: Flip van den Dungen; Editing: Sytse van der Harst; Production: Joke Meerman.
To mark the hundredth anniversary of the birth of Sicco Mansholt, an exhibition was organized in the Veenkoloniaal Museum in Veendam. Louis van Gasteren made a short film for this exhibition.

HET VERDRIET VAN ROERMOND / ROERMOND'S SORROW
2006, digibeta, colour, 90 min.
Camera: Jos van Schoor/Fred van Kuyk/Kester Dixon; Sound: André Patrouillie/Flip van den Dungen; Editing: Cees van Ede/Ilja Lammers.
Short version of the film, aired by national television.

HET VERDRIET VAN ROERMOND / ROERMOND'S SORROW
2005, digibeta colour, 4 x 50 min.
Camera: Jos van Schoor/Fred van Kuyk/Kester Dixon/Mario van den Dungen; Sound: André Patrouillie/Flip van den Dungen; Editing: Anouk Sluizer/Ilja Lammers; Production: Haro op 't Veld, Joke Meerman.
Series of four films about 14 inhabitants of Roermond executed by the Germans on 26 December 1944.

DE PRIJS VAN OVERLEVEN / THE PRICE OF SURVIVAL
2003, digibeta, colour, 56 min.
Camera: Gregor Meerman/Thomas Kist/Deen van der Zaken; Sound: Jaqueline van Vugt/David Schmidt/Bouwe Mulder; Editing: Daphne Rosenthal; Production: Joke Meerman.
A follow-up of the film NOW DO YOU GET IT, WHY I AM CRYING?, made in 1969, related to the children of the survivors of the Second World War; premiere September 2003. Golden Calf for the best (short) documentary, Netherlands Film Festival, Utrecht, 2003, selected by the Berlinale (Forum).

IN EEN JAPANSE STROOMVERSNELLING / IN JAPANESE RAPIDS
2002, 35 mm, colour, 85 min.
In coproduction with Studio Nieuwe Gronden (René Scholten/Digna Sinke)
Camera: Jos van Schoor, Eddy van den Enden/Mark Bakker/Thomas Kist/Gregor Meerman/Junji Aoki/ Robin Probin/Jaqueline van Vugt; Sound: Mori Suemura, Otto Horsch/Shinichi Yamazaki; Editing: Barry van der Sluys; Production: Joke Meerman/ Joanne de Roest.
Film on the role of the Dutch hydraulic engineers in the Meiji era in Japan.

BEYOND WORDS
1997, 35 mm, colour, 30 min.
Camera: Jan de Bont; Sound: Peter Brugman; Editing: Anna Bijl and Ilja Lammers; Production: Ezra Mir/Paul Comar.
Interview with Meher Baba, filmed in Meherabad and Meherazad in 1967.

THE NETHERLANDS MADE IN HOLLAND
1995, Betacam SP, colour, 15 min.
Camera: Thomas Kist; Editing: Ton van Luin; Production: Joke Meerman
Short film on the sounds of Holland, the sound of dry feet!

HOW DO PIGEONS HOME?
1994, Betacam SP, colour, 30 min.
Camera: Thomas Kist/Gregor Meerman; Sound: Otto Horsch; Editing: Ton van Luin; Production: Joke Meerman.
An experiment with mobile pigeon lofts, registered at the campus of the University of Utrecht.

EEN ZAAK VAN NIVEAU / A MATTER OF LEVEL
1989, 16 mm, Betacam SP, colour, 56 min.
Co-director: Raymond le Gué; Camera: Deen van der Zaken/Albert van der Wildt/Dirk Teenstra/Jos van Schoor; Sound: Lukas Boeke/Jan Snijders/Otto Horsch; Editing: Gerard Antonioli; Production: Jeroen Loeffen/Joke Meerman.
1000 years of Dutch water management and hydro civil engineering. Gold Camera Award (Chicago), Sony Video Award (Amsterdam), Amsterdam Film Award, Special Commendation Prix Futura (Berlin).

NN IM RATHAUS / AMSTERDAM ORDNANCE DATUM IN THE AMSTERDAM TOWNHALL
1988, 16 mm, colour, 45 min.
Camera: Jos van Schoor/Albert van der Wildt/Deen van der Zaken; Sound: André Patrouillie/Bert van den Dungen; Editing: Remmelt Lukkien; Production: Joke Meerman.

Film on the realization of the 'NAP-project' in the Townhall/Music Theatre, Amsterdam, Commissioned by the Westdeutscher Rundfunk /Alexander von Cube.

DE EERSTE MENS OP SARDINIË / FIRST MAN ON SARDINIA
1985, 16 mm, colour, 15 mm.
Camera: Jos van Schoor; Sound: André Patrouillie; Editing: Joke Meerman.
An archaeological survey in the cave of Corbeddu with remarkable results.

DODE DUIVEN VALLEN OM MIJ HEEN / DEAD PIGEONS ARE FALLING AROUND ME
1984, 16 mm, colour, 30 min
Camera: Fred van Kuyk/Jos van Schoor; Sound: René van den Berg/André Patrouillie; Editing: Joke Meerman.
Documentary on the music composed by Hans van Sweeden, performed by Vera Beths, Dorothy Dorow, Ary Jongman and Ton Hartsuiker.

ALLEMAAL REBELLEN 1, 2, 3 / ALL REBELS, 1, 2, 3
1983, 16 mm, b/w & colour, 150 min.
Camera: Fred van Kuyk/Jos van Schoor; Sound: René van den Berg/André Patrouillie/Jan Wouter Stam/Christine van Roon; Editing: Remmelt Lukkien/Joke Meerman.
Three documentaries on the Amsterdam 'scene' 1955-1965, each 55 min.

HANS HET LEVEN VOOR DE DOOD / HANS LIFE BEFORE DEATH
1983, 35 mm, b/w & colour, 155 min.
Camera: Paul van den Bos/Fred van Kuyk/Jos van Schoor; Sound: René van den Berg/André Patrouillie/Jan Wouter Stam. Editing: Wim Louwrier/Remmelt Lukkien; Production: Joke Meerman.
A documentary/feature on the life of the young composer Hans van Sweeden and those who knew him intimately. Award for the best Dutch film in 1983. Award of the Dutch film critics, 1983; the Belgian film critics Award, 1984; Best Dutch Documentary 1980-1990.

HÖHE ÜBER NULL/ THE LEVEL ABOVE ZERO
1982, 16 mm, colour, 28 min.
Camera: Jos vanSchoor/Dirk Teenstra; Sound: André Patrouillie/Lucas Boeke; Editing: Remmelt Lukkien; Production: Joke Meerman.
Documentary on the Amsterdam Ordnance Datum.
Commissioned by the Westdeutscher Rundfunk/Alexander von Cube

WIRBULA FLOW FORMS
1980, 16 mm, colour, 10 min.
Camera: Jos van Schoor; Sound: André Patrouillie; Editing: Remmelt Lukkien.
The opening of the artwork by the English artist John Wilks.

DE INGREEP / THE OPERATION
1979, 16 mm, b/w, 22 min.
Camera: Bert Spijkerman; Sound: Ron Visscher; Editing: Wim Louwrier; Photographs: Cor Jaring.
Bart Huges motivates the drilling of a hole in his skull, shot in 1964.

OPEN HET GRAF / OPEN THE GRAVE
1979, 16 mm, b/w, 15 min
Camera: Ton Lefèvre; Editing: Louis van Gasteren.
The first happening of Amsterdam (1962), initiated by Jan Vrijman, edited and produced by Louis van Gasteren in 1979; with commentary of the participants.

**EEN VERSTOORDE MAALTIJD IN EEN RUSSISCH KLOOSTER /
A DISTURBED DINNER IN A RUSSIAN MONASTERY**
1978, 16 mm, b/w, 5 min.
Sound: Louis van Gasteren; Editing: Remmelt Lukkien.
Porno, based upon archive material from 1920.

DO YOU GET IT, NR. 4
1978, 16 mm, colour, 15 min.
Camera: Hans Visser/Louis van Gasteren; Sound: Wim Wolfs; Editing: Louis van Gasteren and Remmelt Lukkien.
The third in the series on perception and interpretation.

**IDEALE RECONSTRUKTIONEN, MENSCHENMUSEUM, LEBENDIGE STEINZEIT, FRÜHE STERNE /
IDEAL RECONSTRUCTIONS, MUSEUM OF MANKIND, VIVID STONE AGE, EARLY STARS**
1976-1979, 16 mm, colour, each 50 min.
Series based upon the films about Sardinia.
Commissioned by the Westdeutscher Rundfunk/Alexander von Cube.

IL RISO SARDONICO / THE SARDONIC SMILE
1977, 16 mm, colour, 56 min.
Camera: Jos van Schoor/Fred van Kuyk; Sound: André Patrouillie/René van den Berg; Editing: Magda Reypens; Production: Joke Meerman.
Myths and science; the third documentary on Sardinia.

SALUDE E LIBERTADE / HEALTH AND LIBERTY
1976, 16 mm, colour, 52 min.
Camera: Jos van Schoor; Sound: André Patrouillie; Editing: Magda Reypens; Production: Joke Meerman.
Sardinia's history and culture, the second film in the Sardinia series.

DO YOU GET IT, NR. 3
1975, 16 mm. colour, 13 min.
Camera: Hans Visser; Editing: Remmelt Lukkien.
The second film on perception and interpretation.

CORBEDDU
1975, 16 mm, colour, 72 min.
Camera: Jos van Schoor; Sound: André Patrouillie; Editing: Edgar Burcksen/Magda Reypens; Production: Joke Meerman.
The first of a series on the island of Sardinia. Can the outlaw Corbeddu be considered as Sardinia's Robin Hood?

MULTINATIONALS
1974, 16 mm, colour, 58 min.
Camera: Frans Bromet/Umberto Galeassi/Jos van Schoor; Sound: Wim Mulder/Lino Galeassi/André Patrouillie; Editing: Huib Duyster.
Documentary on the role of multinational enterprises.

BERICHT UIT PARIJS, LONDON, BOTERBERG, FRANSE VERKIEZINGEN, BERICHT UIT ITALIË / REPORTS FROM PARIS, LONDON, FRANCE, ITALY
1974-1972, 16 mm, colour, 5 x 30 min.
Camera: Jos van Schoor/Raymond Sauvaire/ François About; Sound: André Patrouillie/Robert Meunier/Pierre Gamet; Editing: Barry van der Sluys/Magda Reypens.
Series on Europe, made for the Dutch TV programme E'72, E'73, E'74.

ON NE SAIT PAS / NOBODY KNOWS
1973, 16 mm, colour, 13 min.
Camera: Philippe Dumez; Sound: Leonce Marty/Jos de Hessele; Editing: Huib Duyster.
A portrait of a French peasant woman.

SANS TITRE / WITHOUT TITLE
1972, 16 mm, b/w, 10 min.
Camera: Philippe Dumez; Sound: Michel Bossie; Editing: Aline Jonas.
The counterpoints of European welfare: pollution and the discrimination of the third world.
Commissioned by ORTF, France.

BERICHT UIT EUROPA, NR. 3 / REPORT FROM EUROPE, NO. 3
1972, 16 mm, colour, 45 min.
Camera: Philippe Dumez/Roeland Kerbosch/Jos van Schoor/Hans Visser; Sound: Leonce Marty/Jos de Hessele/André Patrouillie; Editing: Huib Duyster.

Film about the EC, focused on what the European population thinks about the European Community.

ARNE NAESS, LESZEK KOLAKOWSKI, HENRI LEFEBVRE, FREDDY AYER
1971, 16 mm, colour, 4.x 15 min.
Camera: Jos van Schoor/Umberto Galeassi/ Philippe Dumez/Albert van der Wildt; Sound: Hans Muller/Ton van Schalkwijk/André Patrouillie; Editing: Bato Bachman; Production: Janet Pontier.
Portraits of these four philosophers for the International Philosophers Project for Dutch television, NOS.

BERICHT UIT KHARTOUM / REPORT FROM KHARTOUM
1971, 16 mm, colour, 27 min.
Camera: Albert van der Wildt; Sound: Louis van Gasteren; Editing: Bato Bachman.
Report of the trial of the mercenary Rolf Steiner.

BERICHT UIT EUROPA, NR. 1 / REPORT FROM EUROPA, NO. 1
1971, 16 mm, colour, 45 min.
Camera: Umberto Galeassi/Roeland Kerbosch/ Jos van Schoor/ Hans Visser; Sound: Nico Goedbloed, Mady Saks, Jos de Hesselle; Editing: Barry van der Sluys/Huib Duyster.
First of two documentaries on the unification of various European countries into the European Community (Mansholt Plan, language problems).

IL N'Y A PLUS DE TEMPS À PERDRE / THERE IS NO TIME TO LOOSE
1971, 16 mm, b/w, 12 min.
Film about European agrarian politics.
Commissioned by ORTF, France.

WATERWALK
1970, 16 mm, colour, 7 min.
Camera: Louis van Gasteren.
Film about the artwork of Theo Botschuyver, which allows you to walk on water.

BEGRIJPT U NU WAAROM IK HUIL? / NOW DO YOU GET IT, WHY I AM CRYING?
1969, 16 mm, b/w, 62 min.
Camera: Jan de Bont/Jos van Schoor; Sound: Wim Wolfs/Don Heerkens/Barry van der Sluys; Editing: Rolf Orthel/Jan Bosdriesz/Huib Duyster/Bato Bachman.
A therapeutic LSD-session with a former inmate of a German concentration camp.

BERICHT UIT BIAFRA / REPORT FROM BIAFRA
1968, 16 mm, colour, 50 min.
Camera: Roeland Kerbosch/Johan van der Keuken; Sound: Louis van Gasteren/ Roeland Kerbosch/Johan van der Keuken; Editing: Louis van Gasteren/Johan van der Keuken.
A documentary on the Biafran war. State-Award for Film 1969.

DO YOU GET IT, NO. 1
1967, 16 mm, b/w, 9 min.
Camera: Theo Hogers; Sound and Editing: Louis van Gasteren.
The first film in the series on perception and interpretation.

BECAUSE MY BIKE STOOD THERE
1966, b/w, 11 min.
Camera: Theo Hogers; Sound and Editing: Louis van Gasteren.
Filmed at the opening of a Provo photo exhibition in 1966. The police felt provoked and reacted with unexpected violence. The film was prohibited by the Dutch Committee for Film Censorship.

OUT OF MY SKULL
1965, 16 mm, colour & b/w, 15 min.
Camera: Robert Gardner; Sound: Stuart Cody; Editing: Louis van Gasteren.
An experimental film, shot in the US.

JAZZ AND POETRY
1964, 16 mm, b/w, 14 min.
Camera: Ton Lefèvre/Louis van Gasteren; Sound: Ate de Vries; Editing: Louis van Gasteren.
The poet Ted Joans reads his poetry with jazz musicians Piet Kuiters, Ruud Jacobs, Cees See and Herman Schoonderwalt.

MARL – DAS RATHAUS / MARL – THE TOWNHALL
1964, 16 mm. b/w, 56 min.
Camera: Bert Spijkerman/ Ton Lefèvre. Sound and Editing: Louis van Gasteren; Production: Jan van Vuure.
The new town hall of Marl (Germany), designed by the Dutch architects Van den Broek and Bakema.

D'R IS TELEFOON VOOR U / THERE IS A PHONECALL FOR YOU
1964, 35 mm, b/w, 46 min.
Camera: Ton Lefèvre/Louis van Gasteren; Sound: Peter Vink/Louis van Gasteren;

Editing: Louis van Gasteren.
A documentary on the Dutch telephone system.

MAYDAY
1963, 16 mm, b/w, 20 min.
Camera: Wouter de Vries; Sound and Editing: Louis van Gasteren.
Documentary on the rescue work at sea, the successes and the failures.

WARFFUM, 220562
1962, 35 mm, b/w, 26 min.
Camera: Ton Lefèvre; Sound: Rob Zimmerman; Editing: Loet Roozekrans; Production: Jan van Vuure.
The installation of the last automated telephone system, fiction and documentary, focusing on the moment the system starts working.

HET HUIS / THE HOUSE
1961, 35 mm, b/w, 32 min.
Camera: Eddy van den Enden; Sound: Wim Huender; Editing: Max Natkiel/Louis van Gasteren; Production: Kees Romeyn/Jan van Vuure.
A fiction film dealing with a house that is simultaneously built and destroyed. No dialogue. Several awards in Europe and the US.

ALLE VOGELS HEBBEN NESTEN / ALL BIRDS HAVE NESTS
1961, 35 mm, b/w, 25 min.
Camera: Ton Lefèvre; Sound: Rob Zimmerman; Editing: Louis van Gasteren/Loet Roozekrans; Production: Jan van Vuure.
Documentary on the system-building as a result of the post-war housing shortage.

EEN NIEUW DORP OP NIEUW LAND / A NEW VILLAGE ON NEW LAND
1960, 35 mm, b/w, 25 min.
Camera: Wouter de Vries/Louis van Gasteren; Sound: Wim Huender/Peter Vink; Editing: Louis van Gasteren; Production: Kees Romeyn/Jan van Vuure.
A documentary on the planning, building and first pioneers of the village of Nagele in the new IJsselmeerpolder. With architects such as Aldo van Eyck and Gerrit Rietveld.

STRANDING / THE STRANDING
1960, 35 mm, b/w, 90 min.
Camera: Wouter de Vries/Henk Haselaar/Fred Tammes; Sound: Wim Huender/Peter Vink; Editing: Louis van Gasteren/Loet Roozekrans; Production: Jan van Vuure.
A thriller, shot on location on a wrecked ship.

VLIEGENDE SCHOTELS GELAND / FLYING SAUCERS
1955, 35 mm, b/w, 4 min.
Camera: Wouter de Vries; Production: Bert van de Pijpekamp/Kees Romeyn/Jan van Vuure.
Science-fiction commercial for Albert Heijn.

RAILPLAN 68
1954, 35 mm, b/w, 15 min.
Camera: Henk Haselaar; Editing: Louis van Gasteren.
A documentary on the night-time renewal of tramway rails in Amsterdam.

ACCRA, HAVEN ZONDER KRANEN / ACCRA, PORT WITHOUT CRANES
1953, 16 mm, b/w, 10 min.
Direction: Theo van Haren Noman; Camera: Frits Lemaire/Joes Odufré; Sound: Louis van Gasteren; Editing: Lien d'Oliveyra.
Impression of the transportation of bags of cocoa with little boats to the coasters in the mooring of Ghana harbour.

DWARS DOOR DE SAHARA / CROSSING THE SAHARA
1953, 16 mm, b/w, 45 min.
Direction and Camera: Theo van Haren Noman; Editing: Lien d'Oliveyra; Production: Louis van Gasteren.
Report of an adventurous trip by car from Amsterdam to the present Ghana.

BRUIN GOUD / BROWN GOLD
1952, 35 mm, b/w, 90 min.
Direction: Theo van Haren Noman; Camera: Frits Lemaire/Joes Odufré; Sound: Louis van Gasteren/Wim Huender; Editing: Lien d'Oliveyra; Production: Louis van Gasteren.
A documentary on cocoa and chocolate; shot on location in Ghana and the Netherlands.

ART WORKS OF LOUIS VAN GASTEREN

NORMAAL AMSTERDAMS PEIL / AMSTERDAM ORDNANCE DATUM
1988 Public monument in the new city hall of Amsterdam, made in collaboration with Kees van der Veer.

PROJECT NEELTJE JANS
1987 Land art project for the artificial island Neeltje Jans that was used in the water management of the Oosterschelde works. Plan was completed but for financial reasons never realized. With Wilhelm Holzbauer, Frei Otto and Martin Manning.

WORTELS VAN DE STAD / ROOTS OF THE CITY
1980 Public art monument in the underground of Amsterdam

GROETEN VAN DE NIEUWMARKT / GREETINGS FROM THE NIEUWMARKT
1980 Photowork in the underground of Amsterdam. With Jan Sierhuis, Bert Griepink and Roel van den Ende.

MONTE KLAMOTT
1980 An a-political project to reflect on the rubble left by the war. Project not realized.

SIGNAAL / SIGNAL
1978 Monumental crow's foot from stainless steel. Project not realized. Prototypes placed in 'miniature Holland' Madurodam.

SUNNY IMPLO
1970 Made in collaboration with Fred Wessels. Large spheric object with 'electronic brain' with sound and light. No longer exists.

SCHILDPAD SCHILDERIJ / TORTOISE PAINTING

1967 Large painting (3,60 x 4,88 metres) made of different types of paint (with different visibility conditions) of tortoises. Exhibited in 1968 at Fodor. Painting no longer exists.

MILWAUKEE INTERSPACING

1966 Assemblage of police targets with bullet holes. First exhibited at Stedelijk Museum in 1966; at Van Abbe Museum in 1967; and at Fodor Museum and at Cindu NV in 1968.

GLOBE-CONSCIOUS MATERIAL PAINTINGS

1965- 1968 Series of paintings made from roads and streets. First exhibited at Stedelijk Museum in 1966; at Van Abbe Museum in 1967; and at Fodor Museum and at Cindu NV in 1968.

INDUSTRIAL DESIGN

1965 Sculpture of compressed car. Exhibited in Vondelpark.

**AUTOSCULPTUUR IN TELECREATIE - GEEN LICHT, GEEN BEELD /
AUTOSCULPTURE IN TELECREATION - NO LIGHT, NO IMAGE**

1964 Sculpture of car wrecks with car's original lighting. Prototype on display in Stedelijk Museum Amsterdam and Fodor Musuem (in 1968).

AUTOSCULPTUUR / AUTOSCULPTURE

1964 Sculpture of car wrecks

ANATOMY: POP-ART TABLEAU

1964 Objects-painting

ANATOMISCHE LES / ANATOMY LESSON

1963 Paintings

BREINAALD MET KNOOP / KNITTING NEEDLE

1947 Spatial object

ILLUSTRATIONS

All images courtesy of Louis van Gasteren / Spectrum Film. | 177

Introduction	RAILPLAN 68 (1954)
Chapter 1	THE HOUSE (1961)
Chapter 2	AOD monument in Amsterdam City Hall (1988)
Chapter 3	NOW DO YOU GET IT, WHY I AM CRYING? (1969)
Chapter 4	HANS LIFE BEFORE DEATH (1983)
Chapter 5	CHANGING TACK (2009)
Coda	NEMA AVIONA ZA ZAGREB (2012)
Notes	Film-O-Hand editing system developed by Louis van Gasteren
	About this system the filmmaker explains:
	When directing in 1954 my first documentary RAILPLAN 68, editing the film meant standing on my feet in front of a Moviola at Cinetone Studio's in Amsterdam. Equipment and a system to handle cuts and outcuts failed at the time, it simply did not exist. The editing room was as large as a lavatory space, full of clothes-pegs and metal nails. It was only after Italian editor Leo Catozzo had invented the perforated tape splicer, and after the appearance of horizontal editing tables, that I invented the Film-O-Hand System. Editing as such was uplifted from the Stone Age to a modern systematic way of working. Indeed, almost at the end of the 35 and 16mm film era.[1]

BIBLIOGRAPHY

Albers, Rommy, Baeke, Jan and Rob Zeeman, *Film in Nederland*, Amsterdam/Gent: Ludion and Filmmuseum, 2004.
Barad, Karen, *Meeting the Universe Halfway: Quantum Physics and the Entanglement of Matter and Meaning*, Durham and London: Duke University Press, 2007.
Barnouw, Erik, *Documentary: A History of the Non-Fiction Film*, New York: Oxford University Press, 1974.
Beckett, Samuel, *Wostward Ho*, New York: Grove Press, 1984.
Beerekamp, Hans, *Docupedia.nl.: Zekere tendensen in de Nederlandse documentaire*, Amsterdam: Het Ketelhuis, 2012.
— 'Het verzet is ons motief,' in *NRC Handelsblad*, 1 December 1989.
— 'Houdt het dan nooit op die Tweede Wereldoorlog?,' in *NRC Handelsblad*, 27 November 2014.
Bergson, Henri, *Matter and Memory*, trans. N.M. Paul and W.S. Palmer, New York: Zone Books, 1988 (original publication, 1896).
Bernink, Mieke, *Fons Rademakers: Scenes uit leven en werk*, Abcoude: Uniepers, 2003.
Bertina, B.J., '"Stranding" vol beloften,' in *De Volkskrant*, 23 January 1960.
— 'Louis van Gasteren ontdekt de geheimen van Sardinie,' *De Volkskrant*, 5 Juli 1977.
Blokker, Jan, '"Alle vogels hebben nesten" krachtige film over de woningbouw,' *De Volkskrant*, 20 October 1961.
— 'De telefoon en de lijkbezorger' in *Algemeen Handelsblad*, 8 February 1964.
Bordwell, David and Kristin Thompson, *Film Art: An Introduction* Fifth Edition, New York: McGraw-Hill, 1997.
Boost, Charles, 'Tweeërlei filmdebuut' in *De Groene Amsterdammer*, 6 February 1960.
Bosman, Anthony, 'Stranding dobbert op zwak verhaal,' in *Algemeen Dagblad*, 22 January 1960.
Broer, Thijs, *Langs de kust: Nederlanders en de zee*, Amsterdam: Prometheus/Bert Bakker, 2014.

Bruzzi, Stella, *New Documentary: A Critical Introduction*, New York: Routledge, 2000.

Buckland, Warren, ed., *Puzzle Films: Complex Storytelling in Contemporary Cinema*, Malden and Oxford: Wiley-Blackwell, 2009.

Bush, Vannevar, 'As We May Think,' *The Atlantic Monthly*, July 1945, pp. 112-124.

Cameron, Allan, *Modular Narratives in Contemporary Cinema*, Houndmills: Palgrave Macmillan, 2008.

Cowie, Peter. *Dutch Cinema: An Illustrated History*, London: The Tantivy Press, 1979.

Deleuze, Gilles, *Cinema 1: The Movement-Image*, trans. Hugh Tomlinson and Barbara Habberjam, London: The Athlone Press, 1986.

— *Cinema 2: The Time-Image*, trans. Hugh Tomlinson and Robert Galeta, London: The Athlone Press, 1989.

— *Difference and Repetition*, trans. Paul Patton, London: The Athlone Press, 1994 (original publication 1968.

— *Negotiations 1972-1990*, trans. Martin Joughin, New York: Columbia University Press, 1995.

— and Claire Parnet, *Dialogues*, trans. Hugh Tomlinson and Barbara Habberjam, New York: Columbia University Press, 1987.

De Jong, Loe, *Het koninkrijk der Nederlanden in de Tweede Wereldoorlog*, 26 Volumes, The Hague: Staatsdrukkerij (1969-1994).

De Jonge, Hans, *50 Artec contacten*, Amsterdam: Artec, 1983.

De Keizer, Madelon and Marije Plomp, eds., *Een open zenuw: Hoe wij ons de Tweede Wereldoorlog herinneren,* Amsterdam: Uitgeverij Bert Bakker, 2010.

Duyns, Cherry, 'Een Weekje Biafra,' *Haagse Post*, 21 September 1968.

Elsaesser, Thomas, *New German Cinema: A History*, London: BFI, 1989.

— *Fassbinder's Germany: History, Identity, Subject*, Amsterdam: Amsterdam University Press, 1996.

— 'Subject Positions, Speaking Positions: From *Holocaust, Our Hitler and Heimat to Shoah and Schindler's List* in Vivian Sobchack, ed., *The Persistence of History: Cinema, Television and the Modern Event,* New York and London: Routledge, 1996, pp. 145-184.

— *European Cinema Face to Face with Hollywood*, Amsterdam: Amsterdam University Press, 2005.

Elsken, Ed, *Jazz*, with texts by Hugo Claus, Simon Carmiggelt, Jan Vrijman, Amsterdam: Bezige Bij, 1959.

Enning, Bram, *De oorlog van Bastiaans: De LDS behandeling van het kampsyndroom*, Amsterdam and Antwerp: Augustus, 2009.

Frank, Anne, *Het Achterhuis: Dagboek-brieven*, Amsterdam: Prometheus, 2015 (original publication 1947); *The Diary of a Young Girl,* trans. B.M. Mooyaart, New York: Bantam, 1993.

Heerma van Vos, A.J., 'De Strafrechthervormers stonden met lege handen,' in *Haagse Post*, 1 March 1972.

Heidegger, Martin, *Basic Writings. Revised and Expanded Edition*, London: Routlegde, 1993.
Hendriks, Annemieke, 'Louis van Gasteren de liquidatie van de twijfel,' *De Groene Amsterdammer*, 26 November 1997.
Hermans, Willem Frederik, *De tranen der Acacia's*, Amsterdam: Van Oorschot, 1949.
— *De donkere kamer van Damokles*, Amsterdam: Van Oorschot, 1958; *The Darkroom of Damocles*, trans. Ina Rilke, New York: The Overlook Press, 2007.
Hesselink, Ard N., *Louis van Gasteren*, Amsterdam: Stichting Melkweg, 1978.
Hillesum, Etty. *Het denkende hart van de barak: Brieven van Etty Hillesum*, Haarlem: De Haan, 1982.
Hogenkamp, Bert, *De Nederlandse documentaire film 1920-1940*, Amsterdam: Van Gennep, 1988.
— *De Documentaire Film 1945-1965: De bloei van een filmgenre in Nederland*, Rotterdam: Uitgeverij 010, 2003.
Huizinga, Nienke, *Signaal: De beeldende kunst van Louis van Gasteren*, Amsterdam: Uitgeverij Weesperzijde, 2012.
Huhtamo, Erkki and Jussi Parikka, eds., *Media Archaeology: Approaches, Applications, and Implications.* Berkeley, Los Angeles and London: University of California Press, 2011.
Huxley, Aldous, *The Doors of Perception* and *Heaven and Hell*, London, New York and Sydney: Thinking Ink, 2011 (original publications 1952 and 1954).
Kennedy, James, *Nieuw Babylon in aanbouw: Nederland in de jaren zestig*, Amsterdam: Boom, 1995; *Building New Babylon: Cultural Change in the Netherlands during the 1960s.* Iowa: University of Iowa, 1995.
Lattin, Don, *The Harvard Psychedelic Club*, New York: Harper Collins, 2011.
Lazzorato, Maurizio, *The Making of Indebted Man: An Essay on the Neo-Liberal Condition*, translated by Joshua David Jordan, New York: Semiotext(e), 2012.
Leary, Timothy, Metzner, Ralph and Gunther Weil, eds. *The Psychedelic Reader: Classic Selections from The Psychedelic Review*, New York: Citadel Press, 1965.
Levi, Primo, *If this is a Man / The Truce*, trans. S.J. Woolf, London: Little Brown, 1987 (original publication 1947).
Levinson, Charles, *Capital, Inflation and the Multinationals,* London: George Allen & Unwin Ltd, 1971.
— *International Trade Unionism*, London: George Allen & Unwin Ltd, 1972.
— ed., *Industry's Democratic Revolution*, London: George Allen & Unwin Ltd, 1974.
— *Vodka Cola*, London: Gordon and Cremonesi, 1978.
Linthorst, Gerdin, 'Louis van Gasteren, de eeuwige verwondering,' in *Film en TV Maker*, October 1983, pp. 20-23.
Lucebert, *Verzamelde gedichten*, Victor Schiferli, ed., Amsterdam: Bezige Bij, 2002.
Luhman, Niklas, 'The Future Cannot Begin: Temporal Structures in Modern Society,' *Social Research*, vol. 43., no.1, 1976, pp. 130-152.

Luyendijk, Joris, *Dit kan niet waar zijn: Onder bankiers*, Amsterdam/Antwerpen: Atlas/Contact, 2015; *Swimming with Sharks: My Journey into the World of the Banker*. London: Faber & Faber, 2015.

Mansholt, *La crise: Conversations avec Janine Delaunay*, Paris: Stock, 1974; *De crisis*, Amsterdam: Contact, 1975.

McLuhan, Marshall, *The Gutenberg Galaxy: The Making of Typographic Man*, Toronto: University of Toronto Press, 1962.

— *Understanding Media: The Extension of Man*, New York: Signet Books, 1964.

— and Quentin Fiore, coordinated by Jerome Agel, *The Medium is the Massage*, London: Penguin, 1996 (original publication 1967).

Meadows, Donella, Meadows, Dennis, Randers, Jørgen and William Behrens, *The Limits to Growth: A Report for the Club of Rome on the Predicament of Mankind*, New York: Universe Books, 1972.

Michaux, Henri, *Miserable Miracle*, translated by Louise Varèse, New York: New York Review Books, 2002 (original publication 1956).

Middelburg, Bart, 'Moord in de Beethovenstraat,' *Het Parool*, 27 January 1990.

Minco, Marga, *Het bittere kruid: Een kleine kroniek*, Amsterdam: Bert Bakker 2007 (original publication 1957); *Bitter Herbs: The Vivid Memories of a Jewish Girl in Nazi Occupied Holland* trans. Roy Edwards, New York: Penguin, 1991.

Multatuli, *Max Havelaar of de koffieveiling van de Nederlandse handelsmaatschappij*, retranslated and edited by Gijsbert van Es, Amsterdam: Nieuw Amsterdam 2010 (original publication 1860); *Max Havelaar, or the Coffee Auctions of a Dutch Trading Company*, trans. Roy Edwards, London and New York: Penguin Books, 1967.

Mumford, Lewis, *The Culture of Cities*, New York: Harcourt Brace and Co., 1938.

— *City Development: Studies in Disintegration and Renewal*, New York: Harcourt Brace and Co., 1945.

— 'The Sky Line' [Dutch], pp. 1198-1201 in: *Bouw*, 1957 (originally published in *The New Yorker*, 12 October 1957).

Nichols, Bill, *Introduction to Documentary*, Bloomington: Indiana University Press, 2001.

— *Engaging Cinema. An Introduction to Film Studies*, New York: Norton, 2010.

Paalman, Floris, *Cinematic Rotterdam. The Times and Tides of a Modern City*, Rotterdam Uitgeverij 010. 2010. Online PhD version: http://hdl.handle.net/11245/2.77875.

Parikka, Jussi, *What is Media Archaeology?* Cambridge and Malden: Polity, 2012.

Pisters, Patricia, 'Lili and Rachel: Hollywood, History, and Women in Fassbinder and Verhoeven,' in Jaap Kooijman, Patricia Pisters and Wanda Strauven, eds., *Mind the Screen: Media Concepts According to Thomas Elsaesser*, Amsterdam: Amsterdam University Press, 2008, p. 177-188.

— 'Micropolitiek,' in Ed Romein, Marc Schuilenburg, Sjoerd van Tuinen, eds., *Deleuze Compendium*, Amsterdam: Boom, 2009.

- 'Form, Punch, Caress: Johan van der Keuken's Global Amsterdam,' in Marco de Waard, ed. *Imagining Global Amsterdam: History, Culture and Geography in a World-City*, Amsterdam: Amsterdam University Press, 2012, p. 125-141.
- *The Neuro-Image. A Deleuzian Film-Philosophy of Digital Screen Culture*. Stanford: Stanford University Press, 2012.
- 'Flashforward: The Future is Now,' in Shane Denson and Julia Leyda, eds. *Post-Cinema: Theorizing 21st-Century Film,* Sussex: REFRAME Books, 2015 (forthcoming).
- 'Cutting and Folding the Borgesian Map: Film as Complex Temporal Object in the Industrialization of Memory,' in Ekman, Ulrik, Jay David Bolter, Lily Diaz, Maria Engberg, Morten Søndergaard, eds. *Ubiquitous Computing, Complexity, and Culture*. New York: Routledge, 2015.

Poulaki, Maria, *Before or Beyond Narrative? Towards a Complex Systems Theory of Contemporary Films*. Dissertation Amsterdam University, Amsterdam: Rozenberg Publishers, 2011.

Presser, Jacques, *Ondergang: De vervolging en verdelging van het Nederlandse Jodendon 1940-194,* Den Haag: Staatsuitgeverij, 1965; *The Destruction of the Dutch Jews: A Definitive Account of the Holocaust in the Netherlands,* trans. Arnold Pomerans, New York: E.P. Dutton, 1969.

Regenhardt, Jan Willem, 'Louis van Gasteren,' Text for DVD box Louis van Gasteren. Hilversum and Amsterdam: Beeld en Geluid and EYE, 2011.

Roek, Anton, 'Louis van Gasteren, Working between Observation and Participation,' trans. Jeroen Kramer, *Catalogue Dutch Film Days 1989*, pp. 28-31.

Renov, Michael, ed., *Theorizing Documentary*, New York: Routledge, 1993.

Schoots, Hans, *Van Fanfare tot Spetters. Een cultuurgeschiedenis van de jaren zestig en zeventig,* Amsterdam: Uitgeverij Bas Lubberhuizen, 2004.
- *Living Dangerously: A Biography of Joris Ivens*, Amsterdam: Amsterdam University Press, 2000.
- *Bert Haanstra: Filmer van Nederland*, Amsterdam: Balans, 2010.

Slot, Eric, *De dood van een onderduiker*, Amsterdam: Mouria, 2006.

Steiner, Rolf, *Carré Rouge: Du Biafra au Soudan, le dernier condottiere*, Paris : Robert Laffont, 1976.

Stiegler, Bernard, *Technics and Time 3: Cinematic Time and the Question of Malaise*, translated by Stephen Barker, Stanford: Stanford University Press, 2011.

Stienen, Francois, 'Elke revolutie eet haar eigen kinderen,' An interview with Joost Seelen, in *De Filmkrant*, no. 173,1996. http://www.filmkrant.nl/av/org/filmkran/archief/fk173/seelen.html, pp.1-3.

Tee, Ernie, *Professie en passie: Een geschiedenis van de Nederlandse Film en Televisie Academie*, Amsterdam: NFTA, 2002.

Ten Berge, Henk, 'Bert Haanstra: Filmmaker, Magician, Wizard,' http://www.berthaanstra.nl/english.html.

Thooft, Lisette, 'Leef beter, leef fijner met behulp van psychedelica' in *NRC Next*, 23 January 2015.

Truffaut, François, 'A Certain Tendency in French Cinema,' http://www.newwavefilm.com/about/a-certain-tendency-of-french-cinema-truffaut.shtml (original publication in *Cahiers du Cinema*, 1954).

Van der Keuken, Johan, *Wij zijn 17*, with introduction by Simon Carmiggelt, Bussum: C.A.J. Van Dishoeck, 1955.

— *Achter glas*, text by Remco Campert, Hilversum: C. de Boer Jr., 1961.

— *Bewogen beelden: Films, foto's, teksten uit de wereld van een kleine zelfstandige*, Amsterdam: De Geus: 2001.

Van der Laarse, Rob, 'Kamp Westerbork' in Madelon de Keizer and Marije Plomp, eds., *Een open zenuw: Hoe wij ons de Tweede Wereldoorlog herinneren*, Amsterdam: Uitgeverij Bert Bakker, 2010.

— *Nooit meer Auschwitz? Erfgoed van de oorlog na Europa's eeuw van de kampen*, Herinnerings Centrum Kamp Westerbork, 2013.

Van Gasteren, Louis, 'Heb meelij met mij en mijn arme volk!,' in *Avenue* April 1982,

— *Hans het leven voor de dood*, shooting script and interview, Amsterdam: Tabula, 1983.

— *Allemaal rebellen: Amsterdam 1955-1965*, Amsterdam: Tabula, 1984.

— et al., *Een zaak van niveau: 1000 Jaar Nederlandse waterhuishouding*, Amsterdam: Euro Book Productions, 1991.

Van Gelder, Henk, *Hollands Hollywood: Alle Nederlandse speelfilms van de afgelopen zestig jaar*, Amsterdam: Luitingh~Sijthoff, 1995.

Van Lier, Frans, 'Louis van Gasteren werd "broertje" van McLuhan,' in *Ariadne*, 14 August 1968.

Van Merriënboer, Johan, *Mansholt: Een biografie*, Amsterdam: Boom, 2006.

Van Sweeden, Hans, *De mooie stad*, Amsterdam: Meulenhof, 1980.

Van Tijn, Philip, 'Hoop onzin in film over multinationals,' *De Volkskrant*, 28 February 1974.

Van Vree, Frank, *In de schaduw van Auschwitz: Herinneringen, beelden, geschiedenis*, Groningen: Historische uitgeverij, 1995.

— and Rob van der Laarse. *De Dynamiek van de herinnering: Nederland en de Tweede Wereldoorlog in een internationale context*, Amsterdam: Bert Bakker, 2009.

Verstraete, Ginette, 'Underground Visions: Strategies of Resistance along the Amsterdam Metro Lines,' in Christopher Lindner and Andrew Hussey, eds. *Paris-Amsterdam Underground: Essays on Cultural Resistance, Subversion and Diversion*, Amsterdam: Amsterdam University Press, 2013.

Von Sternberg, Josef, *Fun in a Chinese Laundry*, New York: The MacMillan Company, 1965.

Vos, Chris, *Televisie en bezetting: Een onderzoek naar de documentaire verbeelding van de Tweede Wereldoorlog in Nederland*, Hilversum: Uitgeverij Verloren, 1995.

Vriend, Eva, *Het nieuwe land: Het verhaal van een polder die perfect moest zijn*, Amsterdam: Balans, 2012.

Wagenaar, Willem Albert, 'Calibration and the Effects of Knowledge and Reconstruction in the Retrievel from Memory,' *Cognition* 28: 1988, pp. 277-296.

— and J. Groeneweg, 'The Memory of Concentration Camp Survivors,' *Applied Cognitive Psychology*, 4:2, pp. 77-87.

Waugh, Thomas, *The Conscience of Cinema: The Films of Joris Ivens 1912-1989*, Amsterdam: AUP, 2015 (forthcoming).

Wiesel, Elie, *Night*, trans. Marion Wiesel, New York: Hill and Wang, 2006 (original publication 1958).

Williams, James, *Gilles Deleuze's Difference and Repetition: A Critical Introduction and Guide,* Edinburgh: Edinburgh University Press, 2003.

Wolfe, Tom, *The Electric Kool-Aid Acid Test*, New York: Farrar Straus Giroux, 1969.

Young, James, *The Texture of Memory: Holocaust Memorials and Meaning*, New Haven and London: Yale University Press, 1993.

INDEX

10.32 MURDER IN AMSTERDAM
 (10.32 MOORD IN AMSTERDAM) 47
8½ 15

A

ACCRA 16, 174
Agnelli, Gianni 121
ALL BIRDS HAVE NESTS 17, 23, 24, 30, 86,
 159, 173
ALL REBELS 13, 16, 18, 37, 87, 96-98, 100,
 159, 168
ALPHAVILLE 65, 74, 153
AMARCORD 15
Amsterdam Film Liga 76, 86
AMSTERDAM GLOBAL VILLAGE 21
AMSTERDAM ORDNANCE DATUM 10, 167,
 175
Amsterdam Ordnance Datum (AOD) 26,
 41, 44
AND THE SEA WAS NO LONGER (EN DE ZEE
 WAS NIET MEER) 45, 147
Antonioni, Michelangelo 14, 34
ANWB 112, 162
Appel, Karel 85, 158
Artec 10, 21, 161
Arup, Ove & Partners 49
ASSAULT, THE (DE AANSLAG) 66
AUTOSCULPTURE IN TELECREATION
 (AUTOSCULPTUUR IN TELECREATIE)
 58
Ayer, sir Alfred 30

B

Baba, Meher 132, 135, 167
BACK TO NAGELE (TERUG NAAR NAGELE)
 16, 28, 29, 140, 165
BANDITS OF ORGOSOLO (BANDITI A
 ORGOSOLO) 109
Bannenberg, Gijs 50
Barad, Karen 141, 163
Bast, G.H. 60
Bastiaans, Jan 70
Beatrix, Queen of the Netherlands 12, 37
BECAUSE MY BIKE STOOD THERE (OMDAT
 MIJN FIETS DAAR STOND) 12, 13, 18,
 34, 66, 87, 99, 104, 172
Beerekamp, Hans 12, 75, 79, 146, 156-158
BEHIND THE NEWS (ACHTER HET NIEUWS)
 72
Bell, Alexander Graham 62
Bergson, Henri 35, 146
Bermond, Bob 12
Beuys, Joseph 53
Blokker, Jan 63, 147, 152

Boost, Charles 30, 35, 148, 149, 150
Brel, Jacques 114, 118
BRIEF ENCOUNTER 33
BROWN GOLD (BRUIN GOUD) 15, 16, 76, 86, 151, 174

C
Campert, Remco 21, 85
Cannes Film Festival 11, 47
Carné, Marcel 33
Carpenter Center of Harvard University 57
CHAINSAW FOR THE PAST, A (EEN KETTINGZAAG VOOR HET VERLEDEN) 76, 77, 78, 80, 109, 157
CHANGING TACK (OVERSTAG) 13, 18, 108, 114-118, 120, 166, 177
CITY WAS OURS, THE (DE STAD WAS VAN ONS) 38
Claus, Hugo 85, 180
CLOUDED EXISTENCE OF LOUIS VAN GASTEREN, THE 77
COBRA movement, the 85, 160
Congrès Internationaux d'Architecture Moderne (CIAM) 25
Constant 85, 160
CORBEDDU 108, 110, 111, 170
Corman, Roger 103
Corneille 85
Cowie, Peter 11, 14, 15, 21, 145, 146, 180
Cox, Vernon 135
CROSSING THE SAHARA (DWARS DOOR DE SAHARA) 15, 22, 174
Cuyp, Albert 53

D
Dam, Cees 44
DARWINS NIGHTMARE 126
Davidson, Steef 99
De 8 and Opbouw 25
De Bruijn, Hans 111
De Haas, Max 22

De Jong, Loe 68, 69, 154, 156
De Kroon, Maarten 53
De Kroon, Peter-Rim 53
De la Parra, Pim 34, 145
De Rijke, Johannis 54
De Seta, Vittorio 109
De Sica, Vittorio 34
Debussy, Claude 93
Deleuze, Gilles 15, 33-35, 80, 138, 146, 148, 149, 155, 158, 163
Dibbets, Jan 53
Dijkstra, Truda 89
Ditvoorst, Adriaan 12, 34
DO YOU GET IT NR. 3 87, 104
DO YOU GET IT NR. 4 87, 105
Douwes Dekker, Eduard 116
Dreifuss, Arthur 47
Duras, Marguerite 35, 149
Dutch Documentary School 11
DUTCH HOPE (HOLLANDS HOOP) 51
DUTCH LIGHT (HOLLANDS LICHT) 53

E
Ecuador 46, 48
Eichmann, Adolf 69
Ekberg, Anita 131, 136
Ellwood, Alison 95
Elsaesser, Thomas 65, 73, 153, 154, 156
Eno, Brian 91
Escher, George Arnold 54
Escher, Maurtis Cornelis 54
Euro Television Productions 10, 21, 108, 113, 128, 165

F
Fainlight, Harry 96
Fassbinder, Rainer Werner 74
FATHER, MASTER (PADRE, PADRONE) 110
Fellini, Federico 14, 15, 34, 89, 131, 136, 137, 146, 161
Fernhout, John 21

FINAL CUT, THE 137, 139, 140
FLAT JUNGLE, THE (DE PLATTE JUNGLE) 119
Fleury, Pieter 13
FLYING SAUCERS HAVE LANDED 13, 86
Fonda, Peter 103
FOOD. INC 120
FOOTNOTES TO AN OEUVRE (VOETNOTEN BIJ EEN OEUVRE) 11
FOUR WALLS (VIER MUREN) 22, 37
Frank, Anne 69, 154

G

Gammond, Stephen 96
GANGSTER GIRL, THE 34
Gardner, Robert 10, 101, 135, 172
GERMANY, YEAR ZERO 34
Gieling, Ramón 54
Gieske, Wilbert 54
Ginsberg, Alan 96
GLOBE CONSCIOUS MATERIAL PAINTINGS (BOLBEWUSTE MATERIE-SCHILDERIJEN) 10, 23, 58
Godard, Jean-Luc 34, 65, 148
GREETINGS FROM THE NIEUWMARKT (GROETEN UIT DE NIEUWMARKT) 39, 40
Griepink, Bert 39
Groosman, Ernest 24, 27
Grootveld, Robert Jasper 98, 159

H

Haanstra, Bert 11, 13, 21, 25, 45, 147, 165
Hague School, the (Haagse School) 53
HAMARTÍA 77-79, 163
HANS LIFE BEFORE DEATH 13, 16, 18, 23, 37, 87, 88, 92, 115, 131, 140, 145, 159, 168, 177
Hashimoto, Ushie 54
Hazelhoff Roelfzema, Erik 81, 154, 158

HEIGHT OVER ZERO (HÖHE ÜBER NULL) 44
HEIMAT 74, 180
Hensema, Marcel 51
Hermans, Willem Frederik 68, 74
Herrick and Harper 46
HIROSHIMA MON AMOUR 34, 35, 138, 149
Hobbema, Meindert 53
Hofman, Tine 40
Hofmann, Albert 95
Hogenkamp, Bert 11, 145
Hogers, Theo 12, 165, 172
HOLOCAUST 73, 180
Holzbauer, Wilhelm 44, 49, 66
Hopper, Dennis 103, 161
Horovitz, Michael 96
Horsting, Bas 29
HOTEL DU NORD 33
HOUSE, A (EEN HUIS) 22
HOUSE, THE (HET HUIS) 14, 15, 17, 30-36, 77, 78, 86, 89, 132, 137, 158, 173, 177
HOUSING SHORTAGE (WONINGNOOD) 22
Huges, Bart 9, 98, 169

I

I'LL ARRIVE A LITTLE LATER IN MADRA 34
IN JAPANESE RAPIDS (IN EEN JAPANSE STROOMVERSNELLING) 54, 167
INTERVISTA 131, 136, 137
Israel, Josef 53
Ivens, Joris 11, 13, 24

J

James, Henry 22
Jandl, Ernst 96
JAZZ AND POETRY 37, 87, 172
Jones, Ted 87
JOZEF KATUS' NOT SO HAPPY RETURN TO REMBRANDT'S COUNTRY 34
Juliana, Queen of the Netherlands 70

K

Keller, Hans 11, 55, 77, 151
Kennedy, James 7, 99, 160
Kenner, Robert 120
Kerbosch, Roeland 123, 170-172
Kesey, Ken 95
KHARTOUM 123, 126, 171
Kok, Hans 100
Kolakowski, Leszek 30
Korporaal, John 47
Kouwenaar, Gerrit 21, 85

L

LA DOLCE VITA 131, 136
Lakmaaker, Gerrit 99
LAST YEAR IN MARIENBAD 33
Le Gué, Raymond 50, 167
Lean, David 33
Leary, Timothy 95, 101, 132, 135, 159
Ledda, Gavino 110
Leegwater, Gijs 115
Lefebvre, Henri 30
Lely, Cornelis 24, 48
Levinson, Charles 121, 122, 162
Lienhard Frey, Lienhard 48
Losey, Joseph 80
Louw, Tientje 21
Louwrier, Wim 88, 168, 169
Lucebert 21, 65, 85, 153
Lukkien, Remmelt 88, 159, 167-170
Lumière brothers 33

M

MAGIC TRIP 95
Malfatti, Franco 118
Manning, Martin 49
Mansholt, Sicco 13, 18, 108, 113, 114, 121, 128, 166
Maris, Jacob 53
Marsman, Hendrik 45
Mastroianni, Marcello 131, 136
MATTER OF LEVEL, A 13, 17, 25, 49, 52, 53, 167
Matthaeas, Ulrich 83
Mauve, Anton 53
Maxia, Professor Carlo 112
MAYDAY 44, 46, 47, 48, 140, 173
McLuhan, Marshall 10, 57, 101, 132, 136, 152
Meerman, Joke 7, 10, 16, 88, 109, 114, 165-170
Menagé Challa, Elise 10
Mengelberg, Misha 88, 92-94, 102
Metz, Klaas 44
Minco, Marga 21, 69, 154
MIRROR OF HOLLAND (SPIEGEL VAN HOLLAND) 45
Mitchell, Adrian 96
Mondriaan, Piet 51, 53
Monsanto, Ilse 99
MONTE KLAMOTT 66, 175
MORNING OF SIX WEEKS, A 34
Mulisch, Harry 66
Multatuli (see Douwes Dekker, Eduard)
MULTINATIONALS 108, 121, 122, 170
Mumford, Lewis 23, 147

N

Naess, Arne 30, 36
Naim, Omar 137
Nechustan, Dana 51
Neeltje Jans 49, 175
NEMA AVIONA ZA ZAGREB 13, 14, 19, 31, 59, 69, 77, 131, 135, 136, 140-142, 152, 159, 165, 177
NETHERLANDS MADE IN HOLLAND, THE 43, 167
NEW EARTH (NIEUWE GRONDEN) 24
NEW VILLAGE ON NEW LAND, A (EEN NIEUW DORP OP NIEUW LAND) 16, 17, 24, 26-28, 140, 165, 173
Nichols, Bill 12, 145
NIGHT AND FOG 34

Nijholt, Willem 92
Nol, Onno 99
NORTHERNERS, THE (DE NOORDER-
	LINGEN) 27
nouvelle vague 34
NOW DO YOU GET IT, WHY I AM CRYING?
	(BEGRIJPT U NU WAAROM IK HUIL?)
	14, 16, 17, 67, 69, 70, 72-74, 77, 81, 82,
	95, 140, 155, 166, 171, 177

O

OCCUPATION, THE (DE BEZETTING) 68
Oettinger, Walter 75
Of Orange, William 52
OLD TOWN GROWING YOUNGER
	(VLAARDINGEN KOERST OP MORGEN)
	23
OPERATION, THE (DE INGREEP) 9, 18, 98,
	169
Otto Frank 69
Otto, Frei 49
OUT OF MY SKULL 10, 18, 87, 101, 102,
	104, 135, 161, 172
Out, Rob 22

P

Paalman, Floris 22, 147
PANORAMIEK 121
PARANOIA 34
Pattenden, Elspeth 94
PERVERT'S GUIDE TO IDEOLOGY, THE
	127, 163
PHOTOGRAPHER FILMS AMSTERDAM, A
	(EEN FOTOGRAAF FILMT AMSTER-
	DAM) 97
Polygon Journal 10, 76, 86
PORT WITHOUT CRANES (ACCRA, HAVEN
	ZONDER KRANEN) 16
Postel, Henny 117
Potter, Paulus 53
Povel, Wim 62

Presser, Jacques 69
PRICE OF SURVIVAL, THE (DE PRIJS VAN
	OVERLEVEN) 16, 18, 67, 81, 132, 140,
	145, 166
PTT 60, 63

R

Rabbi Soetendorp 72
Rademakers, Fons 66, 68, 74, 91, 156, 157,
	159
Radio Orange (Radio Oranje) 68
Radio Scheveningen 46, 47
RAILPLAN 68 37, 55-57, 76, 86, 174, 177
RAMSES 13
Reitz, Edgar 73
Renov, Michael 13, 146
REPORT FROM BIAFRA 108, 123, 124, 172
REPORTS FROM EUROPE NR. 1 113
Resnais, Alain 14, 33, 34, 36, 148
Rietveld, Gerrit 17, 25, 27, 173
RIFIFI IN AMSTERDAM 47, 150
Rimbaud, Arthur 93
ROERMOND'S SORROW (HET VERDRIET
	VAN ROERMOND) 17, 67, 83, 140, 166
ROME, OPEN CITY 34
Romeyn, Kees 44, 47, 173, 174
ROOTS OF THE CITY (WORTELS VAN DE
	STAD) 10, 17, 37, 39, 41, 175
Rossellini, Roberto 34
Rotha, Paul 68
Rouwenhorst Mulder, Antoine 54
Rubini, Sergio 136
Ruys, Mien 25, 27, 29

S

SANS TITRE 118, 170
SARDONIC SMILE, THE (IL RISO
	SARDONICO) 108
Sauper, Hupert 126
Schaper, Jan 23
Seelen, Joost 38, 183

| 191

INDEX

Sevenich, Jacobus 83
Sevenich, Mathieu 83
's-Gravesande, Ad 76-78
Shaffy, Ramses 13, 92, 99
SHOOT THE NETS (HET SCHOT IS TE BOORD) 47
SICCO MANSHOLT, FROM FARMER TO EUROCOMMISSIONER (SICCO MANSHOLT, VAN BOER TOT EUROCOMMISSARIS) 114
Sierhuis, Jan 39, 41
SILENT RAID, THE (DE OVERVAL) 68
SOLDIER OF ORANGE 81, 154
Spectrum Film 7, 10, 15-17, 21, 55, 159, 161, 162, 165, 177
Spijker, Henny 50, 93
SPITTING IMAGE, THE (ALS TWEE DRUPPELS WATER) 68
Stam, Mart 25, 27
Stam-Beese, Lotte 27
Steiner, Rolf 125, 128, 162, 171
Stiegler, Bernard 137, 163
STRANDING, THE (STRANDING) 14, 44, 46, 76, 86, 89, 173
Strowger, Almon B. 63
SUBSTANCE, THE 95, 155
SUNNY IMPLO 10, 18, 87, 101, 103, 135, 175
SYMMETRY 141

T

Taviani, Paolo and Vittorio 110
TECHNICOLOR DREAM, A 96
Telling, Joop 70, 81
THAT JOYOUS EVE (MAKKERS STAAKT UW WILD GERAAS) 91
THAT WAY TO MADRA (IK KOM WAT LATER NAAR MADRA) 12
THERE IS A PHONE CALL FOR YOU (D'R IS TELEFOON VOOR U) 17, 60, 63, 140

TO YOUR HEALTH AND FREEDOM (SALUDE E LIBERTADE) 108, 112
Trakl, Georg 93
TRIP, THE 103
Truffaut, François 12, 34, 145, 148

V

Van Agt, Dries 72
Van den Berg, Rudolf 77, 78
Van den Ende, Roel 39
Van der Elsken, Ed 86, 97, 145
Van der Heyde, Nicolai 34
Van der Horst, Herman 11, 25, 47
Van der Keuken, Johan 13, 14, 21, 22, 37, 86, 119, 122, 123, 145, 146, 160, 162, 172
Van der Veer, Kees 41, 44
Van Doorn, Cornelis 54
Van Doorn, Johnny 99, 102
Van Eyck, Aldo 17, 25, 26, 27, 173
Van Gasteren, Louis *passim*
Van Gasteren, Louis Augustaaf 10
Van Gennep 12
Van Gogh, Vincent 53
Van Haren Noman, Theo 15, 22, 146, 151, 174
Van Heyningen, Joan 94
Van Houten 15, 21, 22
Van Leer, Ruben 141
Van Ruisdael, Jacob 53
Van Sweeden, Hans 18, 23, 88-90, 92-95, 101, 109, 159, 168
Van Tol, Dick 72
Van Vree, Frank 65, 67, 153, 154
Van Vuure, Jan 47, 172-174
Van Warmerdam, Alex 27
Van Waveren, Guus 39, 40
Van Weerlee, Duco 96, 97, 160
Van Zutphen, Rik 99
Veerman, Cees 120
Verhaaf, Rein 93, 100

Verhoeven, Paul 81, 154
Verstappen, Wim 34, 145
Vinkenoog, Simon 47, 85, 87, 96, 99, 102
Voeten, Bert 21
VOICE OF WATER, THE (DE STEM VAN HET WATER) 45
Von Amsberg, Claus 12
Von Sternberg, Joseph 33
Vos van Marken, Jan 89, 90
Vrijman, Jan 23, 30, 145, 147, 152, 157-159, 169

W

Wagenaar, Willem Albert 80, 158
WARFFUM 60, 61, 140, 173
WAY SOUTH, THE 37, 38
WE COME AS FRIENDS 126
Weissenbruch, Jan Hendrik 53
Weisz, Frans 34, 145, 154
Wessels, Fred 99, 103, 175
Westerbork 66, 69, 153, 154
Whitehead, Peter 96
Who, The 108, 120
WHOLLY COMMUNION 96
Wilhelmina, Queen of the Netherlands 68
Willems, Gerrit, 53
Williams, Robin 137
Witz, Martin 95, 155
Wolkers, Jan 12
WREST FROM THE SEA (DER ZEE ONTRUKT) 25

Z

Žižek, Slavoj 127